Peanuts
A Golden Celebration

A Golden

PEANUTS
Celebration

The Art and the Story of the World's Best-Loved Comic Strip by *Schulz*

Edited and Designed by David Larkin

Comic Strips Researched by
Patrick McDonnell and Karen O'Connell

HarperCollinsPublishers

PEANUTS: A GOLDEN CELEBRATION.

This edition produced for The Book People Ltd,
Hall Wood Avenue, Haydock, St. Helens, WA11 9UL
by HarperCollins*Publishers*
77-85 Fulham Palace Road, Hammersmith, London, W6 8JB

HarperCollins books may be purchased for educational, business, or sales promotional use.
For information write to:
Special Markets Department, HarperCollinsPublishers, Inc.,
10 East 53rd Street, New York, NY 10022

Library of Congress Cataloging in Publication Data

Schulz, Charles M.
Peanuts / the art and the story of the world's best-loved comic strip / Schulz.
p. cm.
ISBN 000 761114 5
1. Schulz, Charles M. Peanuts. I. Title.
PN6728.P4S32494 1999
741.5'973—dc21
99-30314 CIP

www.**fire**and**water**.com

Principal Photography by Paul Rocheleau

Printed by Proost, Belgium

Contents

The Early Years

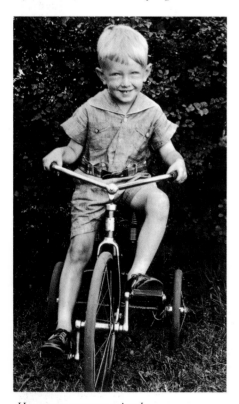

My mother and father as a young couple

The block in Saint Paul where my father's barbershop used to be. My bedroom was on the top right.

THE PUBLICATION OF THIS BOOK MARKS 50 YEARS since the first *Peanuts* strip appeared in newspapers. I have been asked many times if I ever dreamed that *Peanuts* would become so successful. Obviously I did not know that Snoopy was going to go to the moon and I did not know that the term "happiness is a warm puppy" would prompt hundreds of other such definitions and I did not know that the term "security blanket" would become part of the American language; but I did have the hope that I would be able to contribute something to a profession that I can now say I have loved all my life. However, I think I always surprise people when I say, "Well, frankly, I guess I did expect *Peanuts* would be successful, because after all, it was something I had planned for since I was six years old."

The comics entered my world early. I was two days old when an uncle nick-named me "Sparky," short for Sparkplug, Barney Google's horse in a popular comic strip of the time. And that name has stayed with me since.

My earliest recollection of drawing and being complimented on it is from kindergarten. I think it was my first day, and the teacher gave us huge sheets of white paper, large black crayons, and told us to draw anything we wanted. I drew a man shoveling snow, and she came around during the project, looked at my picture, and said, "Someday, Charles, you're going to be an artist."

My father was a barber (like Charlie Brown's father). Frequently in the evenings I went to the barbershop to wait for my father to finish work and then walk home with him. He loved to read the comic strips and we discussed them and worried about what was going to happen next to certain characters. On Saturday evening, I would run to the local drugstore at 9:00 when the Sunday pages were delivered and buy the two Minneapolis papers. The next morning, the two Saint Paul papers would be delivered, so we had four comic sections to read.

In my childhood, sports played a reasonably strong role, although they were strictly the sandlot variety. When the baseball season came, we organized our own team and challenged those of other neighborhoods. We rarely had good fields for our games, and it was always our dream to play on a smooth infield and actually have a backstop behind the catcher so we wouldn't have to chase the foul balls. In Minnesota, almost everyone knows how to skate, but I didn't actually learn on a real skating rink. Every sidewalk in front of every school had a sheet of ice at least ten feet long worn smooth from the kids sliding on it. It was on such a patch of ice, no longer than ten feet or wider than three feet, that I learned to skate. To play hockey on a real rink was a hopeless dream. Our hockey was usually played on a very tiny rink in one of our backyards, or in the street where we simply ran around with shoes rather than skates. I had always wanted to play golf and had seen a series of Bobby Jones movie shorts when I was 9 years old. There was no one to show me the game, and it was not until I was 15 that I had a chance to try it. Immediately I fell totally in love with golf. I could think of almost nothing else for the next few years. I still wanted to be a cartoonist, but I also dreamed of becoming a great amateur golfer.

I have always tried to dig beneath the surface in my sports cartoons by drawing upon an intimate knowledge of the games. The challenges to be faced in sports work marvelously as a caricature of the challenges that we face in the more serious aspects of our lives.

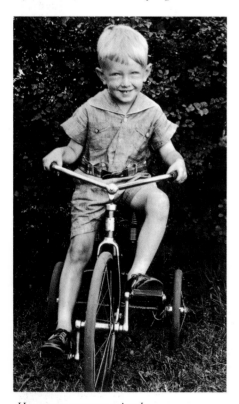

Happy on my new tricycle

During my senior year in high school, my mother showed me an ad that read: "Do you like to draw? Send in for our free talent test." This was my introduction to Art Instruction Schools, Inc., the correspondence school then known as Federal Schools. It was located in Minneapolis. I could have gone to one of several resident schools in the Twin Cities, but it was this correspondence course's emphasis upon cartooning that won me. The entire course came to approximately $170, and I remember my father having difficulty keeping up with the payments. I recall being quite worried when he received dunning letters, and when I expressed these worries to him he said not to become too concerned. I realized then that during those later depression days he had become accustomed to owing people money. I eventually completed the course, and he eventually paid for it.

When I was just out of high school, I started to submit cartoons to most of the major magazines, as all ambitious amateurs do, but received the ordinary rejection slips and no encouragement. After World War II, however, I set about in earnest to sell my work. One day, with my collection of comic strips in hand, I visited the offices of *Timeless Topix*, the publishers of a series of Catholic comic magazines. The art director, Roman Baltes, seemed to like my lettering and said, "I think I may have something for you to do." He gave me several comic book pages that had already been drawn by others but with the balloons left blank, and he told me that I should fill in the dialogue.

This was my first job, but soon after I took it I was also hired by Art Instruction. For the next year, I lettered comic pages for *Timeless Topix*, working sometimes until past midnight, getting up early the next morning, taking a streetcar to downtown Saint Paul, leaving the work outside the door of Mr. Baltes' office, and then going over to Minneapolis to work at the correspondence school. My job there was to correct some of the basic lessons, and it introduced me to a roomful of people who did much to affect my later life.

The head of the department was Walter J. Wilwerding, a famous magazine illustrator of that period. Directly in front of me sat a man named Frank Wing who had drawn a special feature called *Yesterdays*, which ran for a short time during the 1930s. He was a perfectionist at drawing things as they appeared, and I believe he did much to inspire me. He taught me the importance of drawing accurately, and even though I felt he was somewhat disappointed in me, and disapproved of my eventual drawing style, there is no doubt that I learned much from him. Almost everything I draw now, in what is sometimes a quite extreme style, is based on a real knowledge of how to draw that object, whether it be a shoe, a doghouse, or a child's hand. Cartooning, after all, is simply good design. In learning how to design a human hand after knowing how to draw it properly, one produces a good cartoon.

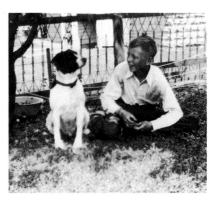

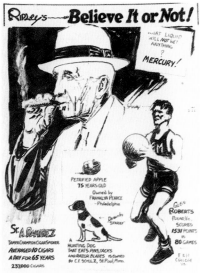

 When I was 13, we were given a black-and-white dog who turned out to be the forerunner of Snoopy. He was a mixed breed and slightly larger than the beagle Snoopy is supposed to be. He probably had a little pointer in him and some other kind of hound, but he was a wild creature; I don't believe he was ever completely tamed. He had a vocabulary of understanding approximately 50 words, and he loved to ride in the car. He waited all day for my dad to come home from the barbershop, and on Saturday evenings, just before 9:00, he always put his paws on my dad's chair to let him know it was time to get the newspapers. Spike would eat almost anything in sight. One day I was playing with a paddle and ball in the backyard and the rubber band broke, and Spike chased down the ball, grabbed it, and swallowed it. That night, after eating too much spaghetti, he threw it back up. Not long afterward, I made this drawing of Spike and sent it in to RIPLEY'S BELIEVE IT OR NOT! It was my first published drawing. The name of Spike lives on, as Snoopy's brother.

A page by my mentor, Frank Wing

My high school art teacher Miss Paro had a project once that I've always remembered with a joyful feeling. She said, "Draw anything you can think of, in sets of three, on one sheet of paper." Something about this appealed to me and I filled my paper with little drawings. She showed them in class, and I can remember feeling good. After graduation I lost contact with her, and then one day some years ago, a big fat envelope arrived in the mail and there was a note in it from Miss Paro, saying, "This is a drawing of yours that I saved for 25 years"—and there was that sheet of paper I'd remembered.

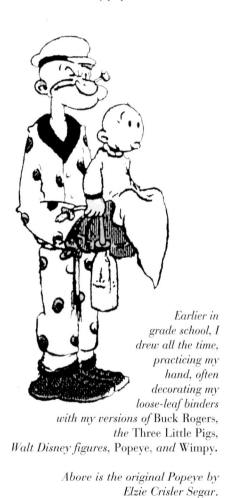

Earlier in grade school, I drew all the time, practicing my hand, often decorating my loose-leaf binders with my versions of Buck Rogers, the Three Little Pigs, Walt Disney figures, Popeye, and Wimpy.

Above is the original Popeye by Elzie Crisler Segar.

8

Some of the people who worked at Art Instruction Schools with me have remained friends all of these years. Those were days filled with hilarity, for there was always someone with a good joke, or laughter from some innocent mistake made by one of the students. It was not unusual for us to receive drawings of thumbs, and whenever we pulled such a drawing from its envelope we realized that once again a student had misunderstood the expression "making a thumbnail sketch."

There were many of us on the staff of Art Instruction who had ambitions to go on to other things, and I used my spare time, after completing the regular lesson criticisms, to work on my own cartoons. I tried never to let a week go by without having something in the mail working for me. During one period of time, from 1948 to 1950, I submitted cartoons regularly to the *Saturday Evening Post*, and sold 15 of them.

It was an exciting time for me because I was involved in the very sort of thing I wished to do. I not only lettered the complete *Timeless Topix* in English, but would do the French and Spanish translations without having any idea as to what the balloons were saying. One day Mr. Baltes bought a page of little panel cartoons that I had drawn and titled *Just Keep Laughing.* One of the cartoons showed a small boy who looked prophetically like Schroeder sitting on the curb with a baseball bat in his hands talking to a little girl who looked prophetically like Patty. He was saying, "I think I could learn to love you, Judy, if your batting average was a little higher." Frank Wing, my fellow instructor at Art Instruction, said, "Sparky, I think you should draw more of those little kids. They are pretty good." So I concentrated on creating a group of samples and eventually sold them as a weekly feature called *Li'l Folks* to the *St. Paul Pioneer Press*.

I continued to mail my work out to major syndicates. In the spring of 1950, I accumulated a batch of some of the better cartoons I had been drawing for the *St. Paul Pioneer Press* and mailed them off to United Feature Syndicate in New York City. I don't know how much time went by without my hearing from them, but I'm sure it was at least six weeks. Convinced that my drawings had been lost in the mail, I finally wrote them a letter describing the drawings I had sent and asking them if they could recall receiving anything similar. If not, I wanted to know so that I could put a tracer on the lost cartoons. Instead, I received a very nice letter from their editorial director who said they were very interested in my work and would I care to come to New York and talk about it.

This was an exciting trip. When I arrived at the syndicate offices early in the morning, no one other than the receptionist was there. I had brought along a new comic strip I had been working on, rather than the panel cartoons which they had seen. I simply wanted to give them a better view of my work. I told the receptionist that I had not had breakfast yet, so I went out to eat and then returned. When I got back to the syndicate offices they had already opened up the package I had left there, and in that short time had decided they would rather publish the strip than the panels. This made me very happy, for I really preferred the strip myself. I was on my way.

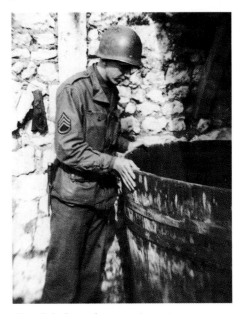

Sgt. Schulz explores a wine vat.

The three years I spent in the army in World War II taught me all I needed to know about loneliness, and my sympathy for the loneliness that all of us experience has dropped heavily upon poor Charlie Brown. From my army years I know what it is like to spend days, evenings, and weekends by myself and also know how uncomfortable anxiety can be. I worry about almost all there is in life to worry about, and because I worry, Charlie Brown has to worry. But I did get to see some of the world and there were the odd moments when I could explore or get a baseball game going, and even do some sketching. My memories of these events and places in France and Germany have reawakened strongly in recent years, emerging in the thoughts and activities of Charlie Brown and friends.

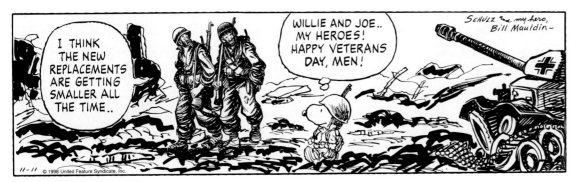

Veteran's Day, 1998

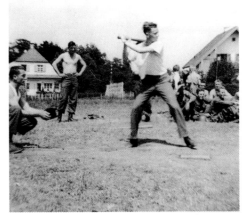

At bat in Germany

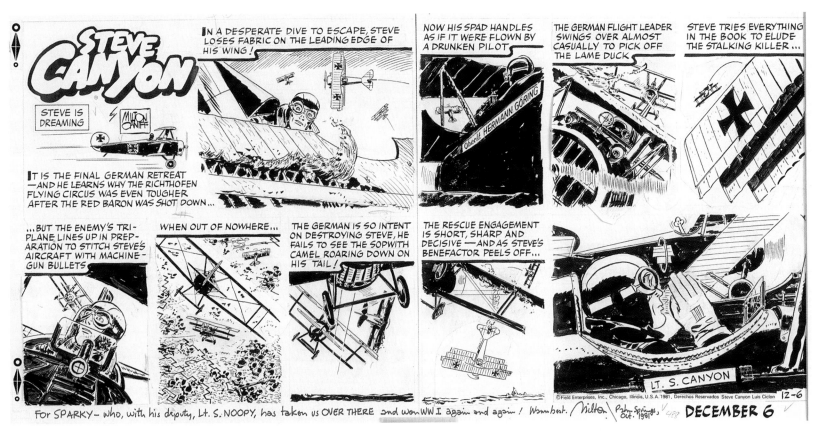

Three originals from the walls of my studio: a *Krazy Kat* page by the great
George Herriman; an early 20th century forerunner of Charlie Brown's problems on
the pitcher's mound by Thomas Aloysuis Dorgan, who wisely signed himself as
TAD; and an inscribed strip from my friend Milt Caniff. Look in the last panel for
the farewell wave of the paw from Steve Canyon's mystery benefactor.

There were many early influences on my work. When I reached high school age, the work of Milt Caniff and Al Capp influenced me considerably, as well as that of some of the earlier cartoonists such as Clare Brigg's *When a Fella Needs a Friend*. I also thought there was no one who drew funnier and more warmhearted cartoons than J.R. Williams. But the man who influenced me most was Roy Crane with his drawings of *Wash Tubbs* and *Captain Easy*. His rollicking style laid the groundwork for many cartoonists who followed him. After World War II, I began to study the *Krazy Kat* strip for the first time, for during my younger years I never had the opportunity to see a newspaper that carried it. A book collection of *Krazy Kat* was published sometime in the late 1940s, which did much to inspire me to create a feature that went beyond the mere actions of ordinary children.

A self-portrait of Roy Crane, and on the right a sampling from my library of books on Roy Crane's Wash Tubbs, *Billy Debeck's* Barney Google, *and Elzie Crisler Segar's* Popeye.

12

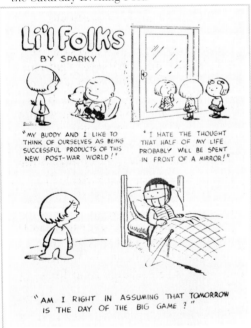

The Beginning of *Peanuts*

After I signed with United Media in 1950, the strip progressed and the characters began to change. Charlie Brown was a flippant little guy who soon turned into the character he is known as today. This was the first of the formulas to develop. Formulas are truly the backbone of the comic strip. In fact, they are probably the backbone of any continuing entertainment. As Charlie Brown developed, so did characters such as Lucy, Schroeder, and Linus. Snoopy was the slowest to develop, and it was his eventually walking around on two feet that turned him into a lead character. It has certainly been difficult to keep him from taking over the feature.

There are various origins for the characters. Charlie Brown is supposed to represent what is sometimes called "everyman." When I was small, I believed that my face was so bland that people would not recognize me if they saw me someplace other than where they normally would. I was sincerely surprised if I happened to be in the downtown area of Saint Paul, shopping with my mother, and we would bump into a fellow student at school, or a teacher, and they recognized me. I thought that my ordinary appearance was a perfect disguise. It was this weird kind of thinking that prompted Charlie Brown's round, ordinary face.

I have always believed that you not only cast a strip to enable the characters to do things you want them to, but that the characters themselves, by their very nature and personality, should provide you with ideas. These are the characters who remain in the feature and are seen most often. The more distinct the personalities are, the better the feature will be. Readers can then respond to the characters as though they were real.

The early years of *Peanuts* contain many ideas which revolved around very tiny children because my own children were still young at the time. As the strip grew, it took on a slight degree of sophistication, although I have never claimed to be the least sophisticated myself. But it also took on a quality which I think is even more important, and that is one which I can describe only as abstraction. The neighborhood in which the characters lived ceased gradually to be real. Snoopy's doghouse could function only if it were drawn from direct side view. Snoopy himself had become a character so unlike a dog that he could no longer inhabit a real doghouse. And the cartooning of the other characters, with their large, round heads and tiny arms, came frequently to prohibit them from doing some of the more realistic things that a more normal style of cartooning would allow. Nevertheless, this was the direction I wanted to take, and I believe it has led me to do some things that no one ever before attempted in a comic strip.

So here we go. You will meet the characters and their idiosyncrasies as they occurred to me over the past 50 years. In the beginning, they are like *Li'l Folks* (which I always wanted the strip to be called)—we look down on the small figures from an adult point of view. But very soon, when I got down to their eye level, Charlie Brown and friends began to bring everyone into their world.

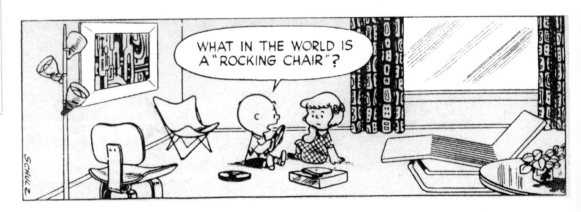

The 50s

October 2, 1950

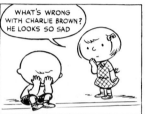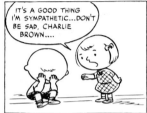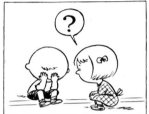

The early years of *Peanuts* contain many ideas which revolved around very tiny children because my own children were still young at the time. There are many standard poses that I use in the *Peanuts* drawings, and they are all used for definite reasons, some more important than others.

I was always overly cautious with my own children, worrying constantly of their becoming injured, or worse, in some mishap. When I began to draw the kids in the strip talking to each other, the obvious pose was to show them sitting on the curb, reminiscent of the early *Skippy* strips, drawn by Percy Crosby. The characters in *Peanuts*, however, were much younger than Skippy and his friends, and I was always sensitive about showing them sitting on a street curb where they could very easily get run over. Therefore, I drew them sitting at the end of the front walk that ran down from the steps, out to the main sidewalk. This was not always a suitable pose for some of the later strips, so I eventually changed it to show them standing by a stone wall. This gave the reader a chance to speculate as to what the characters might be looking at while talking about life's problems.

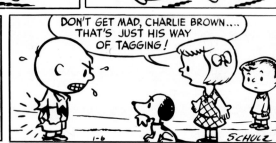

When she was first introduced into the strip in 1952, Lucy was simply a cute, doll-like figure with large round eyes. Jim Freeman, who was our editor at the time, suggested that I eliminate the large round eyes. Lucy began to develop her personality when I started to call her a fussbudget.

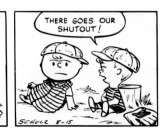

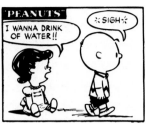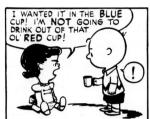

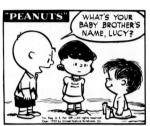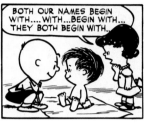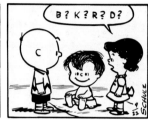

The first mention of Linus.

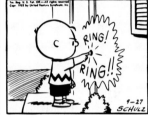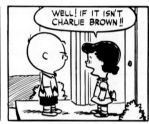

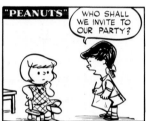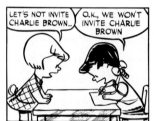

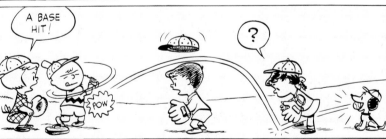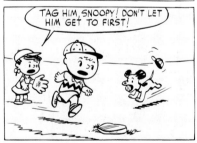

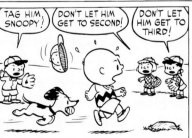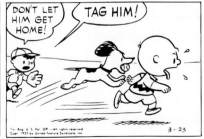

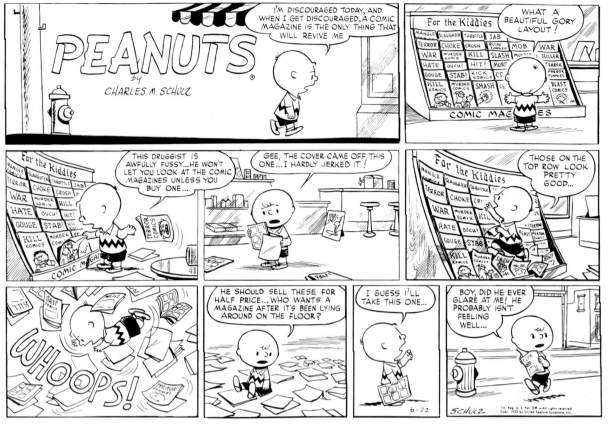

Lucy pulls away the football for the first time.

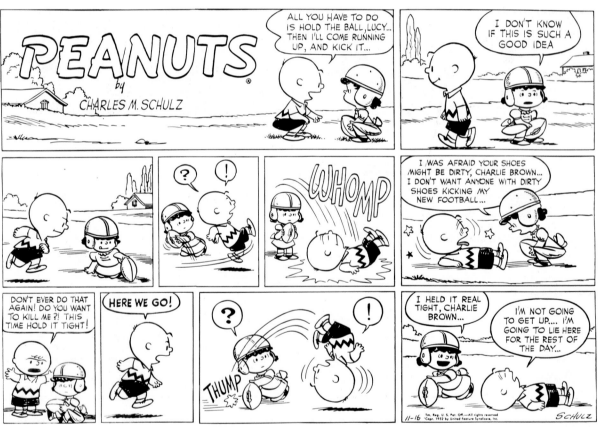

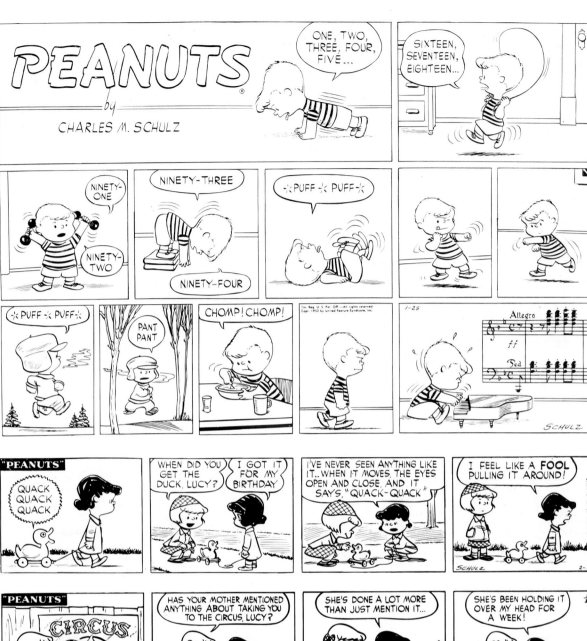

A toy piano which we had bought for our oldest daughter, Meredith, eventually became the piano which Schroeder uses for his daily practicing.

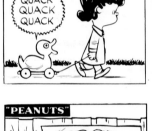
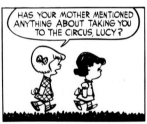
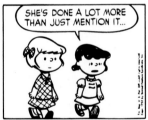

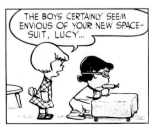
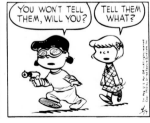
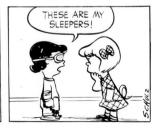

May 1953

Lucy falls in love with
Schroeder and tries to get
his attention.

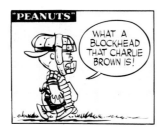
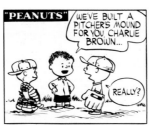
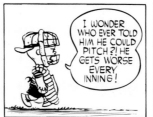
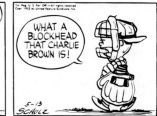

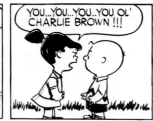
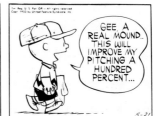
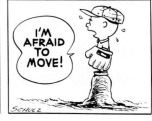

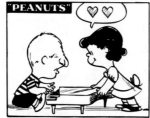
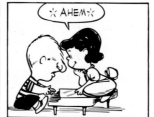

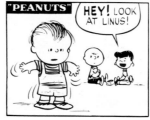
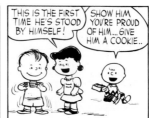
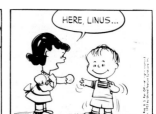

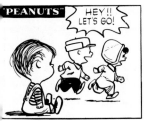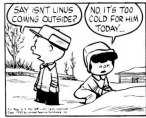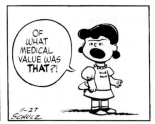

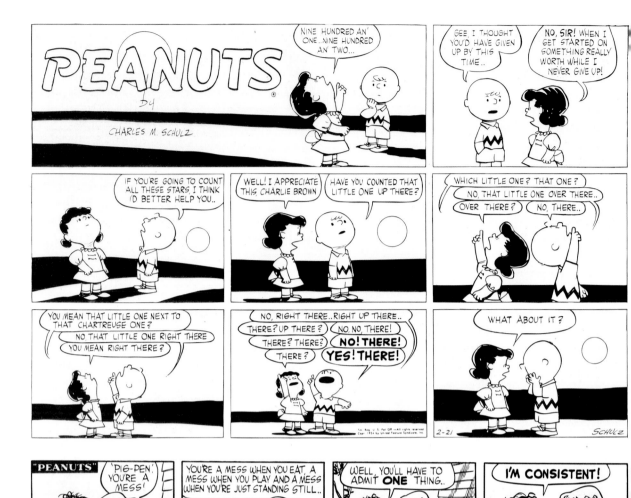

Pigpen appears.

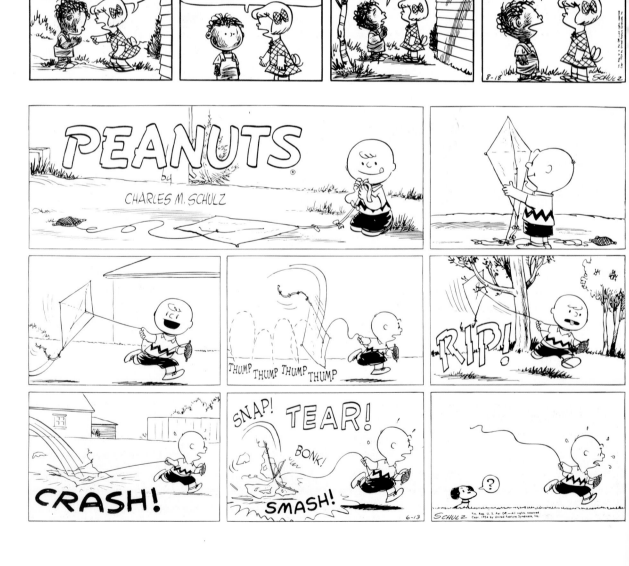

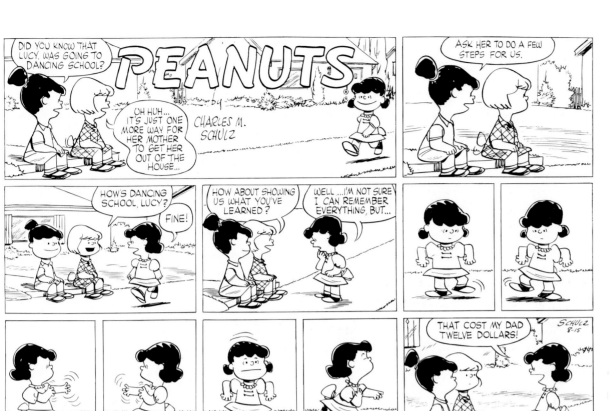

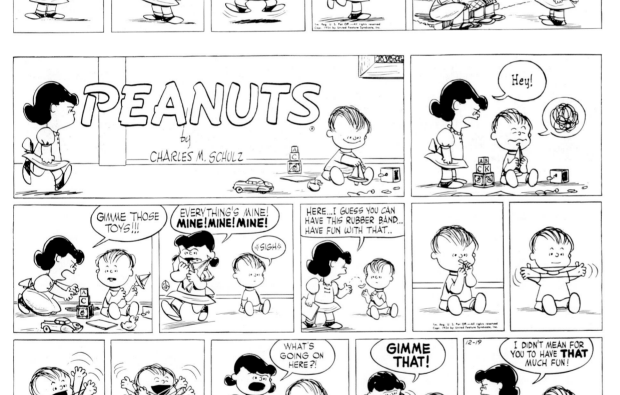

Linus came from a drawing that I made one day of a face almost like the one he now has. I experimented with some wild hair, and I showed the sketch to a friend of mine who sat near me at Art Instruction whose name was Linus Maurer. He thought it was kind of funny, and we both agreed that it might make a good new character for the strip.

It seemed appropriate that I should name the character Linus. It also seemed that Linus would fit very well as Lucy's younger brother. Lucy had already been in the strip for about a year, and had immediately developed her fussbudget personality. We called our oldest daughter, Meredith, a fussbudget when she was very small, and from this I applied the term to Lucy.

In the mid 50s, the first appearance of Linus's blanket was inspired by the blankets that our first three children dragged around the house. I did not know then that the term "security blanket" would later become part of the American language.

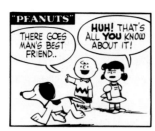

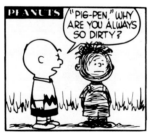 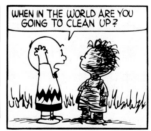 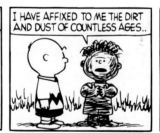 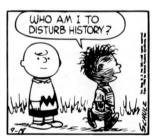

 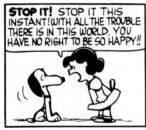 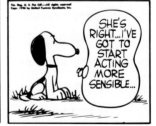 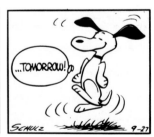

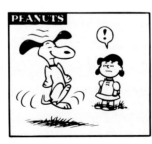

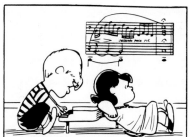

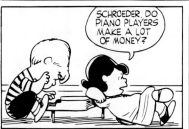
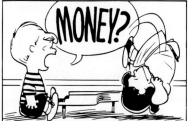
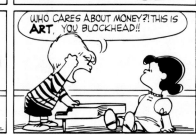

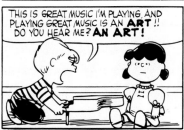
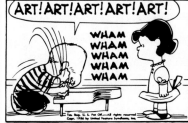
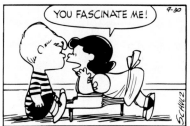

The 50s

Lucy comes from that part of me that's capable of saying mean and sarcastic things, which is not a good trait to have, so Lucy gives me a good outlet. But each character has a weakness, and Lucy's weakness is Schroeder. With Schroeder, even Lucy has moments of sentimentality.

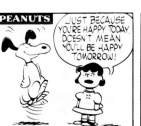

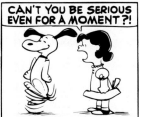
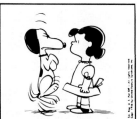
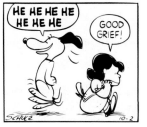

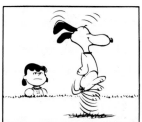
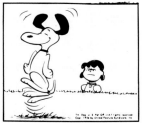
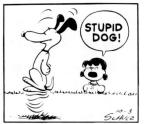

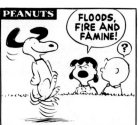
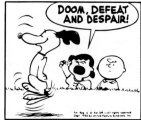
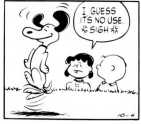
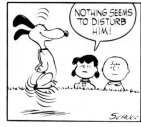

25

United Feature Syndicate needed a name for the strip. All I could think of was "Charlie Brown." or "Good Ol' Charlie Brown." The syndicate people didn't care for those, and then informed me that they had the perfect title, "Peanuts." I was horrified, and called Larry Rutman immediately and told him it was a terrible title. It was undignified, inappropriate, and confusing. I said that readers would almost certainly think it was the name of the lead character, and that no one ever referred to small children as "peanuts."

"Well," he said, "the salesmen are ready to take the feature on the road, and we think it's a title that will catch the attention of editors." What could a young unknown from Saint Paul say? I gave in.

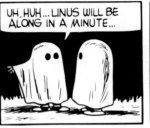
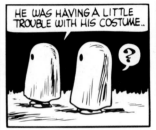
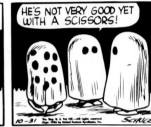

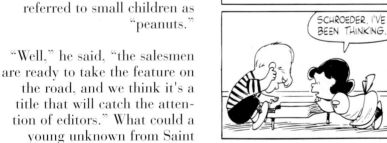
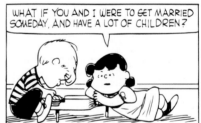
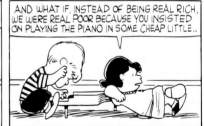

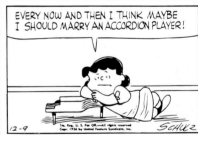

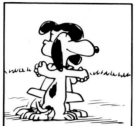
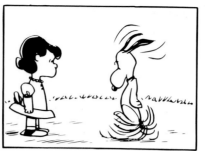

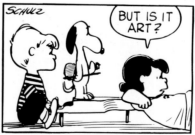

The 50s

From the beginning of the strip I knew the lead character would be a round-headed kid with a rather plain face, and I decided he should be called Charlie Brown. At this time, I was working at the correspondence school, Art Instruction, and one of my closest friends, who also worked there, was named Charlie Brown. He was a very bright young man with a lot of enthusiasm for life. I began to tease him about his love for parties and I used to say, "Here comes good ol' Charlie Brown, now we can have a good time." So when I created this new character I thought it was only considerate to ask for permission to use his name. He seemed to think it was all right, and I remember the day he crossed the room from his desk to mine, looked down at the character I was drawing and said, "What a disappointment, I thought I was going to look more like Milton Caniff's Steve Canyon…"

As the years went by, many humorous things happened to my friend Charlie Brown because of the comic-strip name. In fact, he was invited to go to New York and appear on a television show called *To Tell The Truth* where a panel had to guess who the real Charlie Brown was, and he fooled them all.

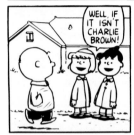
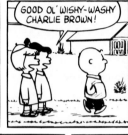
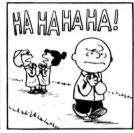
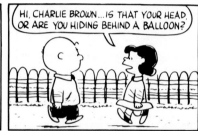

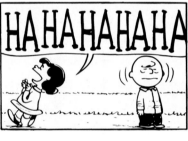

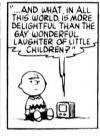

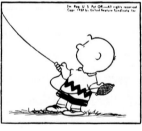
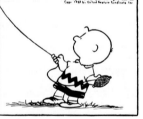
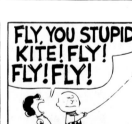

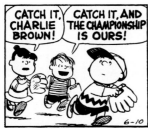
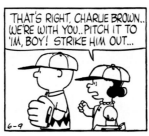
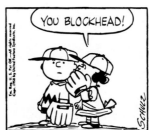

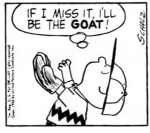
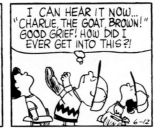

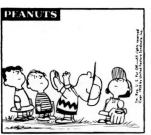
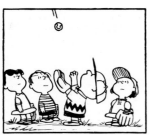
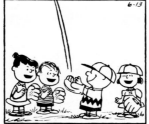
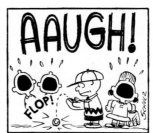

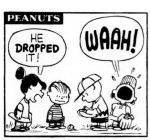
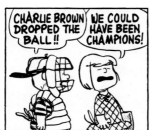
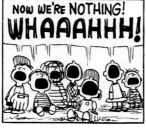
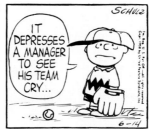

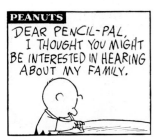
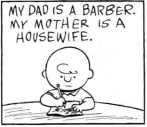

Charlie Brown writes his first pen-pal letter.

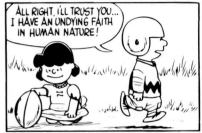
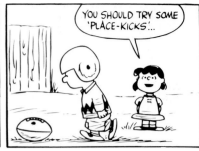

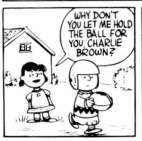
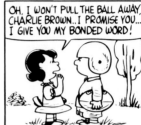
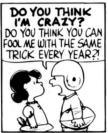
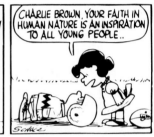

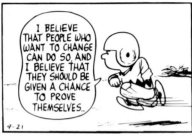

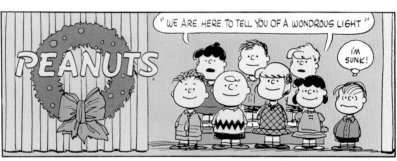
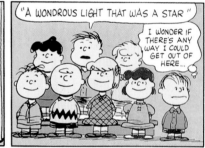

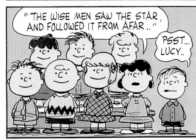

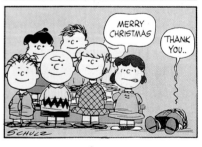

In 1959, Lucy's very first psychiatric booth started out as a parody of children's lemonade stands.

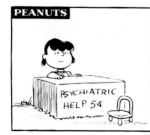
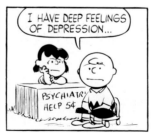

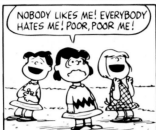

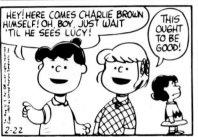
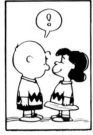
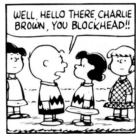
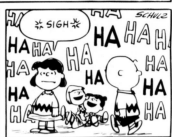

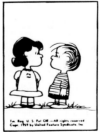

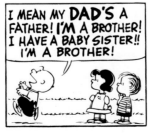
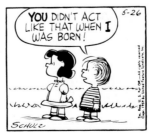

Charlie Brown's sister, Sally, is born.

31

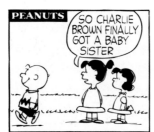
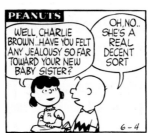
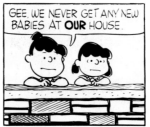
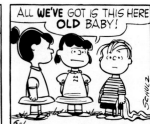

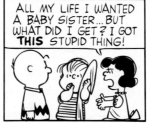
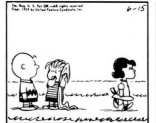
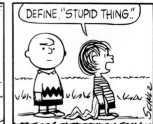

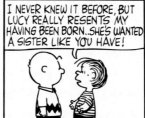
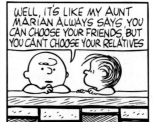
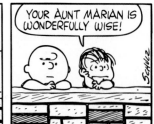

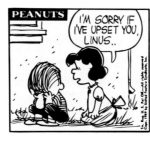
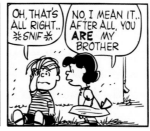
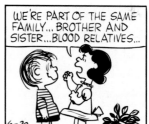
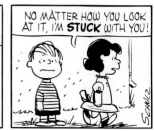

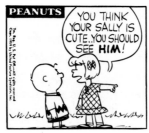
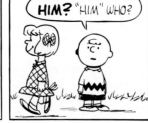

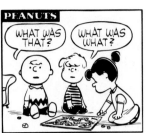

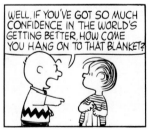

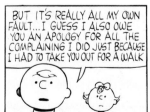
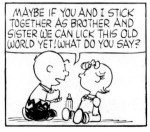
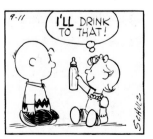

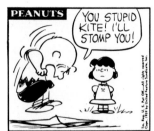
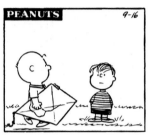

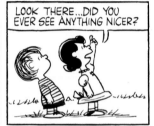
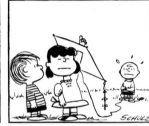

In 1959, at Halloween, the Great Pumpkin is introduced. Linus, who is bright but very innocent, got one holiday ahead of himself and confused Halloween with Christmas. Linus gives to the Great Pumpkin those qualities Santa Claus is supposed to have.

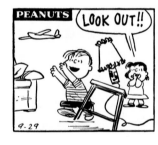
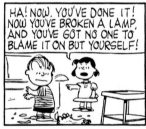

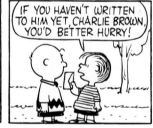
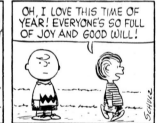

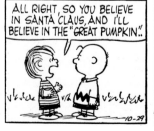

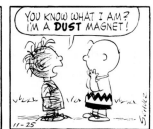

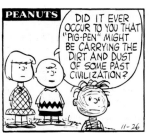
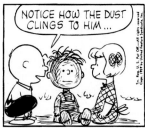
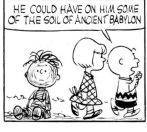

Pigpen is a "human soil bank" who raises a cloud of dust on a perfectly clean street and passes out gumdrops that are invariably black. He's a strange little boy and attracts dirt like a magnet. Hardly does he step outside when his hair is mussed, his clothes are a mess, and he is black from head to foot. Whether in a driving rain or falling snow, Pigpen always leaves a cloud of dust behind him as he walks. The other *Peanuts* characters are divided between sarcasm and admiration in their regard for him.

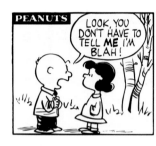
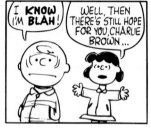
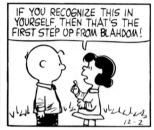

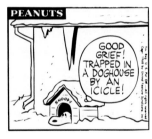
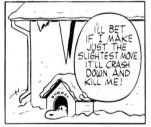
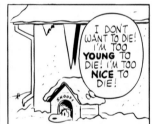

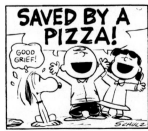

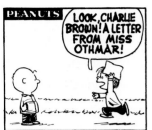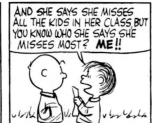

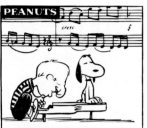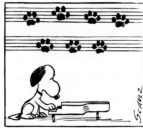

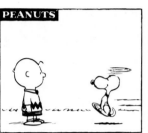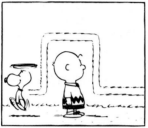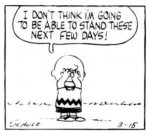

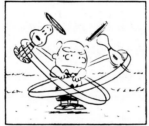

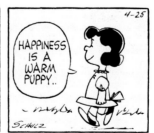

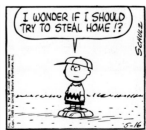

The 60s

Linus's beloved Miss Othmar, his teacher, is a rather strange person, and I tried to do much with her through the conversation of Linus. I have experimented with a two-level story line at times. I have tried to show Linus's view of what is happening at school, but then show what actually was occurring. I have done this to bring out a truth I have observed, and this is that children see more than we think they do, but at the same time almost never seem to know what is going on.

According to *Bartlett's Familiar Quotations*, "Happiness is a warm puppy" comes from the book with that title published in 1962. It actually first appeared in the strip on April 25, 1960.

37

The 60s

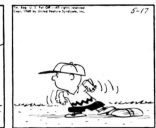
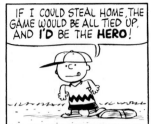
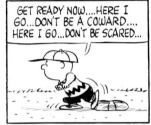

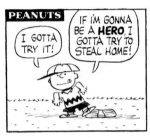

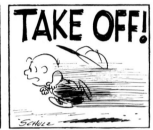

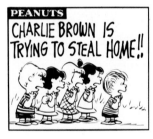
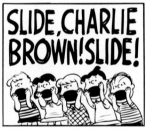

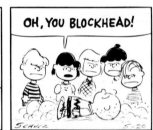

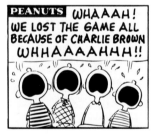
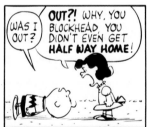

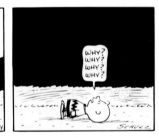

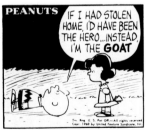
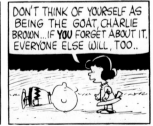
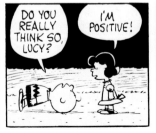

38

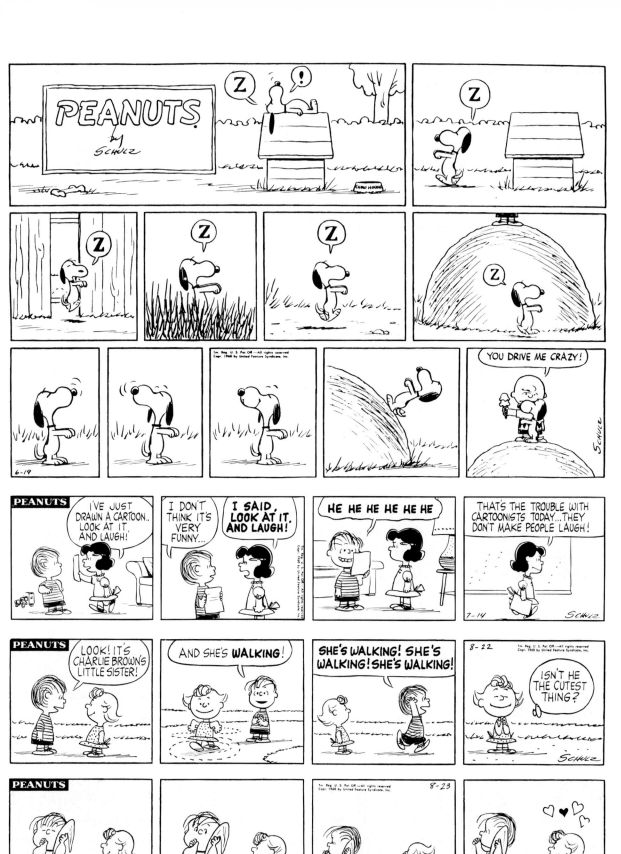

The 60s

In 1960, there was a turning point when Snoopy began thinking his own thoughts and began getting up on his hind feet and walking around. From then on, his doghouse was always shown in its now-familiar side-on profile. There were other events, but the best thing I ever thought of was Snoopy using his own imagination. As my drawing improved, I was able to get him to do things that he couldn't do before. He'd be lying in peculiar positions—his head in his water dish or on a rock. I don't recall how he got on top of the doghouse. The first time he fell off and the strip ended with his saying "Life is full of rude awakenings." After that he was never seen in the doghouse. As long as he was going to live in that fantasy world, it was shown only in side view, never inside—it wouldn't be right.

The 60s

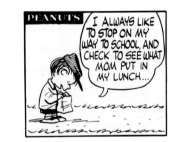

40

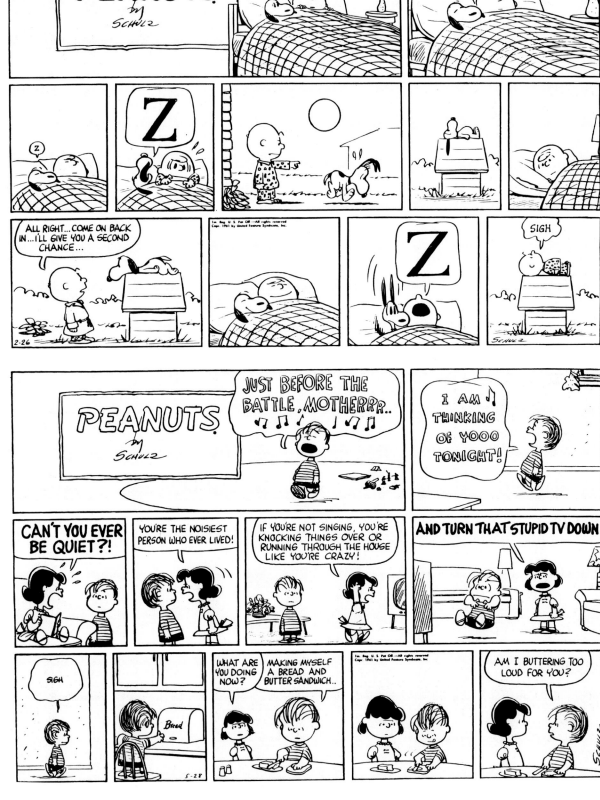

One evening, the entire family was around the dinner table and, for some reason, my daughter Amy seemed particularly noisy. After putting up with this for about ten minutes, I turned to her and said, "Amy, couldn't you be quiet for just a little while!" She said nothing, but picked up a piece of bread and began to butter it with a knife and asked, "Am I buttering too loud for you?" It was very easy to translate this incident into a Linus and Lucy Sunday page.

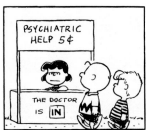

The 60s

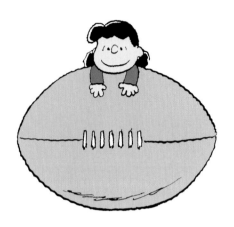

Lucy has been inviting Charlie Brown to come running to kick the football and then pulling it away each year for 47 years. Every time I complete this annual page, I am sure I will never be able to think of another one, but so far I have always managed to come up with a new twist for the finish. It all started, of course, with a childhood memory of being unable to resist the temptation to pull away the football at the kick-off. We all did it, we all fell for it. In fact, I was told by a professional football player that he actually saw it happen in a college game at the University of Minnesota. The Gophers were apparently leading by a good margin, everyone was enjoying himself, and the man holding the football, like the kids in the neighborhood, could not resist the temptation to pull it away. I wish I had been there to see it.

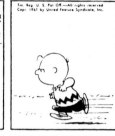
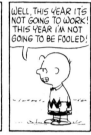
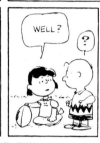
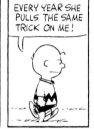

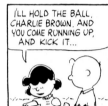
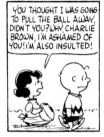
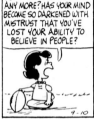

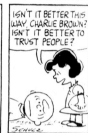

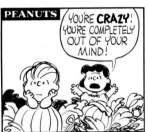
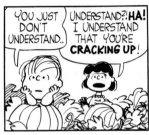
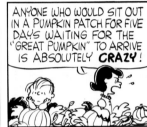
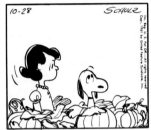

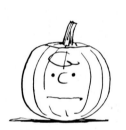

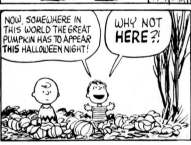
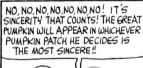
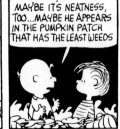
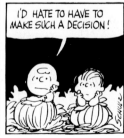
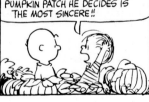
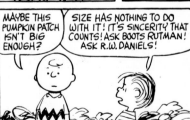
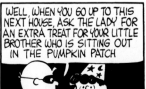

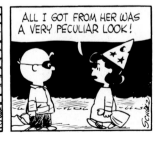
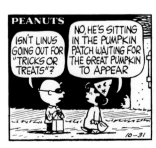
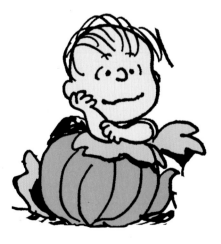

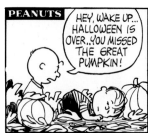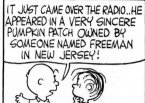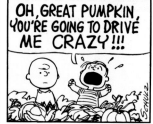

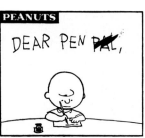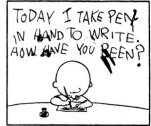

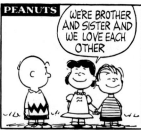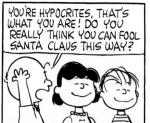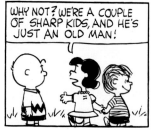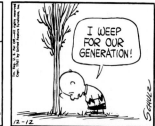

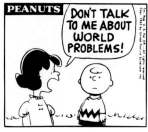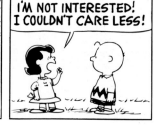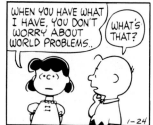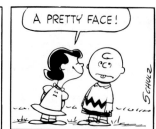

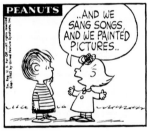
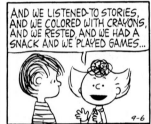
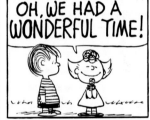

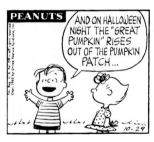

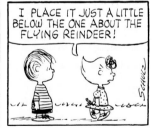

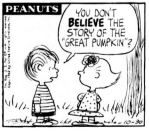

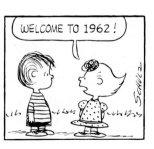

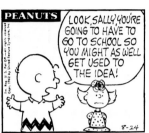
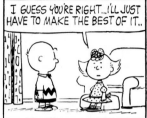
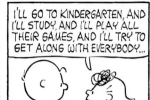
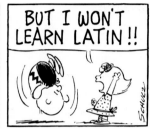

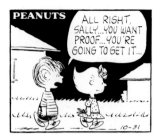
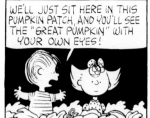

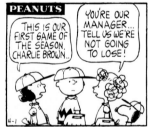
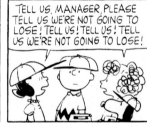
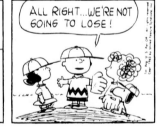

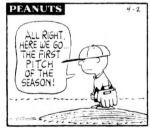
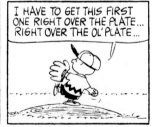

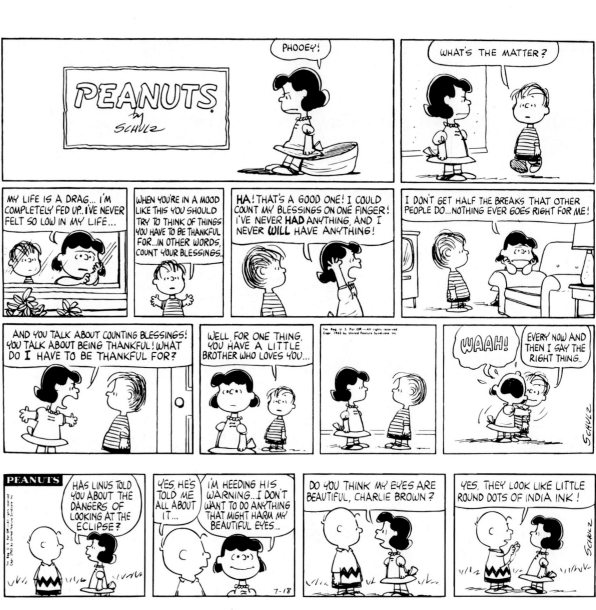

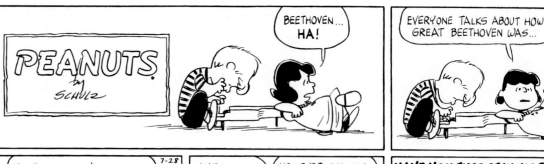

Seeing a portion of Beethoven's Ninth Symphony in print gave me the idea for the many episodes involving Schroeder's admiration for that great composer. I have been asked many times, "Why Beethoven?" The answer is simply that it is funnier that way. There are certain words and certain names that work better than others. My favorite composer is Brahms—I could listen to him all day—but Brahms isn't a funny word, Beethoven is. I don't believe it would be half as funny if Schroeder admired Brahms. There is also the very practical fact that to most of us laymen, Beethoven, Rembrandt, and Shakespeare are the three mountain peaks in music, art, and literature. I have read several biographies of Beethoven, being strangely fascinated by the lives of composers, much more so than by the lives of painters, and from these biographies have managed to come up with different things that have concerned Schroeder. For a long time I had thought the sentence, "Lobkowitz stopped his annuity" extremely funny, and I was happy to eventually find a way to use it.

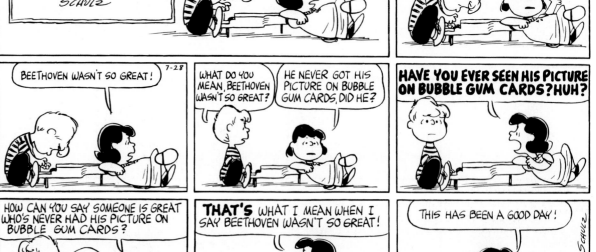

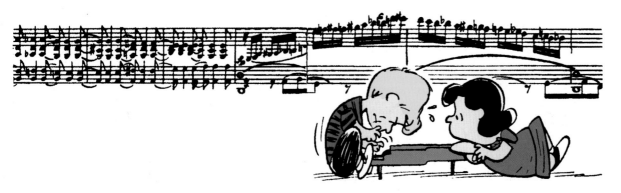

Sometimes, drawing the musical scores that Schroeder plays can be very tedious, but I love the pattern that the notes make on the page. I have always tried to be authentic in this matter. I believe that some readers enjoy trying to determine what it is that Schroeder is playing.

49

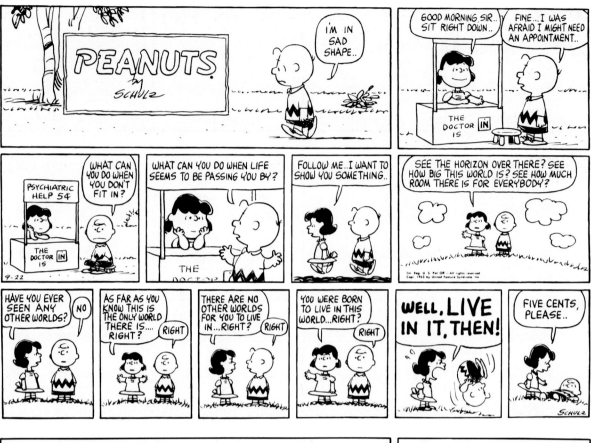

This Sunday page stirred up far more trouble than I had anticipated when it showed Sally coming home and saying to her brother, Charlie Brown, that she had something to tell him but, evidently, did not want anyone else to hear. They went off by themselves and hid behind the couch in their living room where Sally whispered very quietly, "We prayed in school today."

I have letters from people who told me that this was one of the most disgusting things they had seen in a comic strip, that they did not think it was funny, that it was sacrilegious. A woman, writing from West Orange, N.J., said she thought the page should be hung in the Hall of Fame, adding, "I think it is beautiful, and you have our heartiest support." It upset people on both sides of the subject, and also pleased people on both sides.

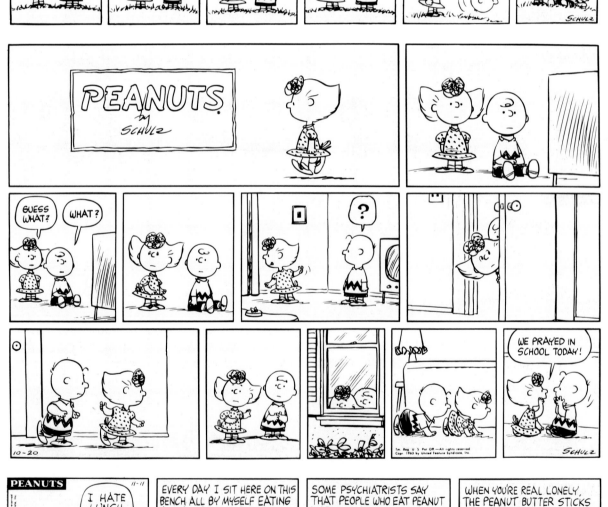

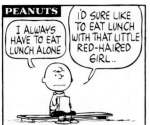
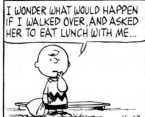

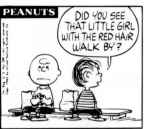
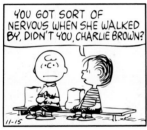

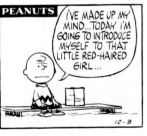

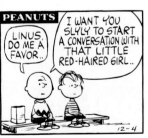
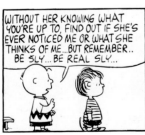
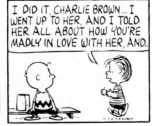
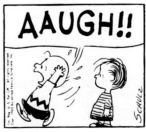

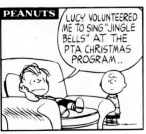
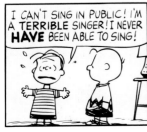
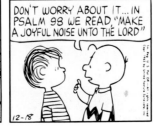

The 60s

Charlie Brown's love for the the little red-headed girl is based on a real-life love for red-haired Donna Johnson, who I courted when I was a young man in Saint Paul. She chose someone else as I was about to propose to her, and that broke my heart. Charlie Brown's unrequited and unknown love is based on it not being returned.

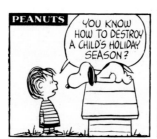
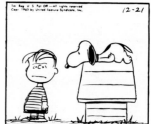
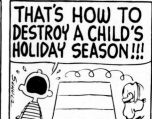

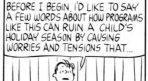

Some of my ideas for *Peanuts* can be traced back. I have drawn many cartoons showing the children standing in line to buy tickets to a movie, because my memories of Saturday afternoons at the Park Theater in Saint Paul are still so vivid.

Almost nothing could prevent us from seeing the latest episode of the Saturday afternoon serial and the movie that followed.

When I was about ten, the movie theater advertised a free Butterfinger candy bar to the first one hundred kids attending that Saturday's matinee. I stood in line and, as I approached the box office, saw the last candy bar disappear. I was the one-hundred-and first!

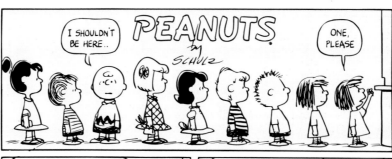

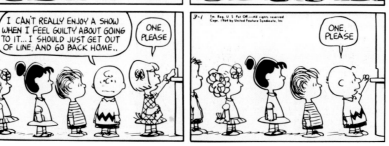
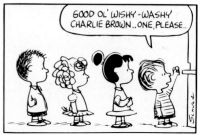

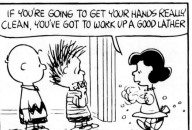
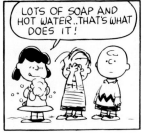
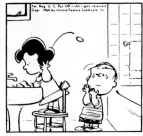
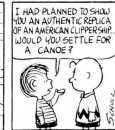

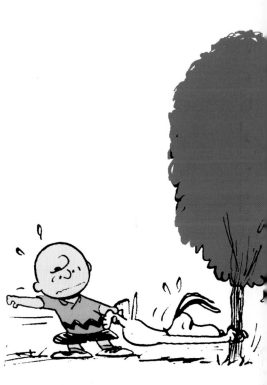

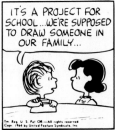
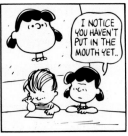
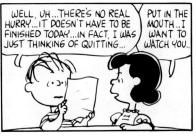
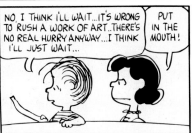

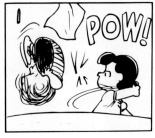

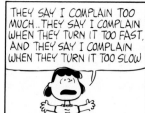
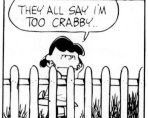
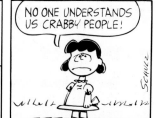

I have treated Charlie Brown's father in a fair amount of detail, because I have let it be known that he is very receptive to his son's impromptu visits to the barbershop.

Most of this is autobiographical, for my dad always greeted me cordially when I would drop in at his barbershop, and I used to go there and sit and read the newspapers and magazines until he closed his shop in the evening. He also never objected if I rang the NO SALE key on the cash register and removed a nickel for a candy bar.

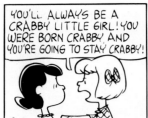

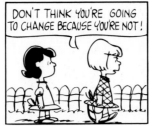

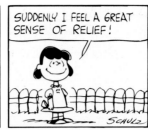

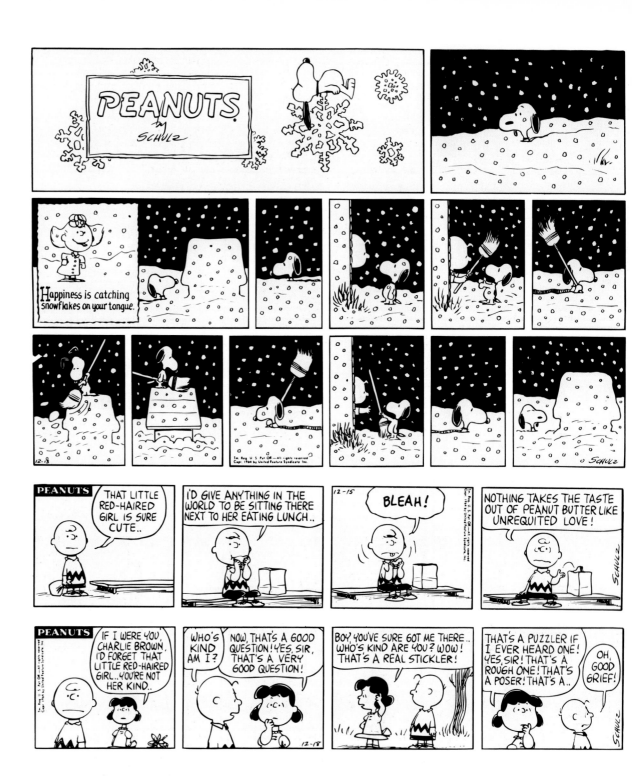

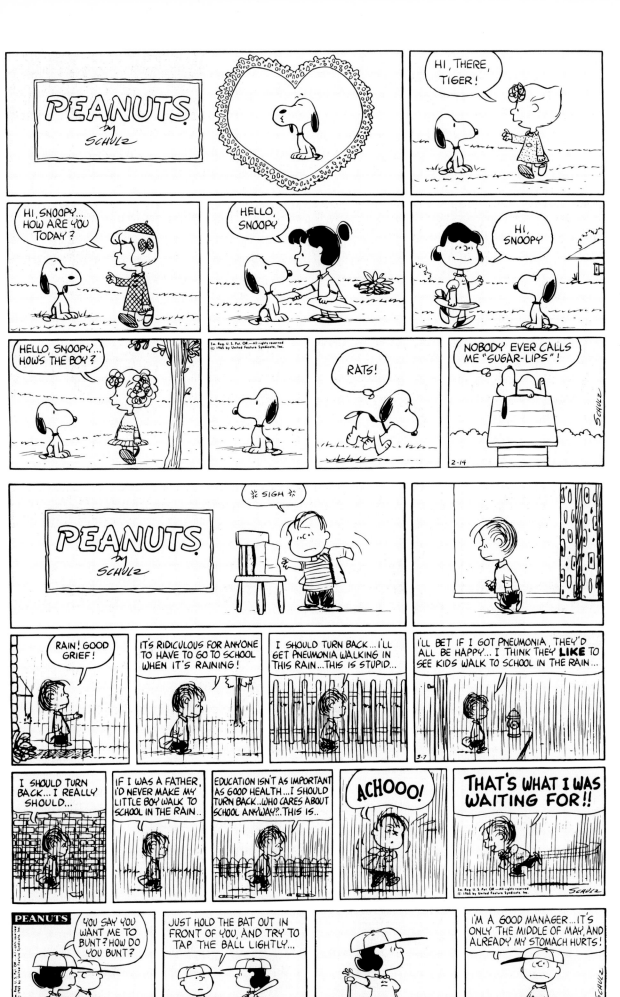

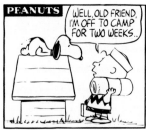 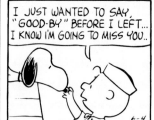 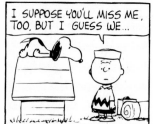

All of the summer camp ideas that I have drawn are a result of my having absolutely no desire as a child to be sent away to a summer camp. To me that was the equivalent of being drafted. When World War II came along, I met it with the same lack of enthusiasm.

 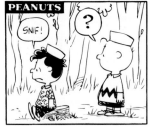 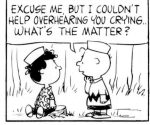 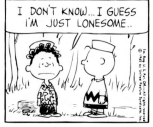 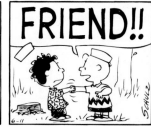

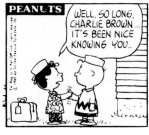 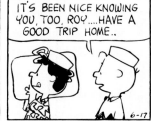 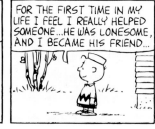 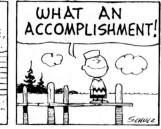

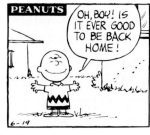 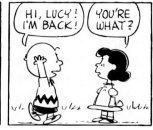 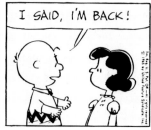 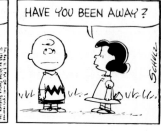

Once he got the typewriter in position, Snoopy's career as a great novelist began in July 1965.

 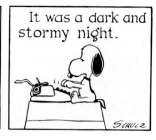

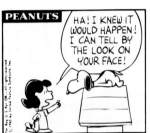
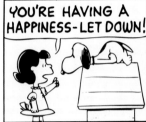
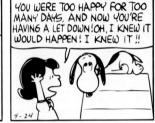
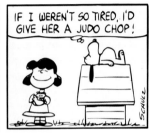

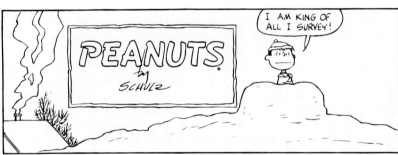
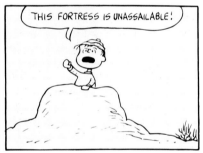

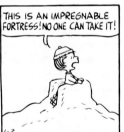
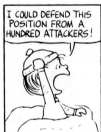

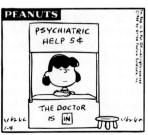
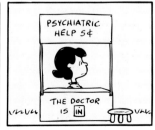
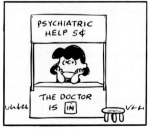

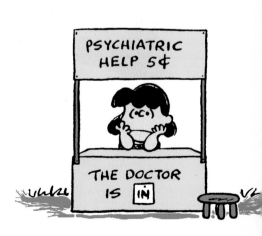

Charlie Brown on the Screen

All the Charlie Brown animated movies are the result of the long collaboration with my friends, the producer Lee Mendelson and the animator Bill Melendez.

A comic strip does not usually translate into animation. The on-screen characters are drawn to revolve. They're drawn with a slick brush line and the eyes, noses, ears, and limbs are placed in a rubbery way, so that the character can do certain things. That kind of drawing does not fit in the comic strip page. The comic strip page has drawing which is often a scratchy pen technique. In some of the great old strips, the characters were only drawn from a couple of different views. Popeye was usually drawn from the left three-quarters or the right three-quarters. When you turn him into an animated subject, he has to become fluid and it doesn't work. Bill Melendez and his animators had a terrible time with the *Peanuts* characters. I told him, "This is just a cartoon. Don't worry about making it so lifelike. They don't have to turn if you don't want them to, just have them flip from one spot to another. It's all right. It's still a cartoon."

I don't interfere with Bill's process of animation, though he recalls I questioned his technique once. Bill said I picked up a stack of drawings of Snoopy. I looked at one and said, "That's good." I looked at another and said, "Not too good." I looked at a third and said, "That's terrible." He gave me his pen and told me to redraw it. "I can't," I said, "Snoopy never gets in that position." Since then, I have left the animation alone.

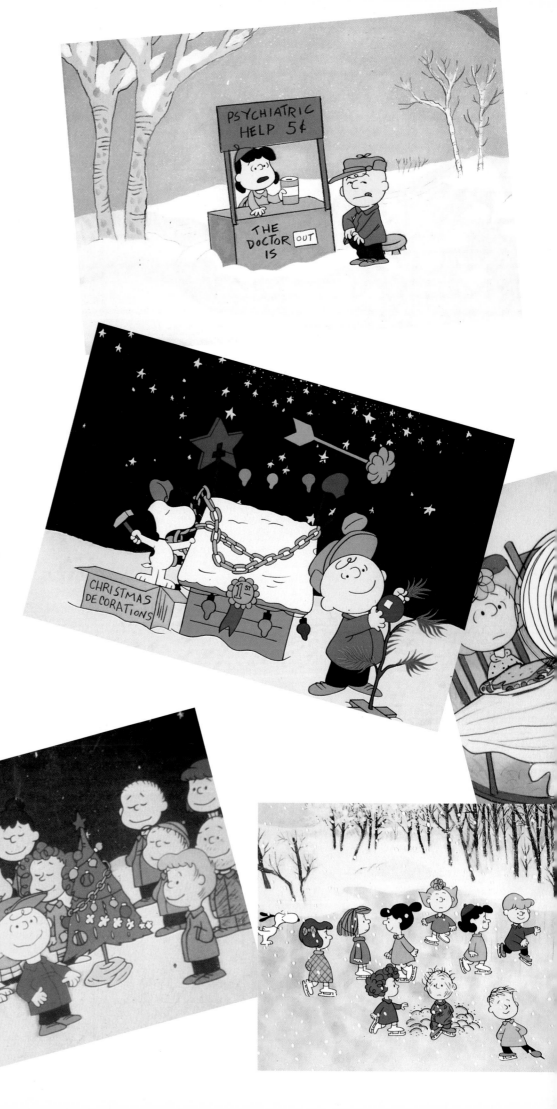

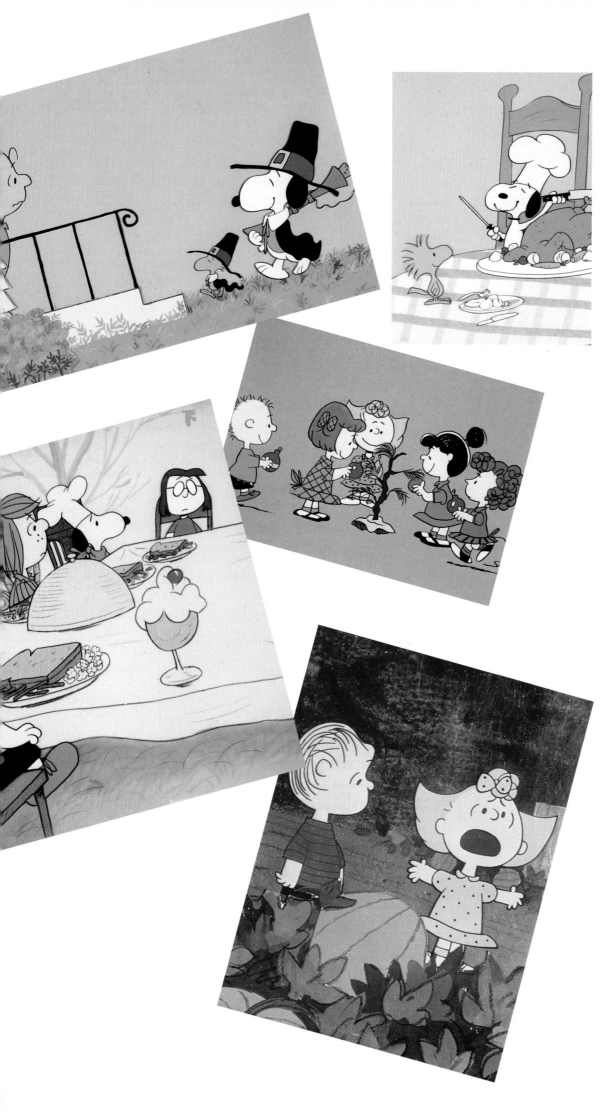

Editor's Note:
In 1965, A Charlie Brown Christmas *was first seen on television, and it told the story of our hero confronted with yet another problem. Good grief! Christmas is coming and he's not happy. As he explains to his friend, Linus, no one is thinking about the true meaning of the holiday. His sister, Sally, is only concerned about the presents she will get; his friend Lucy wants to buy a big, shiny aluminum tree; even his dog, Snoopy, enters his doghouse in a contest for the best-decorated home in the neighborhood. When Charlie Brown is persuaded to direct the school Christmas pageant, he declares, "This is one play that's not going to be commercial." After many frustrations he buys a small pine tree, Linus recites the Story of the First Christmas, and all of his friends lovingly decorate the simple little tree.*

The show won the first of many Peabody and Emmy awards. Both Bill Melendez and I have a hard time watching it over the many Christmas seasons it reappears, for it seems full of inconsistencies—like the continuity error that marred scenes that contain Charlie Brown's droopy wooden tree. Sharp-eyed viewers will notice that the tree grows several branches between the tree lot and its arrival at the rehearsal site.

The original ideas we tried for, keeping to the true meaning of Christmas, using real young children's voices for the characters, picking Vince Guaraldi's cool, spare jazz trio for the sound track, avoiding canned laughter, and aiming for a grown-up *and* family audience, have stood the test of time. But even then, when the show got its award, it had been entered in the children's category.

The 60s

My son Monte claims to have been the one who gave me the idea for Snoopy chasing the Red Baron in his World War I flying gear while atop his Sopwith Camel doghouse. I, of course, deny that he actually gave me the idea, but I will admit that he inspired it, for at the time he was very much involved with building plastic models of World War I airplanes.

It was on an afternoon when he was showing me one of his models that I drew a helmet on Snoopy and placed him in a pilot's pose on top of his doghouse. The whole thing kind of fit together. You might say it simply took off, and I knew I had one of the best things I had thought of in a long time.

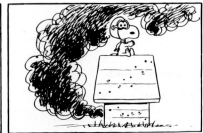
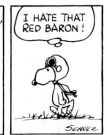

Charlie Brown's love of baseball gets him into trouble in the class spelling bee.

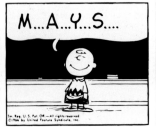
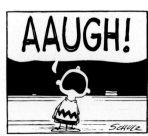

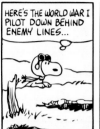
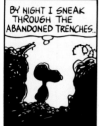
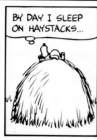
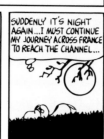

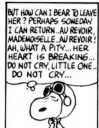

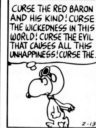

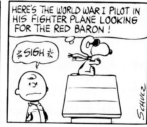
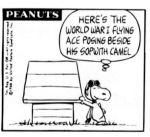
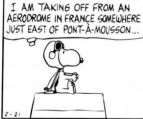
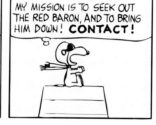
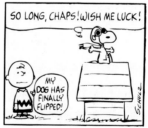
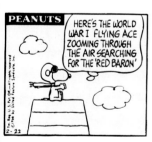
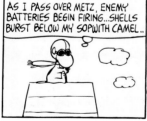
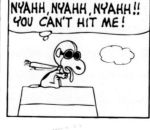
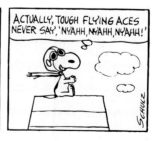
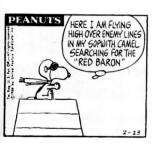
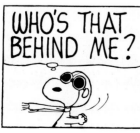
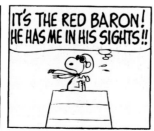
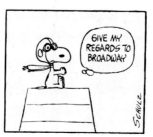
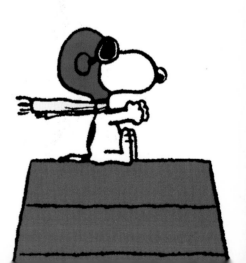

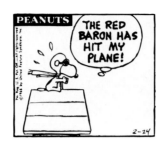
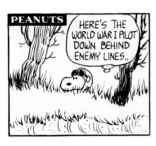
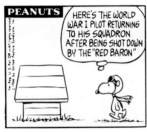

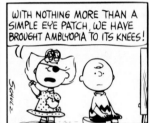

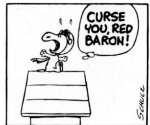
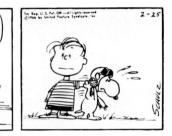
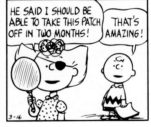
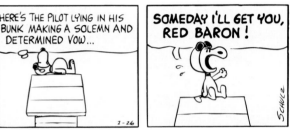

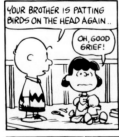
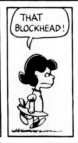
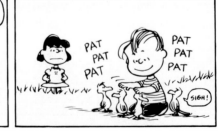
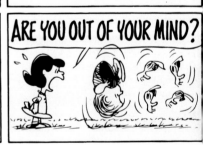

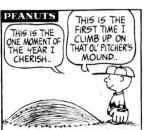
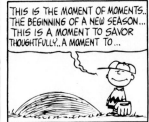
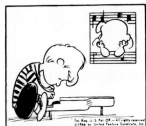
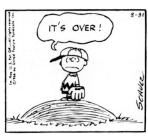

PEANUTS THIS IS THE ONE MOMENT OF THE YEAR I CHERISH.. | THIS IS THE FIRST TIME I CLIMB UP ON THAT OL' PITCHER'S MOUND.. | THIS IS THE MOMENT OF MOMENTS.. THE BEGINNING OF A NEW SEASON... THIS IS A MOMENT TO SAVOR THOUGHTFULLY.. A MOMENT TO... | GET UP THERE AND PITCH, YOU BLOCKHEAD! | IT'S OVER!

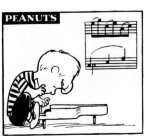
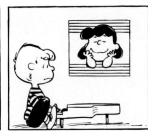
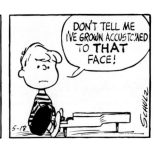

PEANUTS | | | DON'T TELL ME I'VE GROWN ACCUSTOMED TO **THAT** FACE!

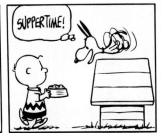

SUPPERTIME! | SUPPERTIME! | OH, IT'S SUPPERTIME! IT'S SUPPERTIME!!!

YAHOO! IT'S SUPPERTIME! | SUPPERTIME! SUPPERTIME! SUPPERTIME! GOOD OL' SUP, SUP, SUP, SUPPERTIME! | SUPPERTIME! | I MUST ADMIT HE'S A VERY SATISFYING PERSON TO COOK FOR

PEANUTS WHAT'S GOING ON? | CHARLIE BROWN DOESN'T FEEL WELL.. HIS STOMACH HURTS... | IT'S NERVES, CHARLIE BROWN... YOU TAKE THIS GAME TOO SERIOUSLY.. BE LIKE FRIEDA AND ME... WE DON'T CARE IF WE WIN OR LOSE! **LA DE DA!** WHO CARES? | LA DE DA! WIN OR LOSE! WHO CARES? LA DE DA! WE DON'T CARE! WE DON'T CARE! | FOR SOME REASON, THE PAIN HAS SUDDENLY INCREASED...

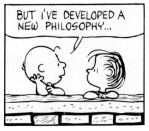
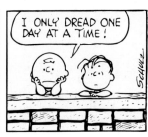

PEANUTS LIFE IS DIFFICULT, ISN'T IT, CHARLIE BROWN? | YES, IT IS | BUT I'VE DEVELOPED A NEW PHILOSOPHY... | I ONLY DREAD ONE DAY AT A TIME!

65

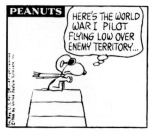

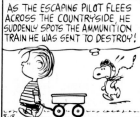
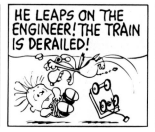
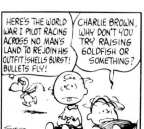

Peppermint Patty first arrived in the summer of 1966.

Her name was inspired by a dish of candy that was sitting around the house. I decided that I had better use this name, lest someone else think of it and beat me to it. So in this case I created the character to fit the name, and Peppermint Patty came into being.

Patty has been a good addition for me, and I think could almost carry another strip by herself. Her little friend Marcie, who she met later and always addresses her as "Sir," has also been a good addition to the strip.

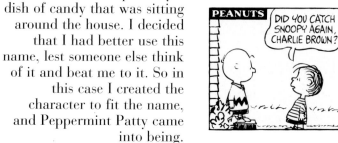
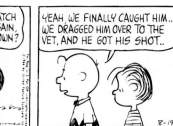
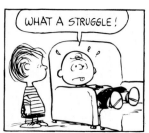
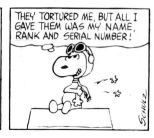

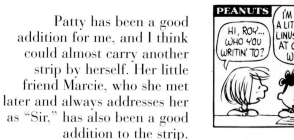
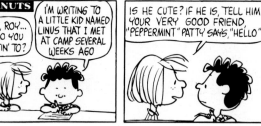
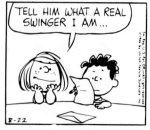
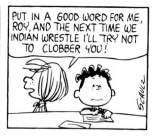

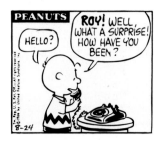
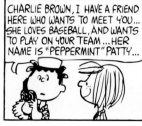
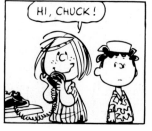
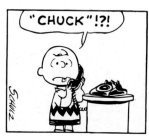

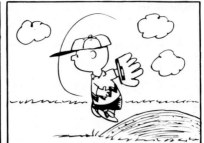

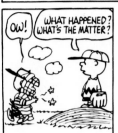
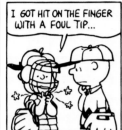
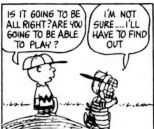

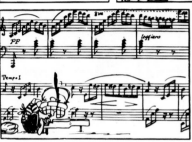

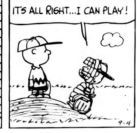
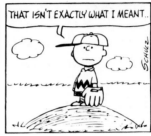

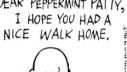
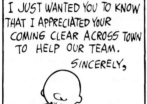

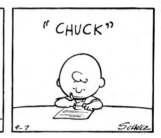

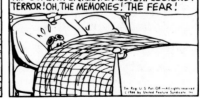

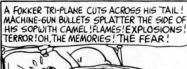

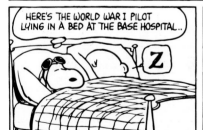

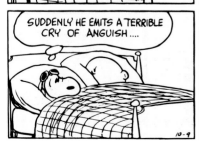
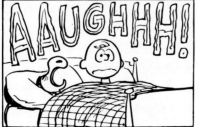
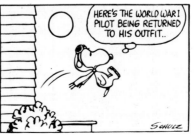

The 60s

My earliest recollection of drawing and getting credit for it is from kindergarten. The teacher gave us huge sheets of white paper, and large black crayons. I drew a man shoveling snow, and she came around, paused, looked at my picture, and said, "Someday, Charles, you're going to be an artist."

Now she wasn't quite right— she didn't say "cartoonist"— but there was an interesting aspect to this. I had drawn the snow shovel as a square, but I knew this was not right. I knew nothing about perspective, and didn't know how to fix it, but I knew that something wasn't right about this picture. I like to think there was some anticipation of what was to come.

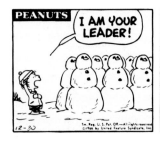

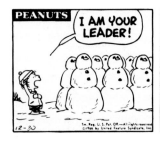

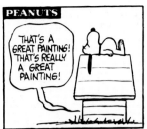
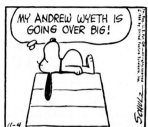
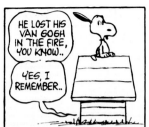

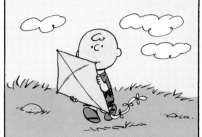

I have never been a very successful kite flyer, and have used the excuse that I never lived where there were good areas to fly them. When I was growing up, we always lived in residential neighborhoods which had too many trees and too many telephone wires. Recollections of those handicaps inspired Charlie Brown's troubles with kite flying. As I grew older and tried to fly kites for my own children, I discovered that I still had the same problems.

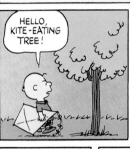
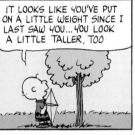
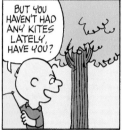
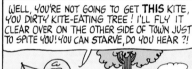

I observed that when a kite becomes caught in a tall tree, it is irretrievable and gradually disappears over a period of several weeks. Now obviously the kite had to go someplace, so it seemed to me that the tree must be eating it. This is how the series developed about Charlie Brown's violent battles with his local kite-eating tree.

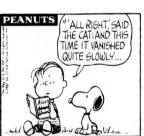
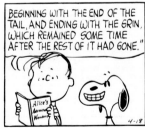
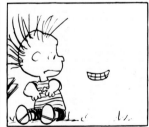
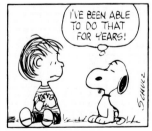

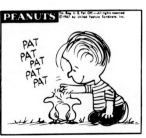

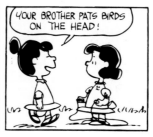

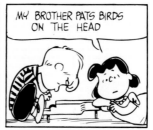

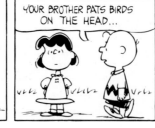
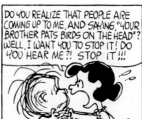

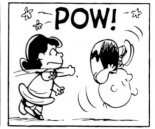

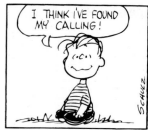

PAT
PAT
PAT
PAT
PAT

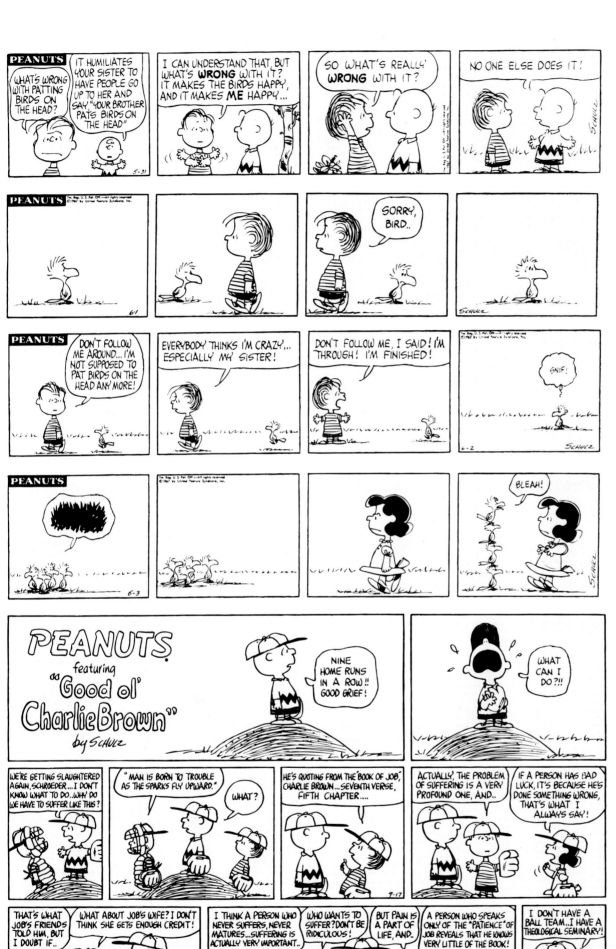

The baseball scenes work wonderfully well even though we never see the other team. Most of the time we are focused on Charlie Brown, standing on top of the pitcher's mound.

It was Robert Short, author of *The Gospel According to Peanuts*, who once reminded me that Charlie Brown's pose on the mound was not unlike that of Job on his ash heap. He was quite surprised when I told him that this had never occurred to me.

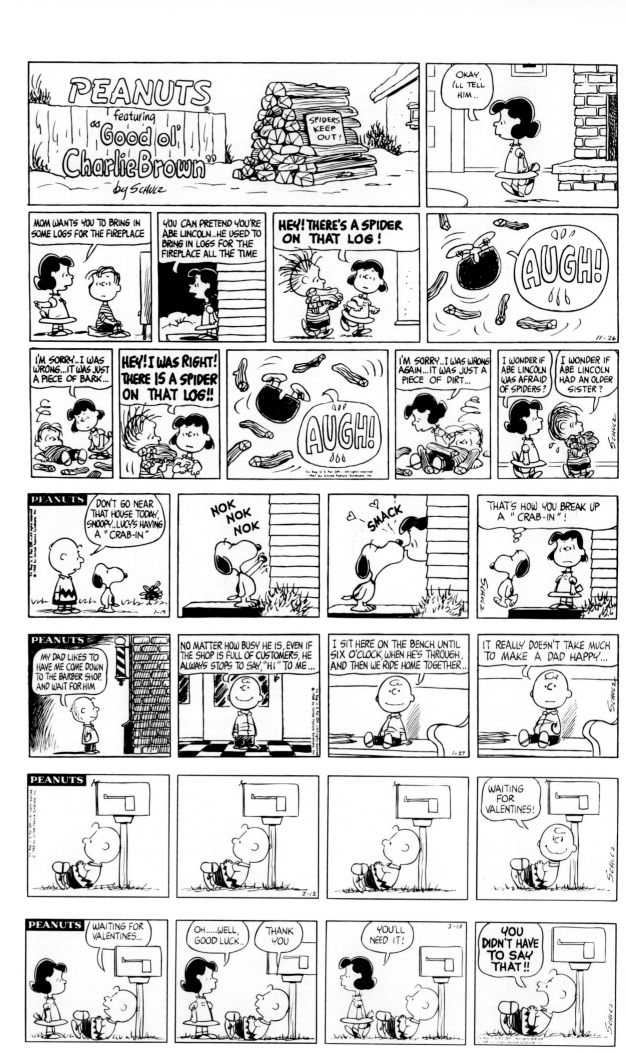

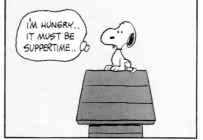

People have to learn to love the characters and care about them. You may notice that Snoopy never smashes the dog dish in Charlie Brown's face. He never scratches the furniture, and he never does any harm. Maybe psychologically he is harming poor Charlie Brown, but there is no meanness to it.

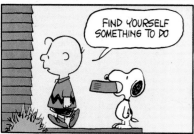

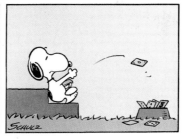

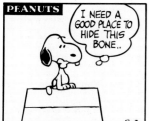
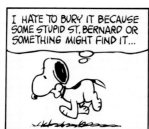
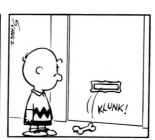
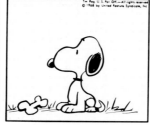

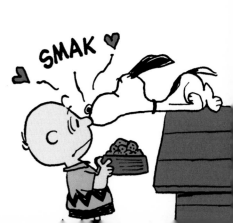

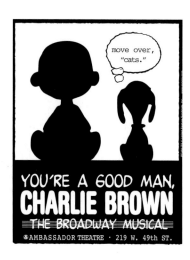

move over, "cats."

YOU'RE A GOOD MAN, CHARLIE BROWN
THE BROADWAY MUSICAL
AMBASSADOR THEATRE · 219 W. 49th ST.

You're on Broadway, Charlie Brown

Editor's Note:

To celebrate the 50th anniversary of Peanuts, You're a Good Man, Charlie Brown *opened for the first time on Broadway at the Longacre Theatre on February 4, 1999. The show brings the world of Charlie Brown to theatrical life in a series of vignettes from a day in his life.*

Director Michael Mayer incorporated new material from strips created in the years since the musical was originally written, and although You're a Good Man, Charlie Brown *has traditionally been staged with minimal sets and costumes, Mayer and his acclaimed production team brought many exciting and eye-filling surprises to this Broadway revival.*

The original production, with book, music, and lyrics by Clark Gesser, premiered in New York, off Broadway, in 1967. It charmed critics and audiences alike for over five years and has since become one of the world's most popular musicals, spawning 13 national and 15 international companies and a Hallmark Hall of Fame Television production.

In updating the Broadway production, Mayer changed the character of Patty, who makes only occasional appearances nowadays, to Sally, Charlie Brown's jump-roping, valentine-collecting little sister. Musical arranger Andrew Lippa composed an additional song for Sally, "My New Philosophy," and one for Schroeder as well, "Beethoven Day."

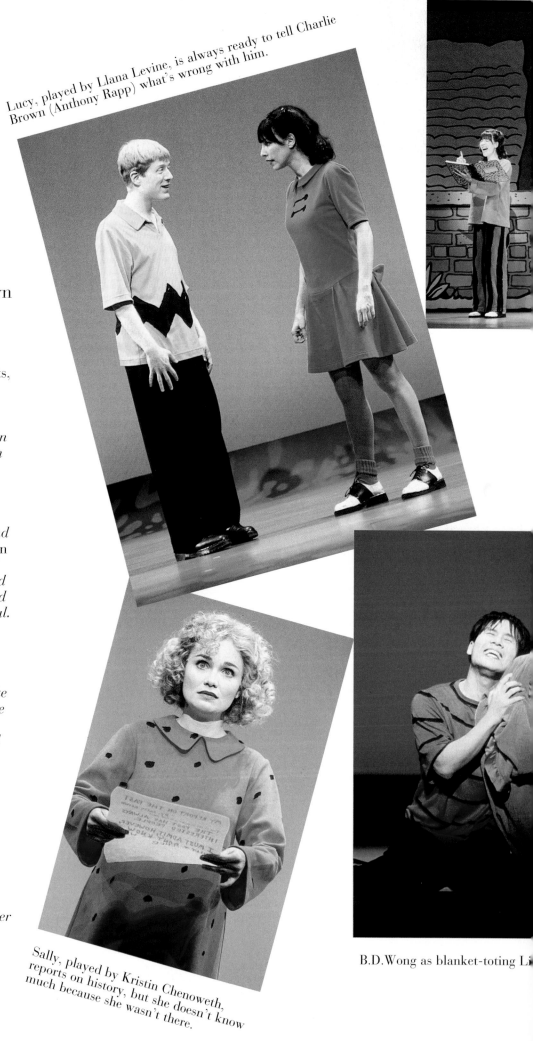

Lucy, played by Llana Levine, is always ready to tell Charlie Brown (Anthony Rapp) what's wrong with him.

Sally, played by Kristin Chenoweth, reports on history, but she doesn't know much because she wasn't there.

B.D. Wong as blanket-toting Li

74

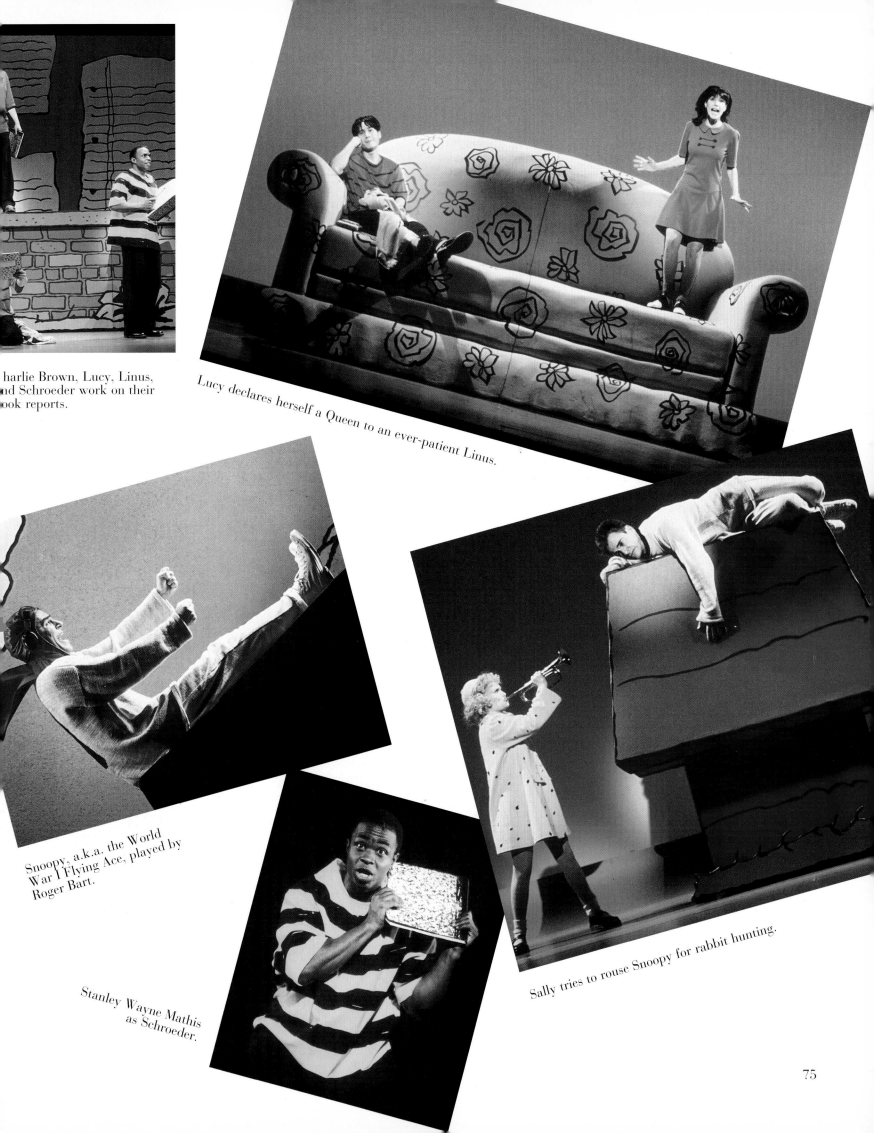

Charlie Brown, Lucy, Linus, and Schroeder work on their book reports.

Lucy declares herself a Queen to an ever-patient Linus.

Snoopy, a.k.a. the World War I Flying Ace, played by Roger Bart.

Stanley Wayne Mathis as Schroeder.

Sally tries to rouse Snoopy for rabbit hunting.

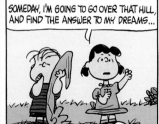
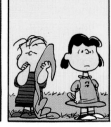

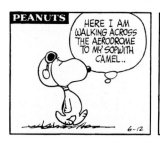

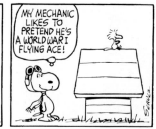

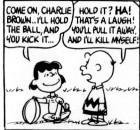

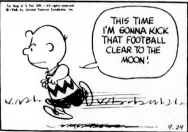
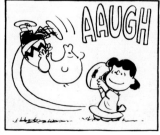
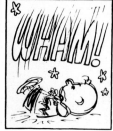
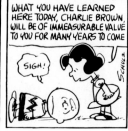

A friend of mine told me once how her young son had come home from school one day, burst through the door, hurled his jacket down on the couch, and moaned, "Mom, I feel just like Charlie Brown." He didn't have to say anything more. She knew exactly what he meant.

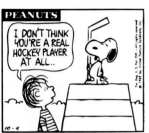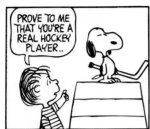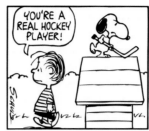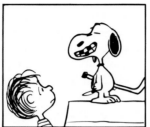

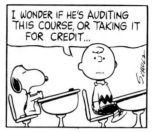

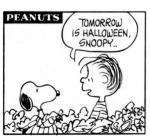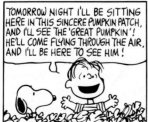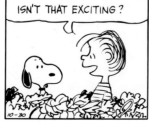

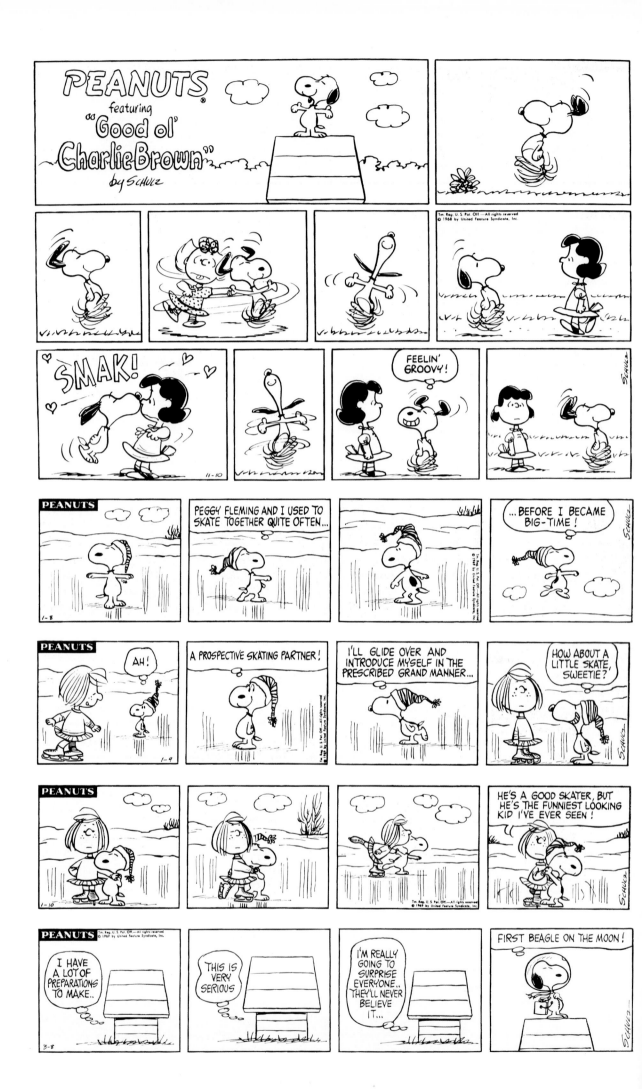

The 60s

Snoopy rivals and sometimes surpasses Charlie Brown in popularity. I have to be careful not to let the ubiquitous beagle run away with the strip. He was adopted by NASA as a promotional device. Snoopy pins were presented to seven North American Rockwell Launch Operations personnel for their work in the Apollo program, and the *Manned Flight Awareness Newsletter* reported that Snoopy emblems were worn by members of the manned space flight team as rewards for outstanding work.

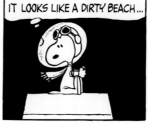

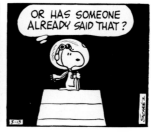

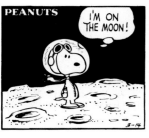

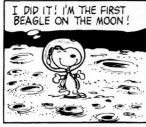

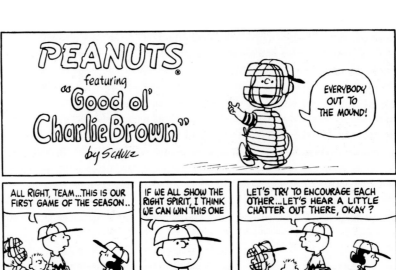

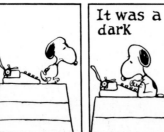

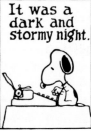
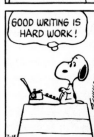

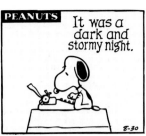
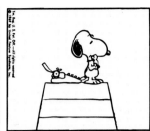
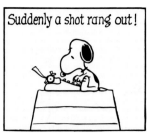
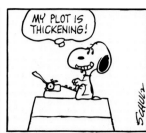

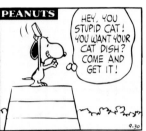
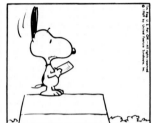
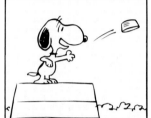
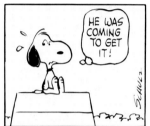

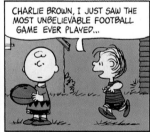
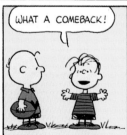
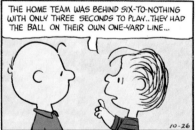

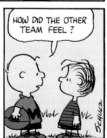

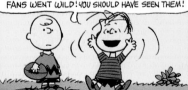

Into the 70s

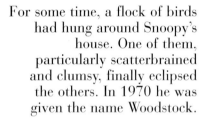

For some time, a flock of birds had hung around Snoopy's house. One of them, particularly scatterbrained and clumsy, finally eclipsed the others. In 1970 he was given the name Woodstock.

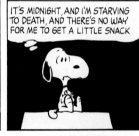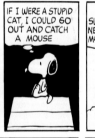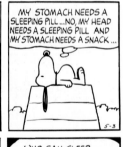

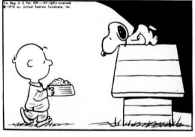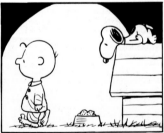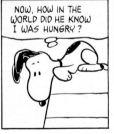

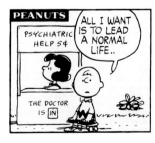

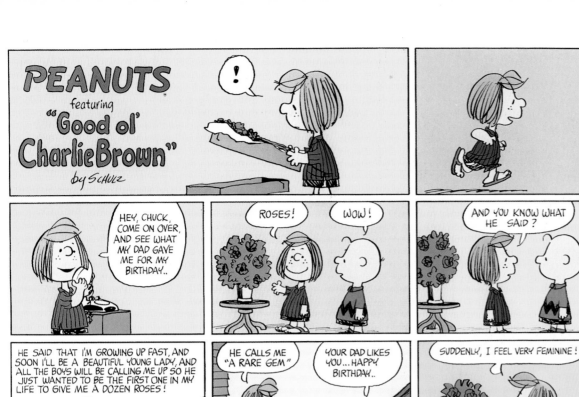

The 70s

When my daughter Amy had her 15th birthday, I gave her a dozen roses and told her that she would soon be a beautiful young lady and that the boys would be calling on her and probably be bringing her presents. This was the inspiration for the Sunday page that showed Peppermint Patty receiving roses from her father on her birthday.

For several years, I have referred to our youngest daughter, Jill, as a "rare gem," so I simply combined our two daughters into one and created the very sentimental page that concludes with Peppermint Patty saying, "Suddenly, I feel very feminine."

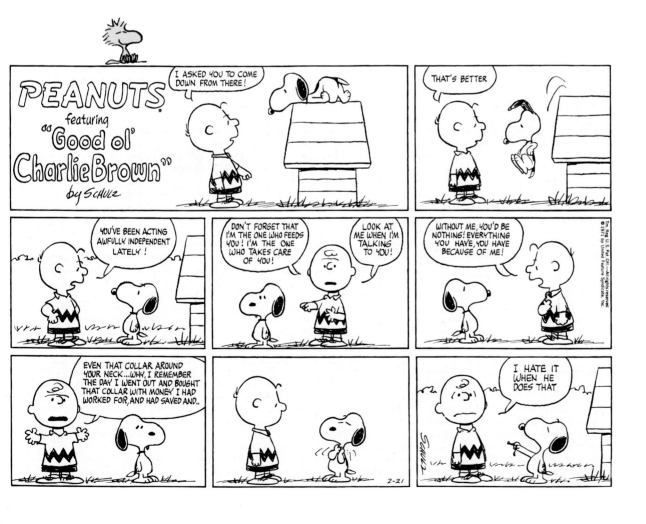

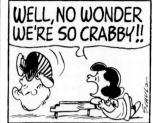

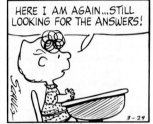

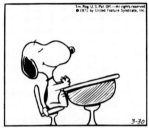

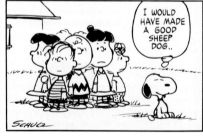

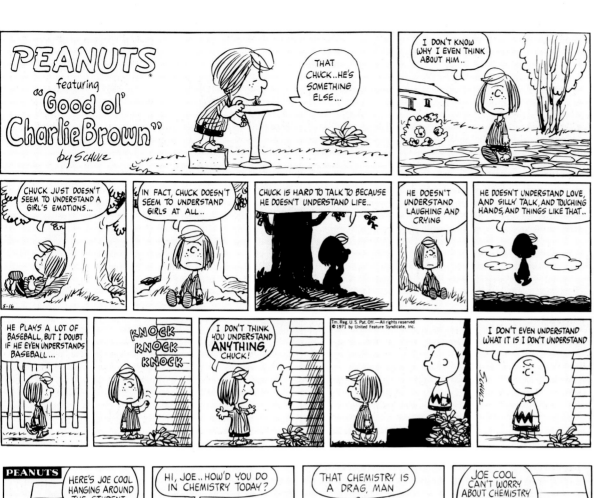

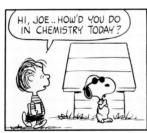
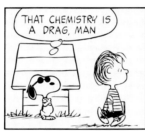
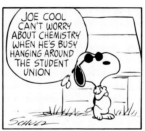

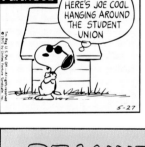

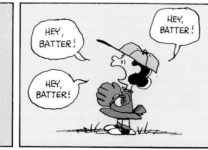

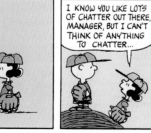
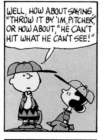
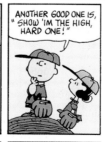
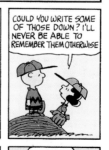

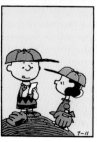

Peppermint Patty and Marcie
meet for the first time at
summer camp in July 1971.

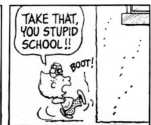

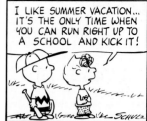

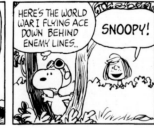
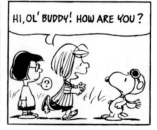

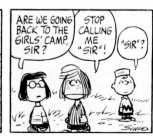

PEANUTS

WELL, SIR, I GUESS IT'S TIME TO SAY GOOD-BY..

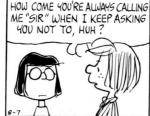

BEFORE WE GO, KID, I WANT TO ASK YOU SOMETHING...

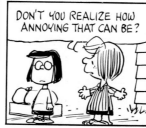

HOW COME YOU'RE ALWAYS CALLING ME "SIR" WHEN I KEEP ASKING YOU NOT TO, HUH?

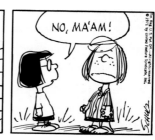

DON'T YOU REALIZE HOW ANNOYING THAT CAN BE?

NO, MA'AM!

PEANUTS featuring "Good ol' Charlie Brown" by Schulz

QUIET

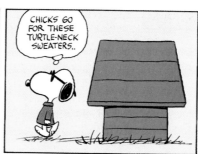

CHICKS GO FOR THESE TURTLE-NECK SWEATERS..

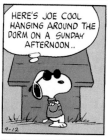

HERE'S JOE COOL HANGING AROUND THE DORM ON A SUNDAY AFTERNOON..

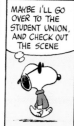

MAYBE I'LL GO OVER TO THE STUDENT UNION, AND CHECK OUT THE SCENE

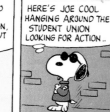

HERE'S JOE COOL HANGING AROUND THE STUDENT UNION LOOKING FOR ACTION..

I SEE THEY'RE SHOWING "CITIZEN KANE" AGAIN... I'VE ONLY SEEN IT TWENTY-THREE TIMES..

MAYBE I'LL GO OVER TO THE LIBRARY, AND SEE WHO'S THERE

RATS..NO CHICKS! MAYBE I SHOULD GO OVER TO THE GYM AND SHOOT A FEW BASKETS...

IF I HAD SOME WHEELS, I'D CRUISE AROUND FOR AWHILE.. MAYBE I SHOULD WALK OVER, AND LOOK AT THE GEOLOGICAL EXHIBIT...

I'VE GOTTA BE KIDDING... LOOK AT THOSE ROCKS AGAIN? NO WAY!

THERE'S A GUY WITH TWO CHICKS.. HOW DOES HE DO IT?

THE LEAVES ARE BEGINNING TO FALL.. THE SUN IS WARM, BUT IT'S KIND OF CHILLY IN THE SHADE

I WONDER WHAT'S GOING ON AT HOME.. MAYBE I SHOULD GO BACK TO THE DORM AND WRITE SOME LETTERS...

SIGH JOE COOL HATES SUNDAY AFTERNOONS...

PEANUTS

YOU'RE WASTING YOUR LIFE!

ALL YOU'RE DOING IS CRAWLING AROUND ON THE GROUND!

DO SOMETHING WITH YOUR LIFE..DON'T JUST CRAWL AROUND!!

BUGS NEVER LISTEN TO GOOD ADVICE..

PEANUTS

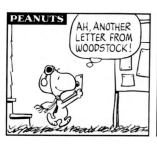

AH, ANOTHER LETTER FROM WOODSTOCK!

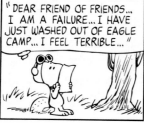

"DEAR FRIEND OF FRIENDS... I AM A FAILURE... I HAVE JUST WASHED OUT OF EAGLE CAMP... I FEEL TERRIBLE..."

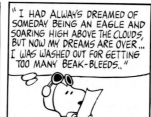

"I HAD ALWAYS DREAMED OF SOMEDAY BEING AN EAGLE AND SOARING HIGH ABOVE THE CLOUDS, BUT NOW MY DREAMS ARE OVER... I WAS WASHED OUT FOR GETTING TOO MANY BEAK-BLEEDS.."

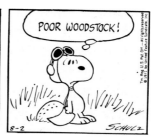

POOR WOODSTOCK!

PEANUTS

grumble grumble grumble

PAT PAT PAT

SIGH

I SOOTHED A RUFFLED FEATHER!

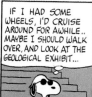

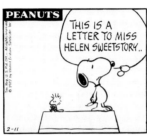

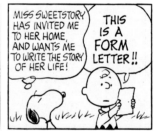

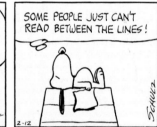

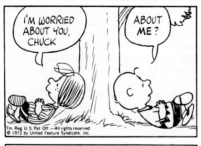

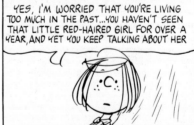

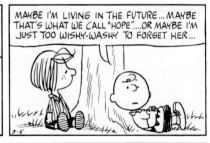

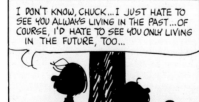

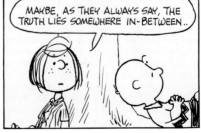

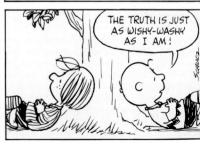

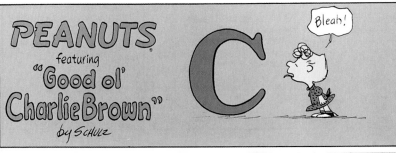
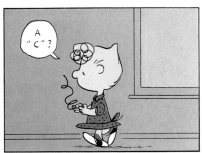
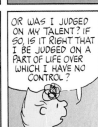
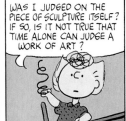

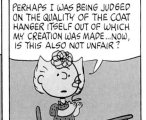
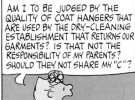
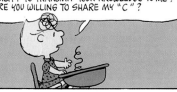

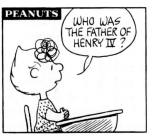
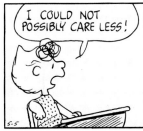
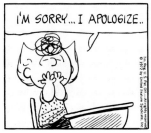
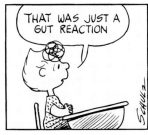

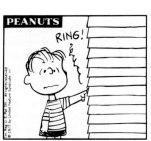
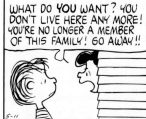
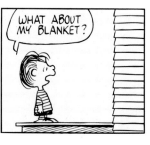
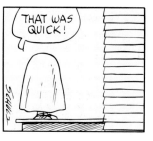

I thought about this Sunday page for over a year. It eventually become one of the most sought-after pages I have ever done. We have received countless requests for the original and for reprints.

It all started when my oldest son, Monte, was involved with an art class where the project was a coat-hanger sculpture. He was telling me about it one day while we were riding home in the car from school, and he said that he was going to transform a coat hanger into the figure of a baseball pitcher. It sounded like a good idea to me, and I was anxious to hear about the final results. Several weeks went by before he mentioned it again, and this time he told me that the teacher had handed back the projects and he had received a C for his coat-hanger sculpture.

I remember being quite disturbed by this, because I could not understand how a teacher was able to grade this kind of project. I thought about it as the months went by, and finally translated it into the Sunday page where Sally expresses her indignation over receiving the same grade for her piece of coat-hanger sculpture. Her questions were the same ones that I wanted to ask. Had Monte's teacher judged the sculpture as a piece of art? If so, what criteria did he use to judge it? Was he grading the person on his ability to create this work of art? If so, what control did the person have over the talent that was given him at birth? Was the person being graded upon what he had learned in the project? If so, should the teacher not be willing to share in the grade? Sally made a good instrument for this kind of idea, for she is a character who expresses indignation well, and who is completely puzzled by all of the things she has to go through in school.

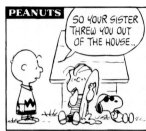
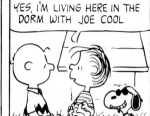
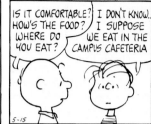
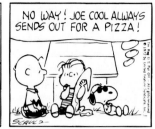

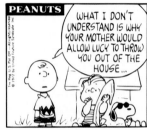
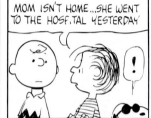
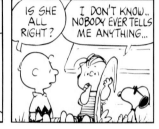
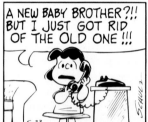

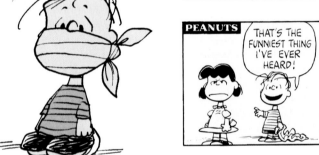

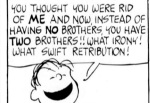
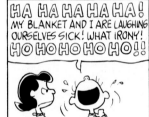
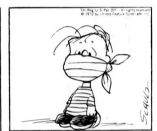

Rerun gets his name.

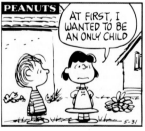
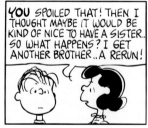
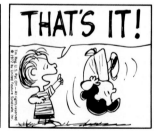
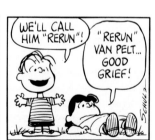

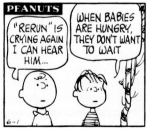
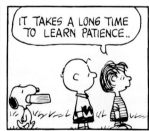

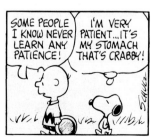

90

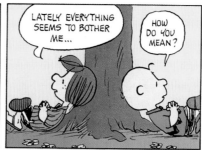

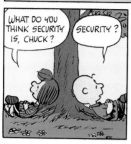
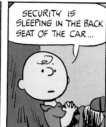
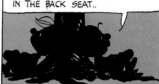
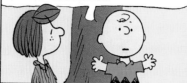

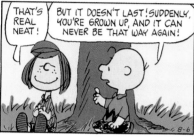
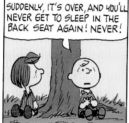

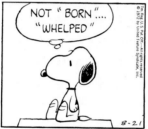
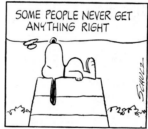

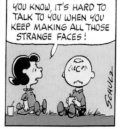

The 70s

Charlie Brown defined security as being able to sleep in the backseat of your parents' car. This, again, is a childhood memory, one supported by many readers who have told me that they also recall the wonderful joy of doing this with a feeling of complete security when returning home late at night. The shattering blow comes in later years when one realizes that this can never happen again. Adults are doomed to ride in the front seat forever.

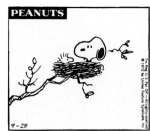 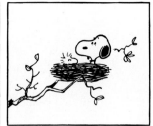

 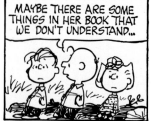 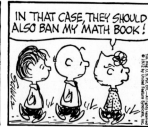

The introduction of Woodstock into the strip is a good demonstration of how some things cannot work until they have been drawn properly. The birds that had appeared earlier were drawn much too realistically to be able to fill humorous roles, but as I loosened up the drawing style, Woodstock gradually developed. I would much prefer that Snoopy not communicate with Woodstock, but there are some ideas that are too important to abandon, so I have him speaking to Woodstock through "thought balloons." I've held fast with Woodstock's means of communication, though it has been tempting at times to have him talk. I feel it would be a mistake to give in on this point, however, for I think it is more important that all of Woodstock's talking remain depicted simply in the little scratch marks that appear above his head.

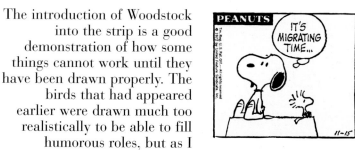

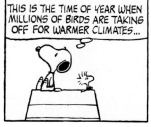

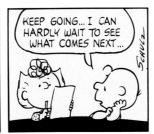

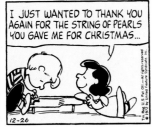
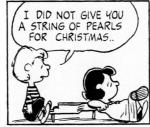

Franklin met Charlie Brown at the beach in 1968. They'd never met before because they went to different schools, but they had fun playing ball so Charlie Brown invited Franklin to visit him at this house across town for another play session. Later, Franklin turned up as center fielder on Peppermint Patty's baseball team and sits in front of her at school. Franklin is thoughtful and can quote the Old Testament as effectively as Linus. In contrast with the other characters, Franklin has the fewest anxieties and obsessions. He and Charlie Brown spend quite a bit of time talking about their respective grandfathers. When Franklin first appeared in the late 60s, his noticeably darker skin set some readers in search of a political meaning. However, the remarkable becomes unremarkable when readers learn that I simply introduced Franklin as another character, not a political statement.

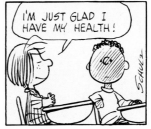

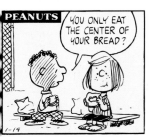
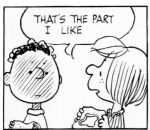
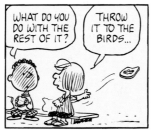

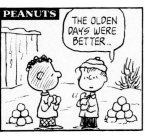
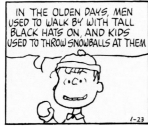

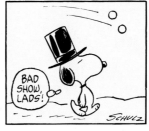

In this Sunday page, Charlie Brown is talking about how things change as we grow older. Of course I used his father as the instrument for my recollections, and his father has apparently told him how the theater that he attended as a small boy seemed to get narrower and narrower as the years went by. This is similar to going back to a house where you once lived when you were young and discovering that the backyard you remember as being so large is really absurdly small.

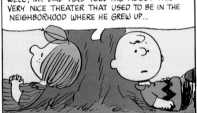
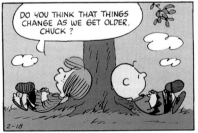
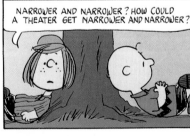

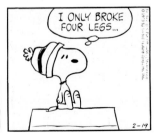
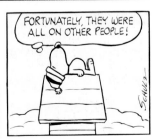

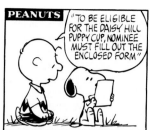
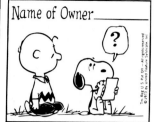

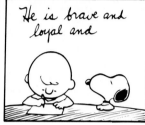
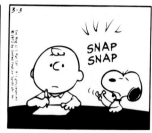
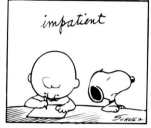

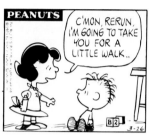

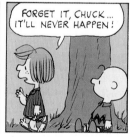
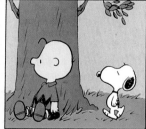
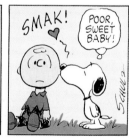

The 70s

I don't know which story has been my favorite, but one that worked out far beyond my expectations concerned Charlie Brown's problem when, instead of seeing the sun rise early one morning, he saw a huge baseball come up over the horizon. Eventually a rash, similar to the stitching on a baseball, began to appear on his head, and his pediatrician told him it would be a good idea if he went off to camp and got some rest. Because he was embarrassed by the rash, he decided to wear a sack over his head. The first day of camp, all of the boys held a meeting and someone jokingly nominated the kid with the sack over his head as camp president. Before he knew it, Charlie Brown was running the camp and had the admiration of everyone. It seemed that no matter what he did, it turned out well, and he became known as "Sack" or "Mr. Sack," and became the best-liked kid in camp.

Unfortunately, he could not resist taking the sack off to see if his rash was cured, and once he had removed the sack, he reverted back to his old self. I don't pretend there is any great truth to this story, or any marvelous moral, but it was a neat little tale, and one of which I was proud. Unfortunately, this kind of story does not come along very often, and I am satisfied if I can think of something that good once every year.

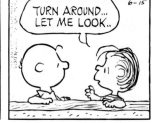
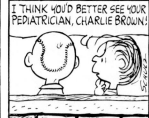

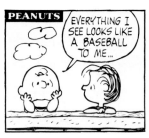
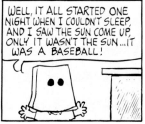

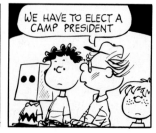
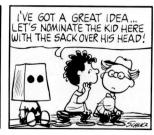

96

PEANUTS

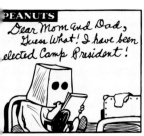

Dear Mom and Dad, Guess What! I have been elected Camp President!

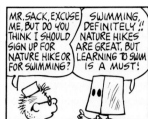

MR. SACK, EXCUSE ME, BUT DO YOU THINK I SHOULD SIGN UP FOR NATURE HIKE OR FOR SWIMMING?

SWIMMING, DEFINITELY!! NATURE HIKES ARE GREAT, BUT LEARNING TO SWIM IS A MUST!

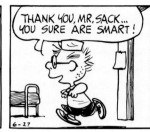

THANK YOU, MR. SACK... YOU SURE ARE SMART!

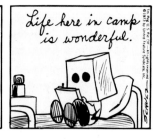

Life here in camp is wonderful.

PEANUTS

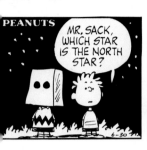

MR. SACK, WHICH STAR IS THE NORTH STAR?

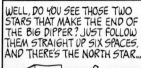

WELL, DO YOU SEE THOSE TWO STARS THAT MAKE THE END OF THE BIG DIPPER? JUST FOLLOW THEM STRAIGHT UP SIX SPACES, AND THERE'S THE NORTH STAR...

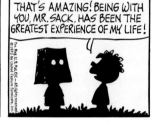

THAT'S AMAZING! BEING WITH YOU, MR. SACK, HAS BEEN THE GREATEST EXPERIENCE OF MY LIFE!

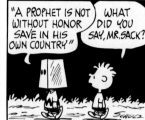

"A PROPHET IS NOT WITHOUT HONOR SAVE IN HIS OWN COUNTRY"

WHAT DID YOU SAY, MR. SACK?

PEANUTS

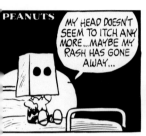

MY HEAD DOESN'T SEEM TO ITCH ANY MORE....MAYBE MY RASH HAS GONE AWAY...

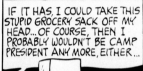

IF IT HAS, I COULD TAKE THIS STUPID GROCERY SACK OFF MY HEAD... OF COURSE, THEN I PROBABLY WOULDN'T BE CAMP PRESIDENT ANY MORE, EITHER...

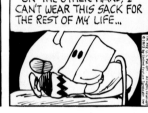

ON THE OTHER HAND, I CAN'T WEAR THIS SACK FOR THE REST OF MY LIFE...

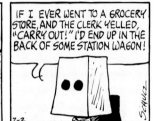

IF I EVER WENT TO A GROCERY STORE, AND THE CLERK YELLED, "CARRY OUT!" I'D END UP IN THE BACK OF SOME STATION WAGON!

PEANUTS

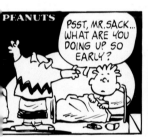

PSST, MR. SACK... WHAT ARE YOU DOING UP SO EARLY?

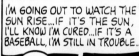

I'M GOING OUT TO WATCH THE SUN RISE...IF IT'S THE SUN, I'LL KNOW I'M CURED...IF IT'S A BASEBALL, I'M STILL IN TROUBLE..

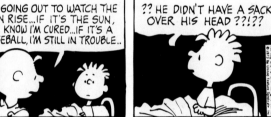

?? HE DIDN'T HAVE A SACK OVER HIS HEAD ??!??

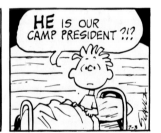

HE IS OUR CAMP PRESIDENT ?!?

PEANUTS

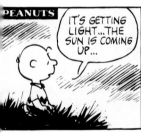

IT'S GETTING LIGHT...THE SUN IS COMING UP...

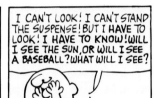

I CAN'T LOOK! I CAN'T STAND THE SUSPENSE! BUT I HAVE TO LOOK! I HAVE TO KNOW! WILL I SEE THE SUN, OR WILL I SEE A BASEBALL? WHAT WILL I SEE?

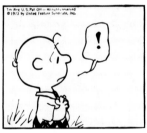

!

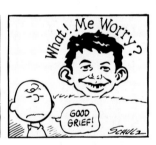

What! Me Worry?

GOOD GRIEF!

PEANUTS

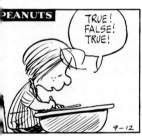

TRUE! FALSE! TRUE!

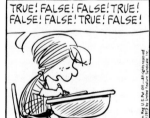

TRUE! FALSE! FALSE! TRUE! FALSE! FALSE! TRUE! FALSE!

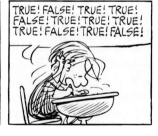

TRUE! FALSE! TRUE! TRUE! FALSE! TRUE! TRUE! TRUE! TRUE! FALSE! TRUE! FALSE!

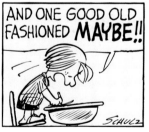

AND ONE GOOD OLD FASHIONED **MAYBE!!**

PEANUTS

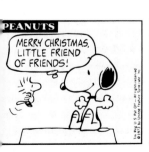

MERRY CHRISTMAS, LITTLE FRIEND OF FRIENDS!

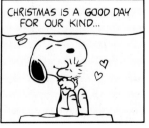

CHRISTMAS IS A GOOD DAY FOR OUR KIND...

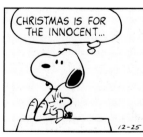

CHRISTMAS IS FOR THE INNOCENT...

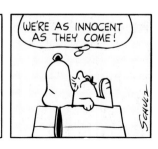

WE'RE AS INNOCENT AS THEY COME!

The 70s

I learned to play hockey in the streets. My friends and I would wait until the snow-plows had come through and then scrape off the loose snow to expose the icy road surface. We would pile clumps of snow at either end of the block to mark the goals. Men drivers would always slow down and weave around the goalposts, but women would roll right over them. The men knew how important those clumps were to us, but the women just didn't understand.

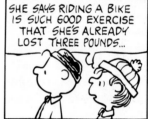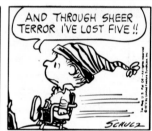

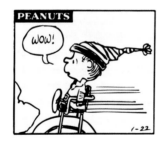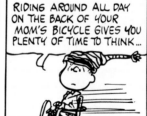

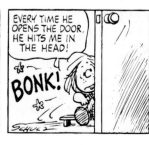

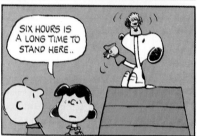

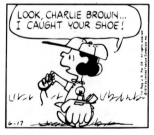
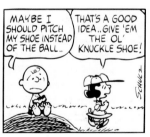

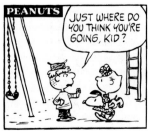

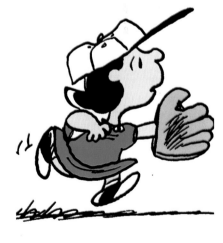

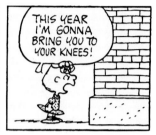
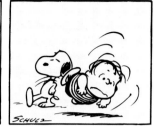

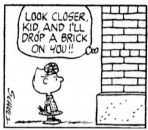

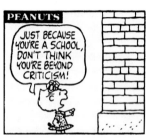
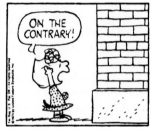

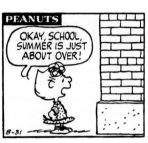

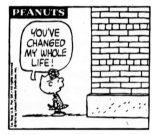
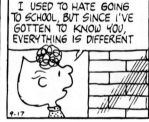
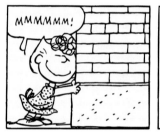
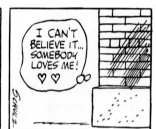

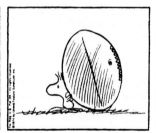
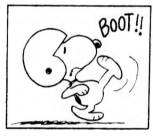
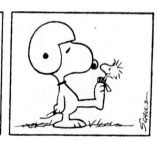

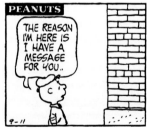
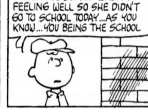
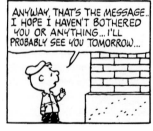
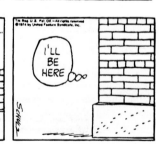

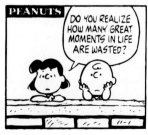
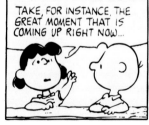
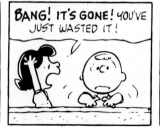
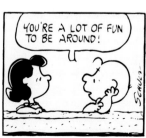

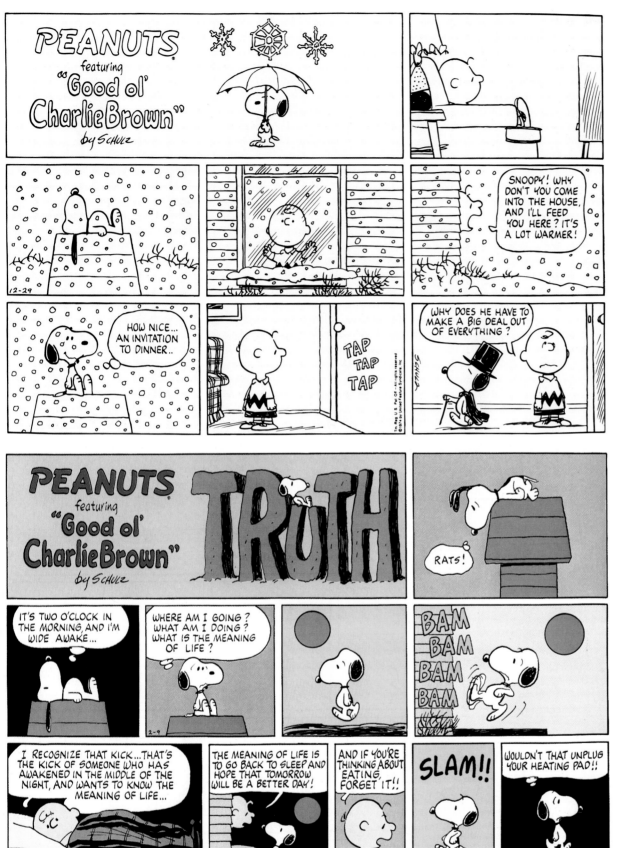

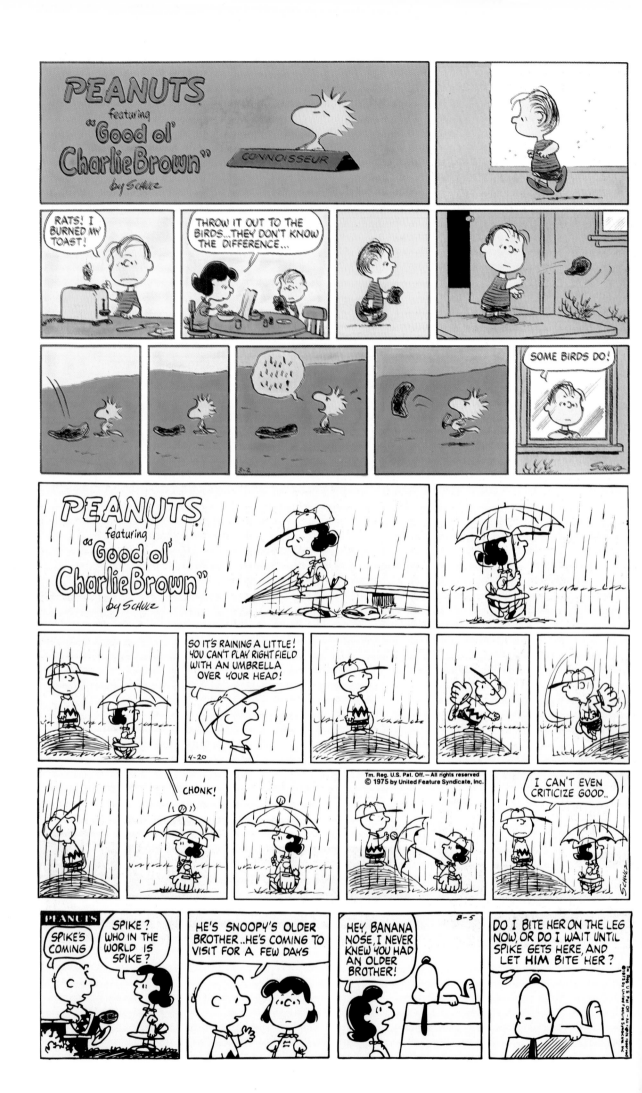

One of the longest series I have ever done involved Peppermint Patty and her ice-skating competition. I was able to stretch it out because I was able to go in several directions. First, there was the matter of her having to practice and of her involvement with her ice-skating pro, who was Snoopy. Then there was the making of her skating dress, as she talked little Marcie, against her will, into making the dress for her. I believe this story went on for five weeks and, of course, ended in disaster for Peppermint Patty, because the ice-skating competition for which she had prepared so diligently turned out to be a roller-skating competition instead.

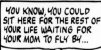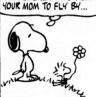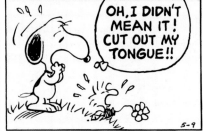

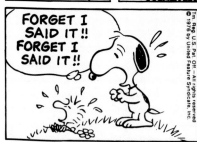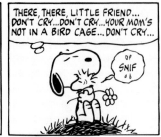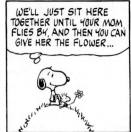

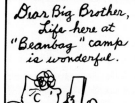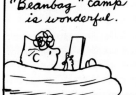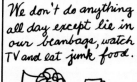

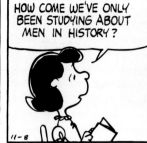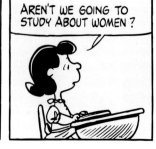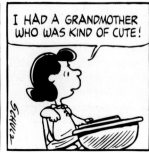

MY GRANDMOTHER HELPED TO MAKE THIS COUNTRY GREAT!

DURING WORLD WAR II, SHE WORKED AS A RIVETER, AND WROTE LETTERS TO SEVENTEEN SERVICEMEN!

TALK ABOUT WOMEN IN HISTORY...

LET'S HEAR IT FOR MY GRANDMOTHER!!

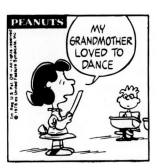
MY GRANDMOTHER LOVED TO DANCE

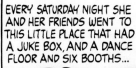
EVERY SATURDAY NIGHT SHE AND HER FRIENDS WENT TO THIS LITTLE PLACE THAT HAD A JUKE BOX, AND A DANCE FLOOR AND SIX BOOTHS...

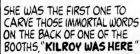
SHE WAS THE FIRST ONE TO CARVE THOSE IMMORTAL WORDS ON THE BACK OF ONE OF THE BOOTHS, "KILROY WAS HERE"

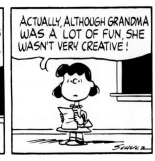
ACTUALLY, ALTHOUGH GRANDMA WAS A LOT OF FUN, SHE WASN'T VERY CREATIVE!

AND SO, WORLD WAR II CAME TO AN END...

MY GRANDMOTHER LEFT HER JOB IN THE DEFENSE PLANT, AND WENT TO WORK FOR THE TELEPHONE COMPANY...

WE NEED TO STUDY THE LIVES OF GREAT WOMEN LIKE MY GRANDMOTHER... TALK TO YOUR OWN GRANDMOTHER TODAY... ASK HER QUESTIONS...

YOU'LL FIND SHE KNOWS MORE THAN PEANUT BUTTER COOKIES! THANK YOU!

PEANUTS featuring "Good ol' Charlie Brown" by Schulz

THEN SHE HEARD SOMEONE TALKING..

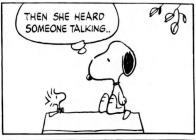

AND WHEN ALICE LOOKED UP, THERE WAS THE CHESHIRE CAT!

YOU'VE NEVER SEEN ME DO MY CHESHIRE BEAGLE TRICK, HAVE YOU?

WATCH THIS...

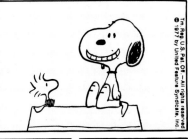

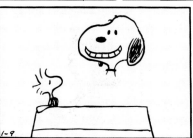
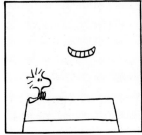
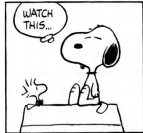
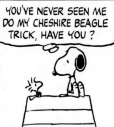
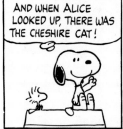

WELL, I NEVER SAID IT WOULD MAKE A WEEKLY SERIES!

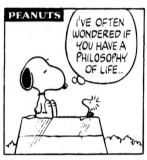
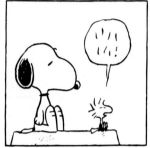
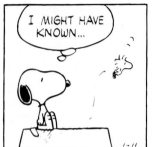
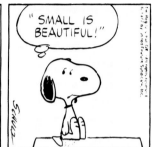

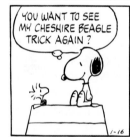

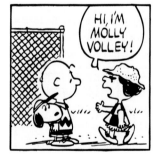
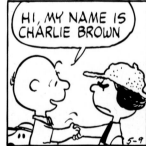
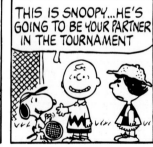
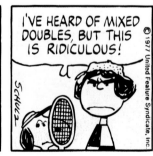

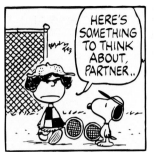
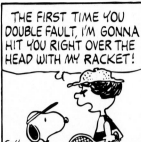
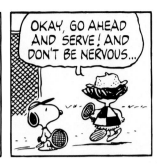

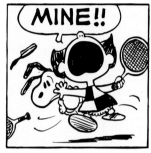

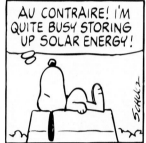

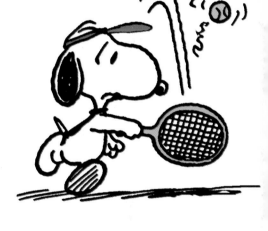

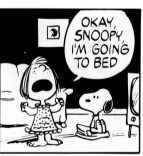
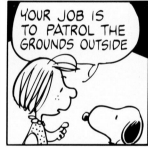

107

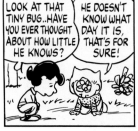

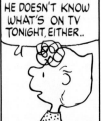

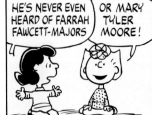

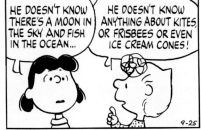

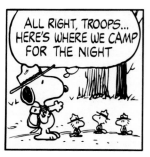
ALL RIGHT, TROOPS... HERE'S WHERE WE CAMP FOR THE NIGHT

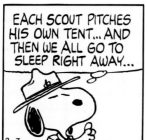
EACH SCOUT PITCHES HIS OWN TENT... AND THEN WE ALL GO TO SLEEP RIGHT AWAY...

2-7

JUST FOLLOW MY EXAMPLE

© 1978 United Feature Syndicate, Inc.

The 70s

I once inquired of a veterinarian how birds stay on tree limbs when they fall asleep. He told me that their claws receive a message from their brain after they have fallen asleep which tightens a certain muscle, keeping them from tumbling off the branch. He said a similar thing occurs to horses, allowing them to sleep while standing. Humans do not have this ability. When I am asked how Snoopy remains on top of his doghouse after falling asleep, I am now able to say that his brain sends a message to his ears which lock him to the top of the doghouse, or even a tent.

PEANUTS featuring "Good ol' Charlie Brown" by Schulz

PUFF PUFF

THIS IS HARD ON US LUNGS

IF I START COMPLAINING, YOU'RE ALL IN TROUBLE

SHUT UP, HEART!

WHY DO WE FEET HAVE TO DO ALL THE WORK?

HOW ABOUT TOES? YOU THINK IT'S EASY BEING A TOE?

YOU GUYS ARE ALWAYS COMPLAINING.. WE EARS CAN HEAR YOU WAY UP HERE!

BESIDES, IT'S US LEGS WHO REALLY DO THE RUNNING...

ALL I KNOW IS, RUNNING IS HARD ON THE BACK... BACKS SHOULD BE HOME IN BED...

HOW ABOUT NOSES? I HATE JOKES ABOUT RUNNING NOSES!

LIPS ARE MADE FOR KISSING, NOT RUNNING...WE NEED MORE KISSING...

I'M HUNGRY!

2-5

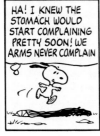
HA! I KNEW THE STOMACH WOULD START COMPLAINING PRETTY SOON! WE ARMS NEVER COMPLAIN

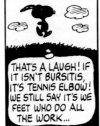
THAT'S A LAUGH! IF IT ISN'T BURSITIS, IT'S TENNIS ELBOW! WE STILL SAY IT'S WE FEET WHO DO ALL THE WORK...

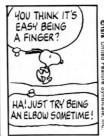
YOU THINK IT'S EASY BEING A FINGER?

HA! JUST TRY BEING AN ELBOW SOMETIME!

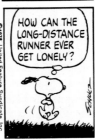
HOW CAN THE LONG-DISTANCE RUNNER EVER GET LONELY?

© 1978 United Feature Syndicate, Inc.

PEANUTS featuring "Good ol' Charlie Brown" by Schulz

No.1 CRAB

SLAM!

BOY, DO I FEEL CRABBY!

MAYBE I CAN BE OF HELP

WHY DON'T YOU JUST TAKE MY PLACE HERE IN FRONT OF THE TV WHILE I GO AND FIX YOU A NICE SNACK?

SOMETIMES WE ALL NEED A LITTLE PAMPERING TO HELP US FEEL BETTER...

4-23

© 1978 United Feature Syndicate, Inc.

SEE? I CAME RIGHT BACK! HERE'S A NICE SANDWICH FOR YOU, SOME CHOCOLATE CHIP COOKIES AND A COLD GLASS OF MILK...

NOW, IS THERE ANYTHING ELSE I CAN GET YOU?

IS THERE ANYTHING I HAVEN'T THOUGHT OF?

YES, THERE'S ONE THING THAT YOU HAVEN'T THOUGHT OF......

I DON'T WANNA FEEL BETTER!!

The 70s

Some cartoon characters are created, but never seem to do anything special or to develop in any particular way. Others, like Snoopy, just seem to take off and become so flexible that you can make them do anything. I never dreamed that he would become the character that he is now.

Of course, the drawing of the character, his appearance, is extremely important. Every time I draw Snoopy, he probably changes a little bit, and when I look back on some of the early drawings, I am appalled that I drew him then as I did. Now I seem to have him as I think he should be, although I still make changes every now and then. But in the end, Snoopy's personality is just as important as his appearance in making him special. I think the relationship that Snoopy has with other characters is good and it's a relationship that would never work with adults. The kids in the strip, especially Charlie Brown, seem to understand the life that he has. Like Snoopy, most people turn to fantasy for fun and refuge. I have always believed that his flights of fancy are what help him to survive, and we must admit that a dog's life is not an easy life.

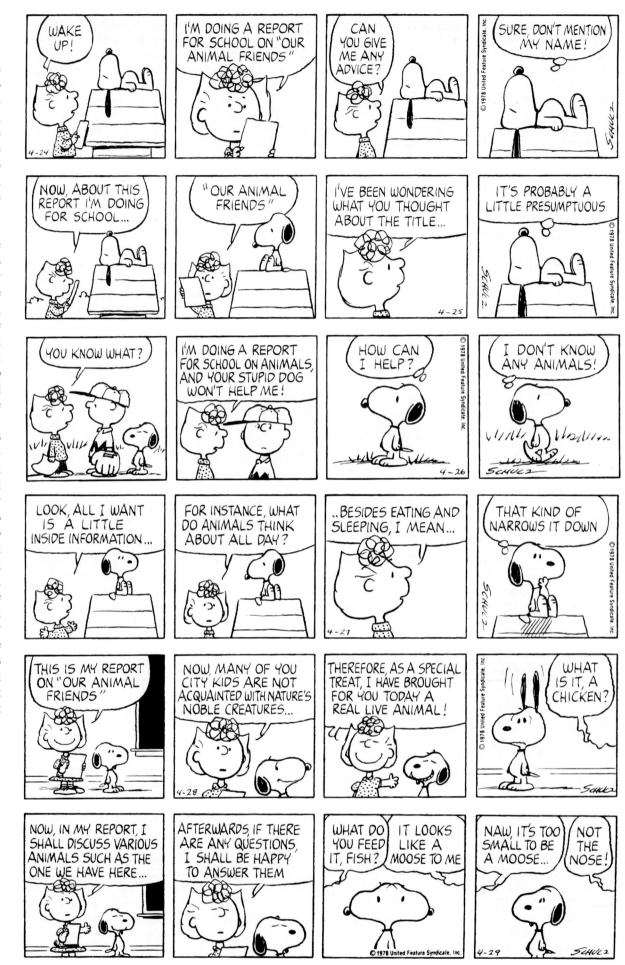

110

SOME PEOPLE THINK THAT ANIMALS WERE PUT HERE ON EARTH TO SERVE HUMANS

ONE WONDERS WHAT SORT OF RESPONSE WE MIGHT GET IF WE WERE TO ASK THE ANIMALS...

HO HO HO HO HO HEE HEE HEE HEE

MAYBE WE HAD BETTER NOT ASK

NOW, THIS ANIMAL I HAVE BROUGHT HERE TODAY IS CALLED A DOG

YOU'RE KIDDING!

YOU'RE PUTTING US ON!

I STILL THINK IT'S A SMALL MOOSE!

I AGREE!

ALL RIGHT, YOU GUYS, CUT IT OUT!

HERE, MOOSIE, MOOSIE, MOOSIE!

I GOT AN "A" ON MY REPORT, SNOOPY!

BECAUSE YOU WERE SUCH A BIG HELP, I'M GOING TO TREAT YOU TO AN ICE-CREAM CONE

FORTY-NINE FLAVORS

YOU WEREN'T THAT BIG A HELP!

PEANUTS featuring "Good ol' Charlie Brown" by Schulz

OBEDIENCE SCHOOL

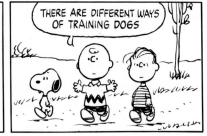

THERE ARE DIFFERENT WAYS OF TRAINING DOGS

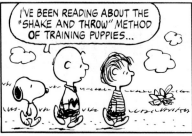

I'VE BEEN READING ABOUT THE "SHAKE AND THROW" METHOD OF TRAINING PUPPIES...

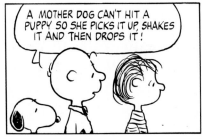

A MOTHER DOG CAN'T HIT A PUPPY SO SHE PICKS IT UP, SHAKES IT AND THEN DROPS IT!

I CAN'T BELIEVE A PUPPY WOULD LEARN ANYTHING FROM THAT...

BONK!

ON THE OTHER HAND, I GUESS HE MIGHT LEARN A LITTLE..

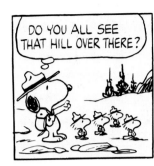

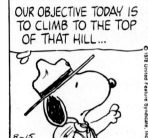

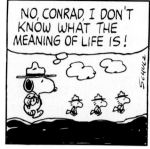

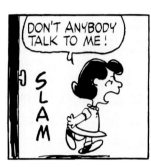

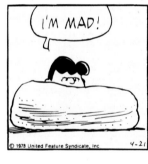

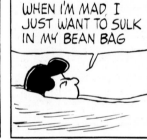

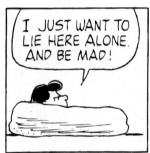

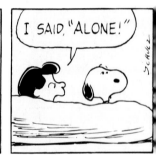

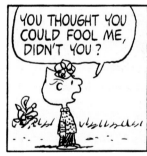

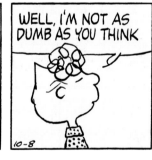

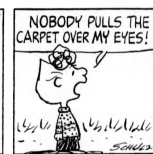

PEANUTS featuring "Good ol' Charlie Brown" by Schulz

YOU'RE KIDDING...

COME SEE FOR YOURSELF...

ARF ARF ARF

SEE? WHAT DID I TELL YOU?

3-4

WHAT A DUMB DOG! HA! HA! HA! HA!

NOT HERE... OVER THERE!

REALLY?

HOW EMBARRASSING

I WAS BARKING UP THE WRONG TREE!

THAT WAS SOME LINE DRIVE, CHARLIE BROWN... IT KNOCKED YOUR SHOESIES AND YOUR SOCKIES RIGHT OFF!

MAYBE WE SHOULD COUNT TO SEE IF YOU STILL HAVE ALL YOUR TOESIES...

GET OUT OF HERE!

JUST FOR THAT, HE CAN COUNT HIS OWN TOESIES!

TRUE OR FALSE? I SAY, TRUE! YES! ABSOLUTELY TRUE!

THIS IS ALSO TRUE! EVERYTHING IS TRUE! NOTHING IS FALSE!

4-30

THE WHOLE WORLD IS TRUE! WE'RE ALL TRUE! TRUE! TRUE! TRUE!

YOU WOULDN'T CRUSH AN OPTIMIST WITH A 'D-MINUS,' WOULD YOU, MA'AM?

HOW CAN I DO A REPORT ON HANNIBAL, MARCIE? I'VE NEVER HEARD OF HIM!

© 1979 United Feature Syndicate, Inc.

RUN DOWN TO THE LIBRARY, SIR, AND LOOK HIM UP IN THE ENCYCLOPEDIA... THAT'S WHAT I DID..

5-1

MAYBE IT'LL SNOW TOMORROW, AND ALL THE SCHOOLS WILL BE CLOSED..

GOOD NIGHT, SIR!

The 70s

I have always tried to dig beneath the surface in my sports cartoons by drawing upon an intimate knowledge of the games. The challenges to be faced in sports work marvelously as a caricature of the challenges that we face in the more serious aspects of our lives. Anytime I experience a crushing defeat in bowling, or have a bad night at bridge, or fail to qualify in the opening round of a golf tournament, I am able to transfer my frustrations to poor Charlie Brown. And when Charlie Brown has tried to analyze his own difficulties in life, he has always been able to express them best in sports terms.

A couple of years after Charlie Brown's short stay in the hospital, I awakened with a strange tight feeling in my chest. At first, I attributed it to having slept crooked during the night. As I dressed and then went into the kitchen, the feeling persisted, and I mentioned it to my wife, Jeannie, and a houseguest. I almost turned around when driving to the studio, for the strange tightness wouldn't go away.

A few very deep breaths seemed to help, however, and I continued to drive. I tried to begin work, but as I sat at the drawing board, the tightness began again.

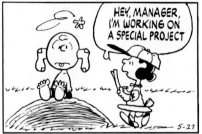

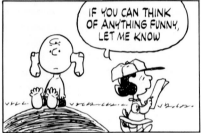
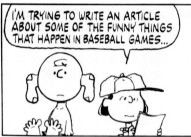
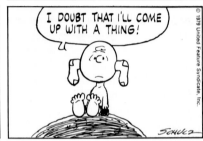

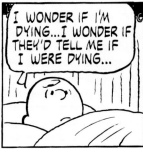
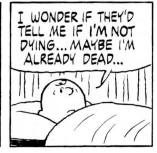
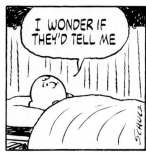
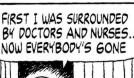

The 70s

I called my doctor, and after a few quick tests was on my way to the hospital. On the fourth night after the heart bypass surgery, I lay in bed staring at the blank wall across the room. Jeannie was sitting quietly next to the bed reading the paper. When I was first admitted to the hospital, one of the nurses placed a large felt-tip pen on a cabinet and said, "Before you leave here, we want you to draw something on the wall." I am not one who goes around drawing pictures on the wall, but I felt I had to fulfill this request. It was now almost 10:30 at night, and like all cartoon ideas, it suddenly came to me. I climbed carefully out of bed, picked up the pen and began to draw a series of five Snoopys, showing him struggling with an inhalator to make the three balls rise to the top and remain there for a moment. All patients could identify with this frustrating exercise, devised to keep the lungs clear and get them back to good working order. The last panel showed him collapsing with exhaustion and triumph.

The triumph, of course, belonged also to Jeannie and me. It was a difficult decision just to have the surgery, but now here I was standing at the wall, drawing again, exhilarated with the feeling that I had gone through something I had not been sure I was brave enough to attempt, and that maybe, somehow, drawing cartoons really was what I was meant to do.

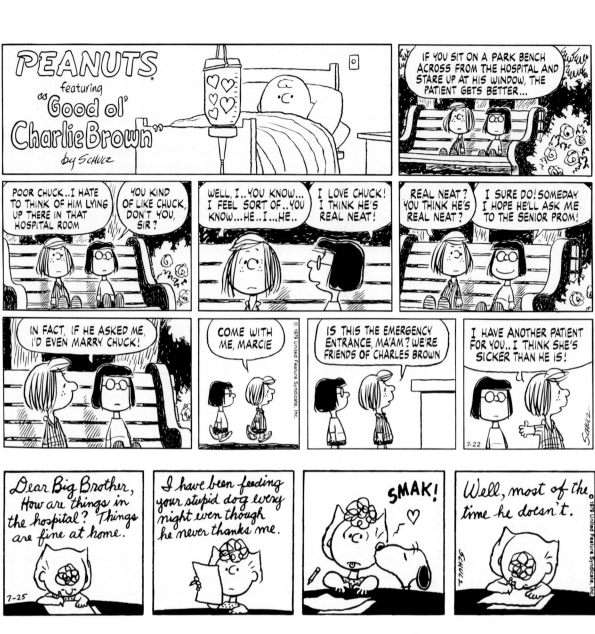

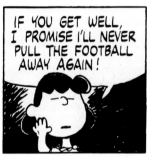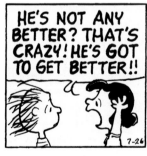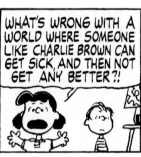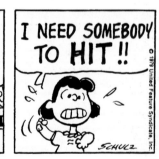

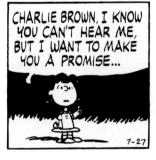

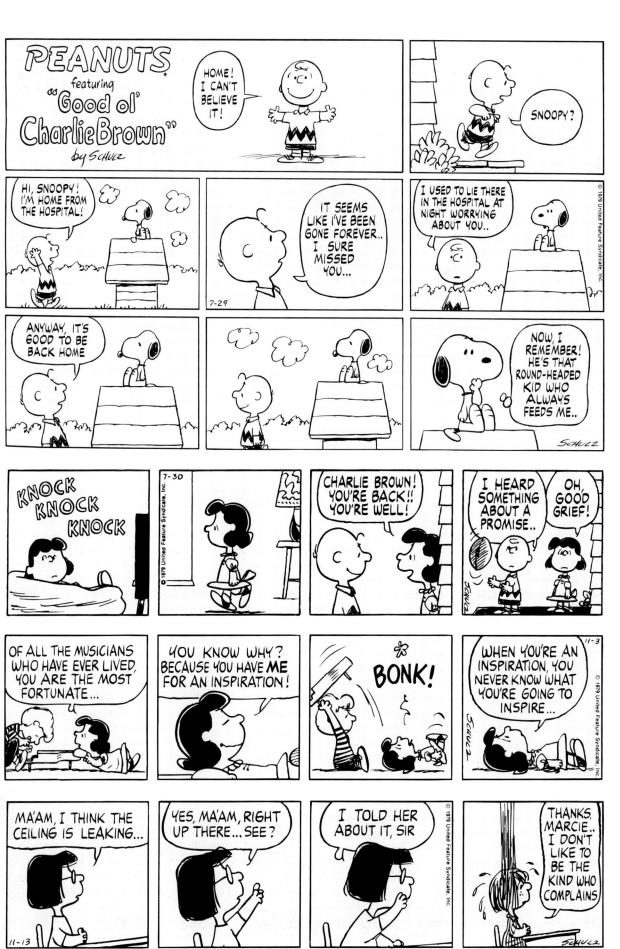

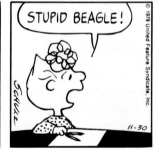

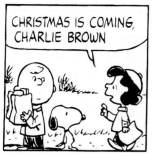 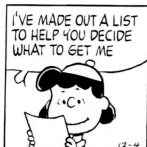 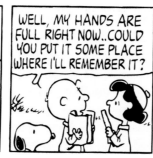

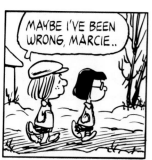

 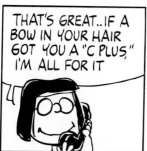 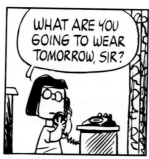 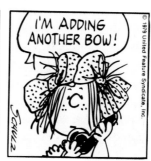

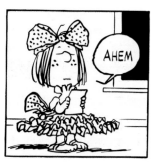

Marcie is Peppermint Patty's best friend. From the moment they met at summer camp, Marcie has called Peppermint Patty "Sir" out of admiration and misguided manners. An unlikely pair, they seem to have nothing in common, yet that is what makes their friendship so genuine. Marcie is the smartest of the *Peanuts* gang, but also the most naive. She's always willing to help out her friend with school work and she's not above sharing test answers or calling her on the phone to remind her of homework assignments. There is an innocence to Marcie, and Peppermint Patty is her protector. Marcie is also completely inept when it comes to sports, yet they still let her play on the baseball team. If Marcie and Peppermint Patty ever have a falling out it's likely to be over Charlie Brown, who they both secretly love.

The 80s

Children do not converse. They say things. They ask, they tell, and they talk, but they know nothing of one of the great joys in life, conversation. Then, along about twelve, give or take a year on either side, two young people sitting on their bicycles near a front porch on a summer evening begin to talk about others that they know, and conversation is discovered. Some confuse conversation with talking, of course, and go on for the rest of their lives, never stopping, boring others with meaningless chatter and complaints.

But real conversation includes asking questions, and asking the right ones before it's too late.

PEANUTS featuring "Good ol' Charlie Brown" by Schulz

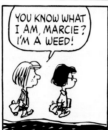

YOU KNOW WHAT I AM, MARCIE? I'M A WEED!

THE WORLD IS FILLED WITH BEAUTIFUL PLANTS AND FLOWERS, BUT I'M JUST AN UGLY WEED

I'M A POOR UGLY WEED TRYING TO PUSH HER WAY UP THROUGH THE SIDEWALK OF LIFE!

THAT'S A GREAT METAPHOR, SIR

DID YOU KNOW THAT WEEDS HAVE A WIDE TOLERANCE FOR ENVIRONMENTAL CONDITIONS AND THE RARE ABILITY TO EXPLOIT RECENTLY DISTURBED TERRAIN?

WHAT IN THE WORLD DOES THAT MEAN?

YOU CAN ROLL WITH THE PUNCHES, SIR!

BY GOLLY, MARCIE, I THINK YOU'RE RIGHT...

I'VE GOT MY CONFIDENCE BACK, MA'AM! ASK ME ANYTHING! GIVE ME YOUR BEST SHOT!!

I'LL BET THE PRINCIPAL WOULD BE SURPRISED TO FIND A WEED GROWING IN FRONT OF HIS OFFICE...

RULERS ARE USED TO MEASURE THINGS AND TO DRAW STRAIGHT LINES...

IN THE OLD DAYS, TEACHERS SOMETIMES USED RULERS TO HIT THEIR PUPILS...

...IN THE OLD DAYS!

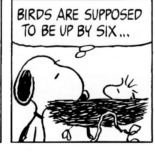
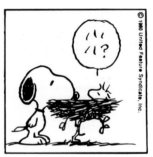
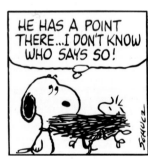

PSST...IT'S ELEVEN O'CLOCK

Z

BIRDS ARE SUPPOSED TO BE UP BY SIX...

/\!?

HE HAS A POINT THERE...I DON'T KNOW WHO SAYS SO!

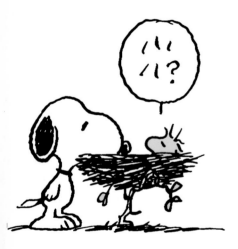

/\!?

PSST! WAKE UP...IT'S ALMOST NOON...

Z

THE EARLY BIRD GETS THE WORM

/\!?

THAT'S TRUE...YOU CAN GET PIZZA UNTIL MIDNIGHT!

The 80s

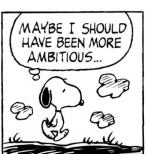

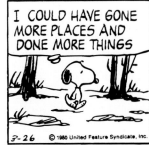

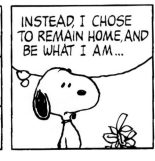

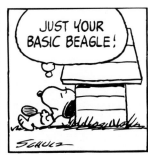

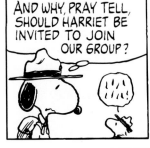

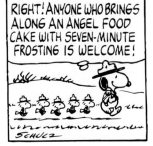

121

The Travels of Charlie Brown

Editor's Note:

Since A Charlie Brown Christmas, *Charles Schulz and Bill Melendez have collaborated on many award-winning programs and features. In 1967 the Television Academy gave three nominations to Bill Melendez; two for producing the outstanding children's program for* Charlie Brown's All-Stars *and for* It's the Great Pumpkin, Charlie Brown *and one for outstanding individual achievement for directing* It's the Great Pumpkin, Charlie Brown. *Since then they have worked on over 75 half-hour Charlie Brown specials, as well as four feature-length motion pictures:* A Boy Named Charlie Brown *(nominated for an Oscar),* Snoopy Come Home, Race for Your Life, Charlie Brown, *and* Bon Voyage, Charlie Brown.

By the way, the stentorian tenor behind Snoopy's vocalizations is the same Bill Melendez.

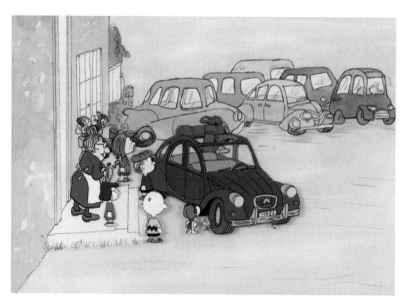

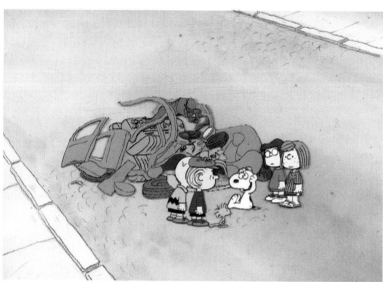

Scenes from Bon Voyage, Charlie Brown.

Bon Voyage, Charlie Brown showed the kids in France as exchange students. The ending was purposely open-ended in case we decided to do something else with them in Europe before their final return home. The last scene showed them bidding their recent friends good-bye, and then piling into the little French car with Snoopy driving, and heading up the road to Paris and the airport. I kept thinking how interesting it might be if they should get lost on this little trip and somehow end up at Omaha Beach and the scenes of the famous D-Day invasion of World War II. I even thought that they might pass through Belgium and we could show some landscapes affected by World War I, and how emotional it could be if one of the characters somehow could be made to recite the immortal poem, John McCrae's *In Flanders Fields.*

None of this fit together in a reasonable way, however, until one night soon after my heart surgery when I was lying awake at about three o'clock in the morning. After your chest has been sawed in half, sleeping on one's back is a definite requirement for at least a few weeks, and of course sleep does not always come as easily in this restricted position. While lying there staring into the dark, I began to think some more about the story line that I wanted for this show. I knew if I could get just one phrase I could tie the whole thing together. All of a sudden the line "What have we learned, Charlie Brown?" came to me. This helped everything else fall into place, and as soon as I got home I called Bill Melendez, the animator, and we agreed that we had something really new and different to add to television cartoon programming.

The Peabody Award we received for *What Have We Learned, Charlie Brown?* was a very gratifying response to the program, plus many wonderful letters from appreciative young viewers who said that they now understood a little better what happened on June 6, 1944. We labeled this show with the subtitle *A Tribute*, because that was exactly what we wanted it to be; no more and certainly no less. It proved also that the characters of Charlie Brown, Linus, Snoopy, and the others were close enough to being real to handle delicately a subject that other animated characters would destroy.

A scene from Flashbeagle

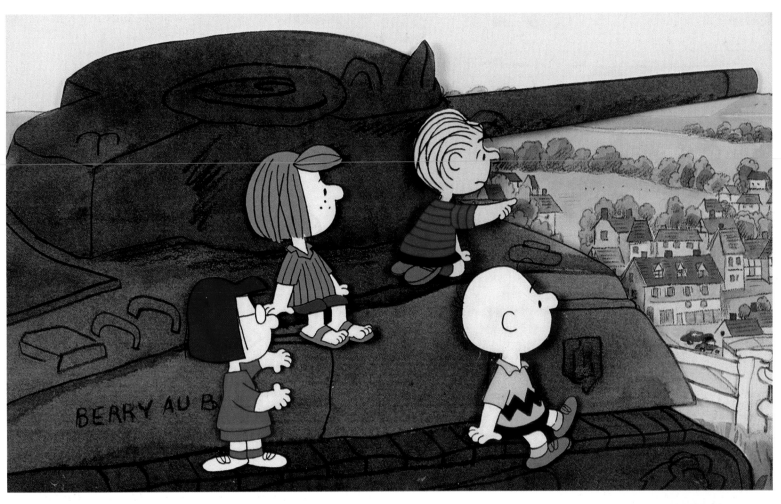

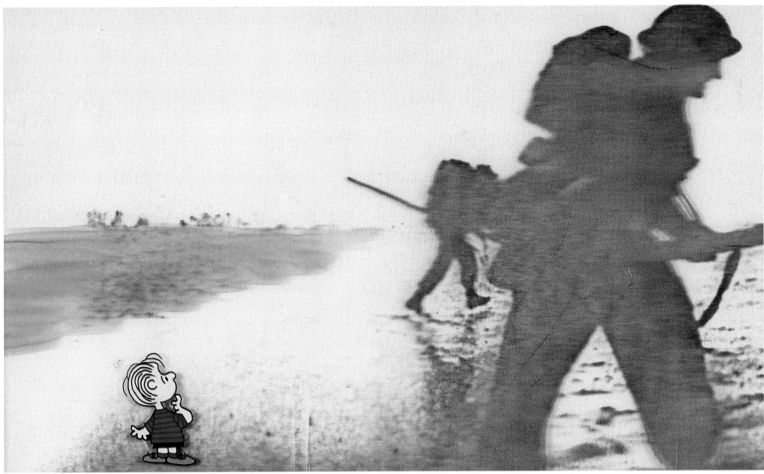

Scenes from What Have We Learned Charlie Brown?

Panel 1: GOOD AFTERNOON... MY NAME IS LUCY..

Panel 2: I'M GOING TO BE YOUR RIGHT-FIELDER...OUR SPECIAL TODAY IS A MISJUDGED FLY-BALL

Panel 3: WE ALSO HAVE A NICE BOBBLED GROUND BALL AND AN EXCELLENT LATE THROW TO THE INFIELD...

Panel 4: I'LL BE BACK IN A MOMENT TO TAKE YOUR ORDER

6-23

Panel 5: HEY, PITCHER, WHY DON'T YOU GIVE THIS GUY THE OL' SCHMUCKLE BALL?

Panel 6: SCHMUCKLE BALL?

Panel 7: JUST SORT OF SCHMUSH YOUR KNUCKLES AROUND THE BALL LIKE THIS, AND THEN THROW IT AS HARD AS YOU CAN...

Panel 8: NOT YET...WAIT 'TIL I GET OUT OF THE WAY!

6-24

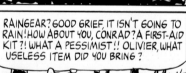

Panel 9: WHAT WAS THAT LAST PITCH YOU THREW, CHARLIE BROWN? THAT GUY MISSED IT A MILE!

Panel 10: THAT WAS THE OL' SCHMUCKLE BALL..LUCY INVENTED IT...

Panel 11: YOU JUST SORT OF SCHMUSH YOUR KNUCKLES AROUND THE BALL LIKE THIS, AND THEN THROW IT AS HARD AS YOU CAN

Panel 12: EVERY TIME IT WORKS I GET A ROYALTY!

6-25

Hiking, camping, and roasting marshmallows over an open fire can revive the writer's dampened spirit. As a Beaglescout, Snoopy boldly hikes into the woods and over the hills, followed by his little feathered friends, Woodstock and pals.

PEANUTS featuring "Good ol' Charlie Brown" by Schulz

EVERYBODY OUT! ON THE DOUBLE!

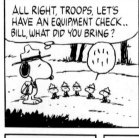
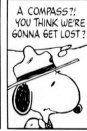
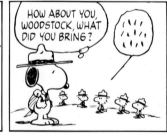

Panel: ALL RIGHT, TROOPS, LET'S HAVE AN EQUIPMENT CHECK.. BILL, WHAT DID YOU BRING?

Panel: A COMPASS?! YOU THINK WE'RE GONNA GET LOST?

Panel: HOW ABOUT YOU, WOODSTOCK, WHAT DID YOU BRING?

Panel: RAINGEAR? GOOD GRIEF, IT ISN'T GOING TO RAIN! HOW ABOUT YOU, CONRAD? A FIRST-AID KIT ?! WHAT A PESSIMIST!! OLIVIER, WHAT USELESS ITEM DID YOU BRING?

Panel: A FLASHLIGHT ?!! DON'T TELL ME YOU'RE AFRAID OF THE DARK?

Panel: ALL RIGHT, HARRIET, HOW ABOUT YOU? WHAT DID YOU BRING?

Panel: AN ANGEL FOOD CAKE WITH SEVEN-MINUTE FROSTING ?!!!

Panel: WELL, I'M GLAD WE HAVE AT LEAST ONE SENSIBLE HIKER IN OUR GROUP!

6-29

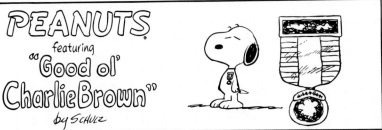

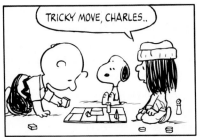

TRICKY MOVE, CHARLES..

IS IT FIVE O'CLOCK ALREADY? I GUESS WE SHOULD GO..

WE'VE HAD A NICE TIME TODAY, EUDORA

GOOD.. I'M GLAD YOU CAME

OH, CHARLES!

MY MOTHER SAID TO TELL YOU THAT YOU HAVE A VERY WELL-BEHAVED DOG...

THANK YOU.. THANK YOU VERY MUCH...

THE ONLY TIME A DOG GETS COMPLIMENTED IS WHEN HE DOESN'T DO ANYTHING!

SO LONG, SCHROEDER... HAVE A NICE TIME AT SUMMER MUSIC CAMP

THANK YOU.. I'M STILL NOT SURE I..

DO YOU WISH TO CHECK YOUR PIANO, SIR?

WELL, I...

THERE YOU GO.. NO PROBLEM!

CHUNK

THIS IS MY PLANE?

FLIGHT FIFTY-FOUR CALLING TOWER

GOOD AFTERNOON, LADIES AND GENTLEMEN.. THIS IS YOUR STEWARDESS SPEAKING..

OUR FLIGHT HAS BEEN DELAYED TEMPORARILY WHILE THE MECHANIC REPAIRS A MINOR PROBLEM..

BAM BAM BAM

KICK KICK KICK

GIVE IT ANOTHER KICK... I THOUGHT IT SOUNDED KIND OF FUNNY ON THE LAST TRIP...

LADIES AND GENTLEMEN, WE ARE NOW READY FOR TAKEOFF...PLEASE FASTEN YOUR SEAT BELTS

ALSO, MAKE SURE THAT YOUR SEAT IS IN AN UPRIGHT POSITION...

I DON'T HAVE A SEAT..

THEN MAKE SURE THE PILOT IS IN AN UPRIGHT POSITION!

125

 I'VE HEARD THAT OUR CAPTAIN WAS A FIGHTER PILOT DURING THE WAR...

 I DON'T SUPPOSE THOSE EXPERIENCES ARE EASILY FORGOTTEN...

 CURSE YOU, RED BARON!

 NO, I GUESS NOT

 GOOD AFTERNOON, LADIES AND GENTLEMEN..WE ARE ABOUT TO SERVE LUNCH..

 WE WOULD LIKE TO GIVE YOU A CHOICE BETWEEN RACK OF LAMB AND BEEF BORDELAISE

 BUT WE CAN'T

 SO HOW ABOUT A BANANA?

 OUR IN-FLIGHT MOVIE TODAY WILL BE "CITIZEN KANE"

 MOVIE? WE GET TO SEE A MOVIE?

 WELL, IT ISN'T EXACTLY A MOVIE..

 "ROSEBUD!"

 I MUST ADMIT THIS HAS BEEN A VERY SMOOTH FLIGHT SO FAR

 YES, BUT IT PROBABLY WOULD HAVE BEEN BETTER IF...

 ..YOU HADN'T MENTIONED IT!

 LADIES AND GENTLEMEN, WE WILL BE LANDING SHORTLY..THE CAPTAIN HAS TURNED ON THE "NO SMOKING" SIGN... I HAVE?

 PLEASE BE SURE YOUR SEAT IS IN AN UPRIGHT POSITION AND ALL HAND-LUGGAGE IS STORED UNDER THE SEAT IN FRONT OF YOU

 IT HAS BEEN A PLEASURE SERVING YOU..THANK YOU FOR FLYING "ACE AIRLINES"..HAVE A NICE DAY!

 WHERE ARE WE?

 LADIES AND GENTLEMEN, WE HAVE ARRIVED AT OUR DESTINATION... CLICK SNAP SWITCH

 PLEASE REMAIN SEATED UNTIL THE AIRCRAFT HAS COME TO A STOP...

 KLUNK!

DON'T MIND HIM, SIR.. HE FAINTS AFTER EVERY LANDING!

GOODBYE, SIR.. DID YOU ENJOY THE FLIGHT? / YES, THANK YOU

NO, I'M SORRY..I NEVER DATE THE PASSENGERS

I DIDN'T ASK FOR A DATE! WHERE'S "BAGGAGE RETURN"? WHERE'S MY PIANO?

BONK!!

STAY RIGHT WHERE YOU ARE, OR I'LL POUND YOU!

THIS IS GOING TO BE HARD TO DO...

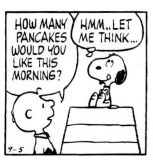

HOW MANY PANCAKES WOULD YOU LIKE THIS MORNING? / HMM..LET ME THINK...

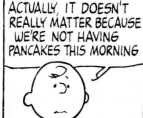

ACTUALLY, IT DOESN'T REALLY MATTER BECAUSE WE'RE NOT HAVING PANCAKES THIS MORNING

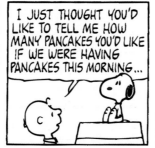

I JUST THOUGHT YOU'D LIKE TO TELL ME HOW MANY PANCAKES YOU'D LIKE IF WE WERE HAVING PANCAKES THIS MORNING...

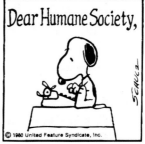

Dear Humane Society,

YOU KNOW WHAT YOU NEED TO DO? YOU NEED TO LEARN TO OBEY COMMANDS

SIT!

LAW AND LAWYERS ARE ALWAYS WITH US

WE ALL HAVE TO DEAL WITH THE LAW FROM THE VERY DAY WE'RE BORN

THAT'S TRUE

JUST LAST WEEK I SUED A BABY!

TOMORROW IS BEETHOVEN'S BIRTHDAY

SOME OF THE GREATEST MUSIC IN ALL THE WORLD WAS WRITTEN BY BEETHOVEN!

NO, HE WASN'T A BIRD!

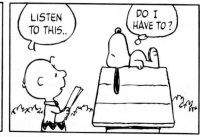
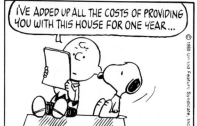

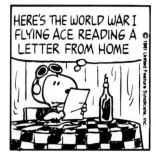
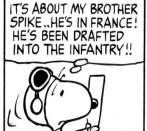
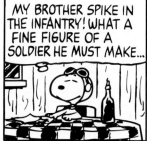
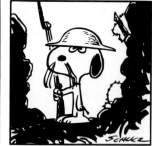

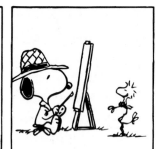
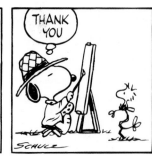

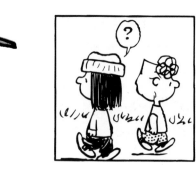
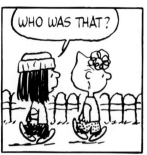

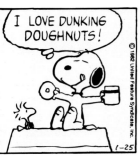

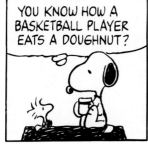

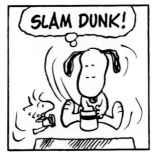

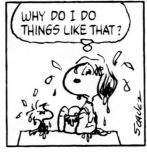

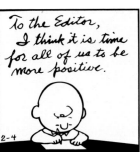

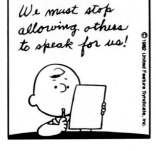

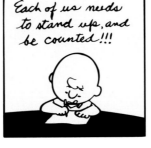

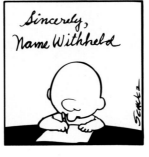

The 80s

When I was in the sixth grade, there would frequently be interruptions in our class as a particular boy was suddenly ordered to go to the principal's office. Soon he would return with a nice grin on his face, wearing a striking leather belt with an attached shoulder strap and a silver badge. Everyone in the class would applaud, for it meant that he had been chosen to be on the school patrol. I never achieved this honor, probably because I was not considered forceful enough, and was also either the smallest or the next-to-the-smallest kid in class. I did get to be substitute, however, but that never rated the leather Sam Browne belt. Girls were never chosen. Somehow, not being chosen bothered me only a little. I simply decided that I was not quite good enough, and let it go at that. It would have been nice, though, to have walked into the class with that leather belt.

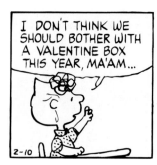
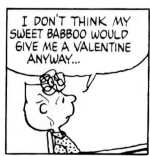
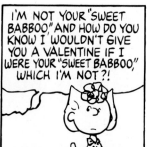

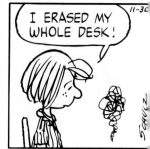

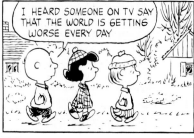
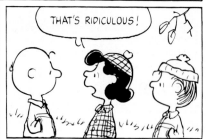
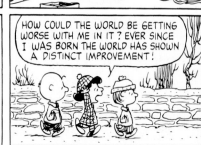

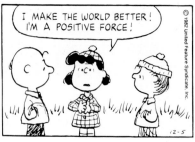
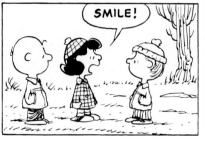
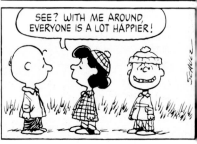

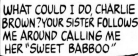

WHY DO WE ALWAYS TEACH LITTLE KIDS TO WAVE "BYE-BYE"?

BECAUSE FOR THE REST OF HIS LIFE PEOPLE WILL BE LEAVING HIM

HELLO, THERE!

WHAT COULD I DO, CHARLIE BROWN? YOUR SISTER FOLLOWS ME AROUND CALLING ME HER "SWEET BABBOO"

I NEVER SAID I WAS GOING TO GIVE HER A VALENTINE! IT WAS ALL IN HER IMAGINATION!

SO IF YOU STILL WANT TO PUNCH ME IN THE NOSE, GO RIGHT AHEAD!

WHY DON'T I JUST HOLD MY FIST OUT, AND THEN YOU WALK INTO IT?

I FEEL GRUMPY TODAY.. I DON'T WANT TO TALK TO ANYBODY OR SEE ANYBODY!

I'LL HOLD MY FIST OUT, LINUS, AND YOU WALK INTO IT...

GET OUT OF MY WAY!

BONK!

DID IT HURT?

NO, BUT IT MIGHT LATER IF WE STICK AROUND

PEANUTS featuring "Good ol' Charlie Brown" by Schulz

WHAT ARE YOU THINKING ABOUT, CHARLIE BROWN?

AM I WRONG OR DID THERE USED TO BE MORE TREES THAN THERE ARE NOW?

THEY SAY THAT WHEN THE COLONISTS FIRST CAME TO THIS COUNTRY, A SQUIRREL COULD TRAVEL TREETOP TO TREETOP FROM THE ATLANTIC TO THE MISSISSIPPI RIVER WITHOUT EVER TOUCHING THE GROUND...

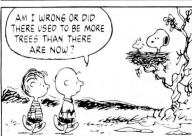

EITHER THAT WAS A LONG TIME AGO, OR THAT WAS SOME SQUIRREL!

BONK! BONK!

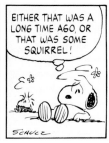

The 80s

It is interesting to observe that many of the lead characters in our most successful comic strips have had similar personalities. Readers are generally sympathetic toward a lead character who is rather gentle, sometimes put upon, and not always the brightest person. Perhaps this is the kind of person who is easiest to love. I really don't know. It may also be that giving the supporting characters the most distinct personalities makes for a more controllable story. A character with more of a "middle-ground" personality can hold the rest of the group together. In the cast of *Peanuts*, I like to have Charlie Brown eventually be the focal point of almost every story. No matter what happens to any of the other characters, somehow Charlie Brown is involved at the end and usually is the one who brings disaster upon one of his friends or receives the brunt of the blow. Charlie Brown has to be the one who suffers, because he is a caricature of the average person. Most of us are much more acquainted with losing than we are with winning. Winning is great, but it isn't funny. While one person is a happy winner, there may be a hundred losers using funny stories to console themselves.

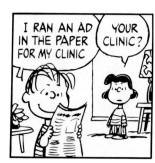
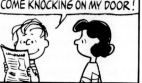

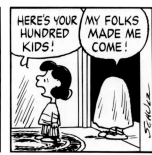

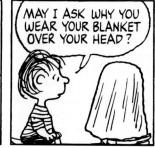
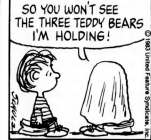

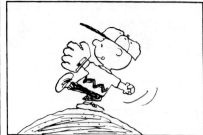

PEANUTS featuring "Good ol' Charlie Brown" by Schulz

MY REPORT? I'M SORRY, MA'AM, IT'S IN MY BINDER, AND MY BINDER IS CAUGHT IN MY HAIR...

I DON'T KNOW... I FELL ASLEEP LAST NIGHT DOING MY HOMEWORK, AND THERE IT WAS

I'VE TRIED WHIPPING IT BACKWARD AND FORWARD...

BONK!

© 1983 United Feature Syndicate, Inc.

BONK!

BUT NOTHING SEEMS TO HELP

ANYWAY, MY REPORT WAS CALLED, "DOES EDUCATION HAVE TO BE PAINFUL?" I THINK MAYBE IT DOES..

6-5

BEAUTIFUL, ISN'T IT?

MAYBE, WHEN WE GET BACK, YOU CAN SELL SOME OF YOUR PHOTOGRAPHS TO A WILDLIFE MAGAZINE...

© 1983 United Feature Syndicate, Inc. 6-27

WHAT'S WILDLIFE? YOU'RE WILDLIFE

I'M WHAT YOU CALL SEMI-WILDLIFE

WOW! LOOK AT THAT!

YOU SHOULD GET A SHOT OF THAT TREE, OLIVIER...TRY f/8 AT 1/125....OKAY?

YOU MIGHT ALSO WANT TO USE A TRIPOD...

6-28

ME AND MY SUGGESTIONS..

© 1983 United Feature Syndicate, Inc.

I HATE EVERYTHING! I HATE THE WHOLE WORLD!

I THOUGHT YOU HAD INNER PEACE

I DO

© 1983 United Feature Syndicate, Inc.

BUT I STILL HAVE OUTER OBNOXIOUSNESS!

9-1

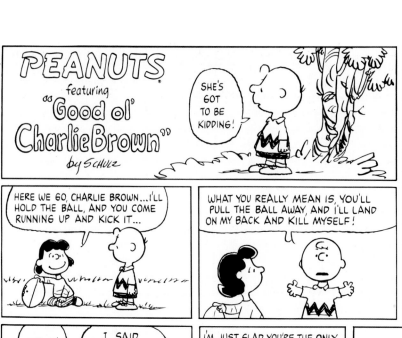

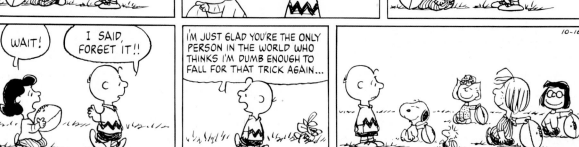

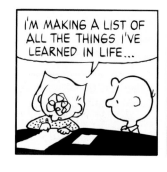
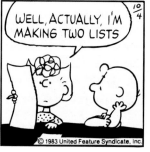
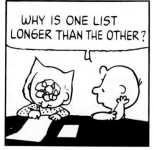
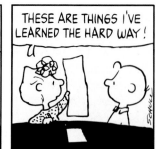

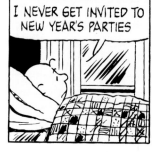
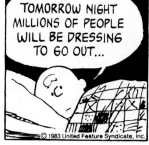
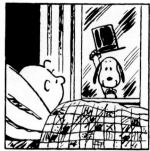

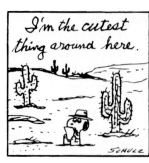

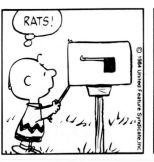

RATS!

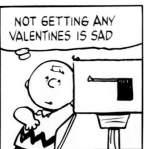

NOT GETTING ANY VALENTINES IS SAD

THERE'S ONLY ONE THING WORSE..

GETTING YOUR HEAD CAUGHT IN THE MAILBOX!

LOOK, MARCIE, I GOT A FORTUNE COOKIE IN MY LUNCH...

IT SAYS, "YOU ARE GOING TO GET AN IMPORTANT LETTER"

IT WAS RIGHT... I GOT AN IMPORTANT LETTER THIS MORNING...

A "D MINUS"!

Dear Chuck, Well, your ol' friend Patty is here in Paris.

Show Snoopy this picture of me drinking root beer in a sidewalk cafe.

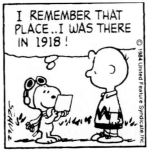

I REMEMBER THAT PLACE..I WAS THERE IN 1918!

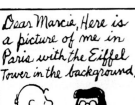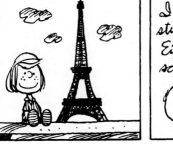

Dear Marcie, Here is a picture of me in Paris with the Eiffel Tower in the background.

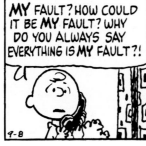

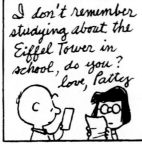

I don't remember studying about the Eiffel Tower in school, do you? love, Patty

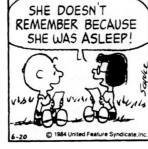

SHE DOESN'T REMEMBER BECAUSE SHE WAS ASLEEP!

GUESS WHAT, CHUCK ... THE FIRST DAY OF SCHOOL, AND I GOT SENT TO THE PRINCIPAL'S OFFICE.. IT WAS YOUR FAULT, CHUCK!

MY FAULT? HOW COULD IT BE MY FAULT? WHY DO YOU ALWAYS SAY EVERYTHING IS MY FAULT?!

YOU'RE MY FRIEND, AREN'T YOU, CHUCK?

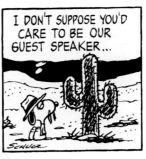

YOU SHOULD HAVE BEEN A BETTER INFLUENCE ON ME!

I'M ALSO PROGRAM CHAIRMAN FOR THE LOCAL CACTUS CLUB...

WE'RE MEETING OUT HERE TOMORROW NIGHT

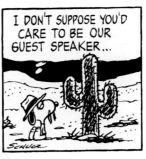

I DON'T SUPPOSE YOU'D CARE TO BE OUR GUEST SPEAKER...

When I was in the first grade, the teacher put a valentine box on a table in front of the room. It was two days before Valentine's Day and we were to bring to school the cards we wanted to give to the kids we liked. Obviously, there were some I liked more than others, but because I didn't wish to offend anyone, I made out a list that included everyone. My mother helped me select all the cards, and I took them to school the next day. Classrooms are pretty big to a first grader, and it was a long walk from where I sat up to the front of the room where the valentine box waited. Everyone could watch you as you walked to the front of the room and dropped each card through the slit on top of the box.

I couldn't do it. I took all the valentines home.

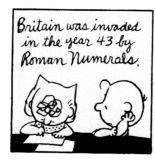 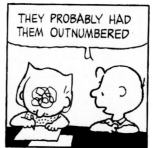

 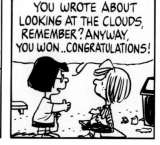 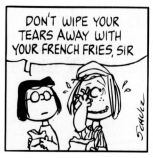

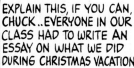
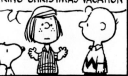

For two years the narcolepsy people at Stanford University were after me to do something on narcolepsy. They said, "Peppermint Patty shouldn't be falling asleep in school like she does. It's not normal. We think she should be sent to a sleep-disorder center." Well, I thought, that's fine, but how do you break that down into daily episodes?

So I asked them to let me think about it, and they sent me all sorts of material on narcolepsy. I would read it and nothing would happen. But finally after a couple of years I began to see how I could have it work out. As your characters begin to shift and do different things, you can begin to work with them in ways that you didn't use before.

The narcolepsy people were overjoyed. They thought that this was the greatest thing that ever had happened. They wanted to reprint the strips in their literature. And they wrote me grateful letters. But then I got a letter from another narcolepsy person saying, "We're outraged. You insulted us. If you knew what it was to have narcolepsy...."

The 80s

This Sunday page was inspired by the memory of a strange high-command order—an order whose short life was proof of its impracticality. A few weeks after the Sunday page appeared, I was astounded to receive a letter from a retired colonel who proudly announced that he was the officer who originated the regulation. Apparently, it was an attempt to solve an epidemic of athlete's foot by forcing the men to change shoes and socks each day.

He admitted to receiving much "good-natured ribbing" as he traveled in the field with an inspection team. I couldn't resist telling him that we had always regarded it as one of the dumbest orders ever received.

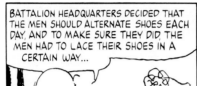

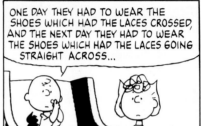

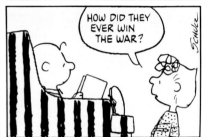

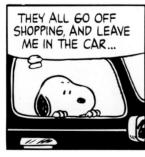

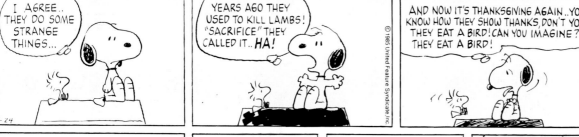

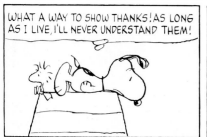

This Sunday cartoon elicited the letter reproduced on the following page.

Nov. 31, 1985

Mr. Charles Schulz
c/o United Features Syndicate
New York, New York

Dear Mr. Schulz:

It was widely rumored in the Christian community that you were a Christian. Were you? When did you stop, and decide that the Bible was laughable?

I'm referring to the strip which mocked the sacrifice mandated by Almighty God for atonement in the Old Testament, which was a type of Jesus Christ's sacrifice in the New. (Nov. 24).

I'm wondering if you have been caught up in a New Age type of deception, where vegetarianism mixes with Eastern philosophy and denies an omnipotent God in heaven Who demands to be worshipped. Such philosophies make gods out of men, with the lie that we can all find "god within". Is this what happened to you?

Sir, even if your personal philosophy is at odds with the majority of this country which was founded on the Judeo-Christian ethic, can you not control your urge to lead astray our little ones and proselytyze instead your adult peers who can better defend themselves? Sneaking your anti-Jewish, anti-American philosophy into the minds of hapless children via a comic strip is just plain dirty pool. I would not want to be in your shoes on judgement day. Jesus Christ said that people who lead astray His little ones should be cast into the sea with a millstone tied around their necks. An apology is due America.

As Linus asked of himself, "What was that all about?"

140

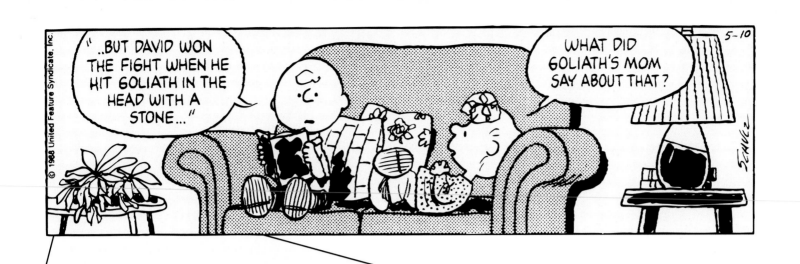

May 12, 1988

Dear Mr. Schulz:

It is because occasionally I find an extraordinary gem like the above that I still read the comics at age 67.

You have done your readers a distinct service by subtly suggesting that they look behind the scenes.

So, "What did Goliath's mother say . . .? " I seriously doubt if Goliath had a mother worthy of the name. He swaggered and bullied in order to compensate for the lack of security which genuine mother love would have given him.

My guess is that the only grief over Goliath's death was in the camp of the Philistines, and their mourning was for themselves rather than for Goliath, for they no longer had him to fight their battles for them.

Long live Charles M. Schulz and <u>Peanuts</u>! This ~~ad~~ and groggy world desperately needs the pleasure ~~nd~~ stimulus you give it.

I consider that children posssess some highly refined moral convictions and are quite capable of expressing them with humorous results. The strip of Charlie Brown reading a Bible story to his sister Sally caused some comments, like this letter at the left.

And I got a letter from a woman saying, "Well, it probably served Goliath right, because he was hanging out with the wrong crowd, and she wasn't much of a mother anyway."

141

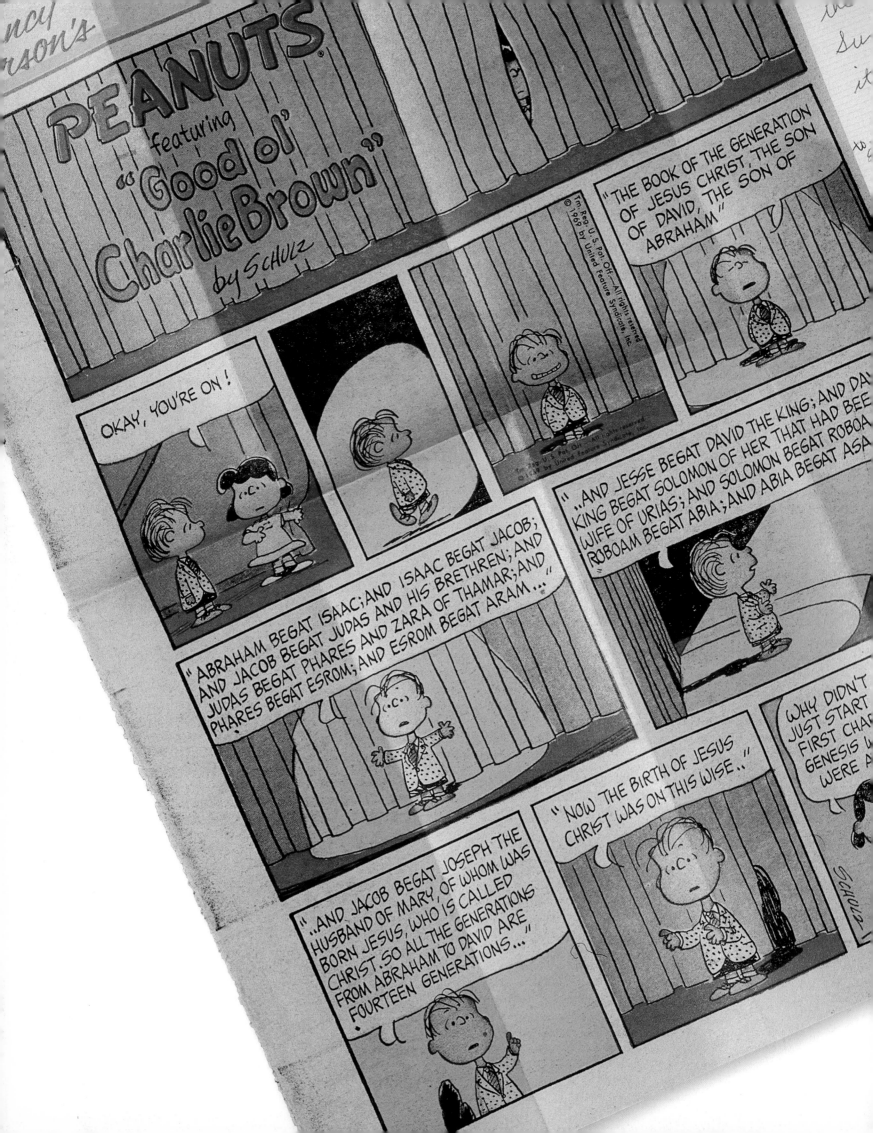

Mr. Charles Schulz
United Features Syndicate
200 East 42nd Street
New York City, N.Y. 10017

Dear Sir:

Enclosed herewith is copy of the comic-strip "Peanuts" as it appeared in the Boston Herald Traveler yesterday, December 21st, 1969.

I believe it is in unexcusably poor taste, and offensive to many readers both Christian and Jewish, to use texts from and references to the Bible — both Old and New Testaments — especially in a comic strip and at this particular time of the year. I write to register my own extreme irritation at your comic strip of December 21st, 1969.

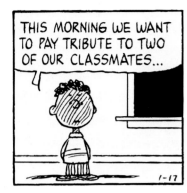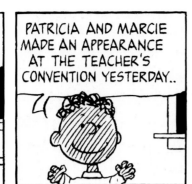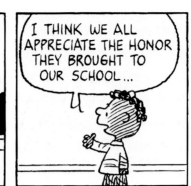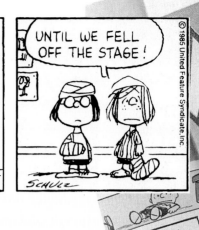

THIS MORNING WE WANT TO PAY TRIBUTE TO TWO OF OUR CLASSMATES...

PATRICIA AND MARCIE MADE AN APPEARANCE AT THE TEACHER'S CONVENTION YESTERDAY..

I THINK WE ALL APPRECIATE THE HONOR THEY BROUGHT TO OUR SCHOOL...

UNTIL WE FELL OFF THE STAGE!

November 12, 1969

United Feature Syndicate
220 East 42nd Street
New York, N.Y. 10017

Gentlemen:

In today's "Peanuts" comic strip Negro and white children are portrayed together in school.

School integration is a sensitive subject here, particularly at this time when our city and county schools are under court order for massive compulsory race mixing.

We would appreciate it if future "Peanuts" strips did not have this type of content.

Thank you.

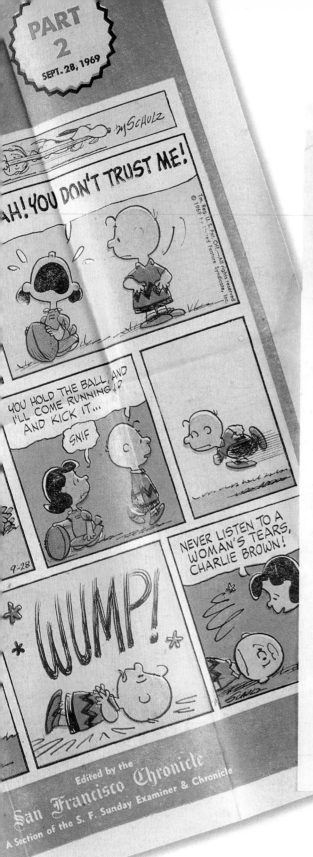

Mr Charles Schultz:

C/o San Francisco Chronicle,

San Francisco, Calif.

Dear Mr Schultz.

What I have to say is said with _love_ and as a _Christian_. Your Comic strip of Sept. 28, 1969 IS SADISTIC. You have thousands of well meaning children reading "Peanuts" I is _sad_ that you must _print_ a lie in order to get a _laugh_.

Revelations 21: 7-8 "He that over cometh shall inherit those things; and I will be his God and He shall be my son. 8 But for the fearful, and unbeliving, and abomination, and murderers, and fornicators, and sorcerers, and idolaters, _AND ALL LIARS_, and _THEIR PART_ shall be in the _Lake that Burneth_ with _Fire and Brimstone_: _which is the second Death_."

You are too good a man to print a comic like this one. Think of the price you are going to pay and those you take with you.

His was a story that had to be told.

Well, maybe not.

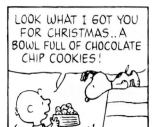
LOOK WHAT I GOT YOU FOR CHRISTMAS.. A BOWL FULL OF CHOCOLATE CHIP COOKIES!

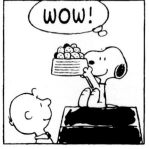
WOW!

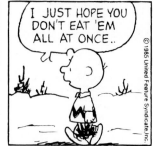
I JUST HOPE YOU DON'T EAT 'EM ALL AT ONCE..

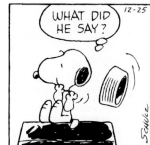
WHAT DID HE SAY?

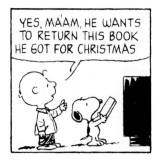
YES, MA'AM, HE WANTS TO RETURN THIS BOOK HE GOT FOR CHRISTMAS

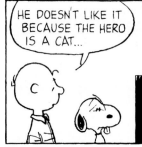
HE DOESN'T LIKE IT BECAUSE THE HERO IS A CAT...

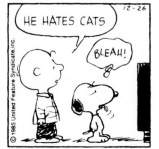
HE HATES CATS
BLEAH!

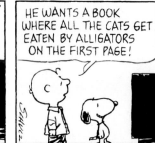
HE WANTS A BOOK WHERE ALL THE CATS GET EATEN BY ALLIGATORS ON THE FIRST PAGE!

Spike is the loner brother of Snoopy and lives out in the desert near Needles, California. Though most of his time is spent lying on rocks, talking to cacti, and writing letters to Snoopy, he has left the desert on occasion. Most of the time the reason for his outings is either a trip to look for chicks in Needles or a visit to his brother. Spike doesn't really smile much, since there's not much to smile about in the desert, but he seems to have a good time just the same.

Dear

I miss you more each day. I love you more than words can say.

THAT'S NICE, BUT WHO ARE YOU WRITING TO?

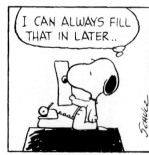
I CAN ALWAYS FILL THAT IN LATER..

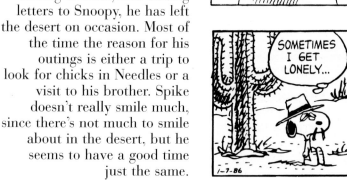
SOMETIMES I GET LONELY...

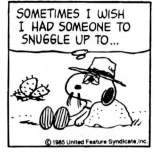
SOMETIMES I WISH I HAD SOMEONE TO SNUGGLE UP TO...

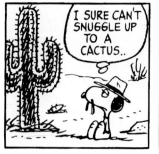
I SURE CAN'T SNUGGLE UP TO A CACTUS..

TUMBLEWEEDS DON'T DO MUCH FOR ME, EITHER!

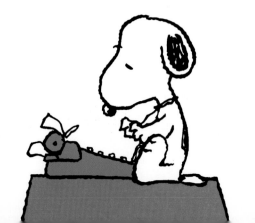

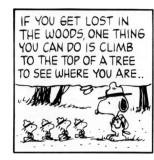

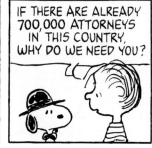

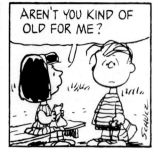

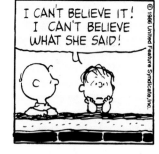
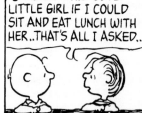
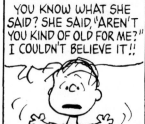
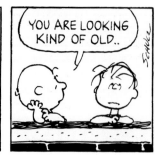

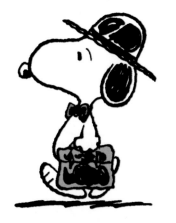

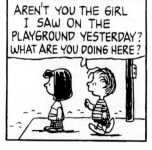
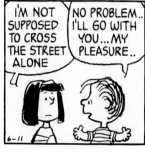

ALL RIGHT, THAT DOES IT!

JUST ANSWER ME THIS ONE QUESTION..

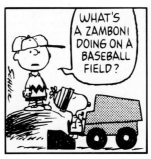
I THINK I HAVE A RIGHT TO KNOW

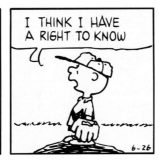
WHAT'S A ZAMBONI DOING ON A BASEBALL FIELD?

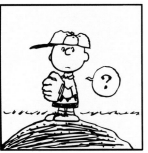
?

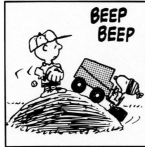
BEEP BEEP

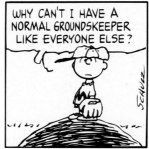

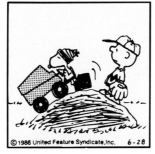
WHY CAN'T I HAVE A NORMAL GROUNDSKEEPER LIKE EVERYONE ELSE?

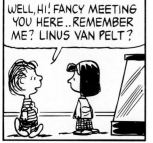
WELL, HI! FANCY MEETING YOU HERE.. REMEMBER ME? LINUS VAN PELT?

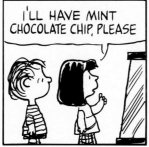
I'LL HAVE MINT CHOCOLATE CHIP, PLEASE

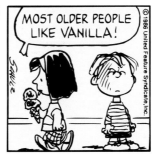
I'LL HAVE THE SAME, PLEASE... YOU LIKE MINT CHOCOLATE CHIP? I'M SURPRISED...

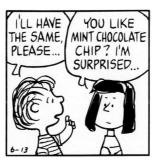
MOST OLDER PEOPLE LIKE VANILLA!

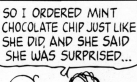
SO I ORDERED MINT CHOCOLATE CHIP JUST LIKE SHE DID, AND SHE SAID SHE WAS SURPRISED...

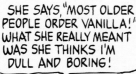
SHE SAYS, "MOST OLDER PEOPLE ORDER VANILLA!" WHAT SHE REALLY MEANT WAS SHE THINKS I'M DULL AND BORING!

I'VE ALWAYS LIKED VANILLA

THAT WAS GREAT! THAT WAS JUST GREAT!!

HERE I AM TRYING TO CONVINCE THIS GIRL I'M NOT TOO OLD FOR HER, AND YOU TELL HER THAT I STILL HAVE A BLANKET!

WHAT CAN I SAY? DON'T SAY ANYTHING!

I'M GOOD AT THAT..

MAY I SPEAK TO YOU ABOUT MY FRIEND HERE?

I THINK YOU'RE WRONG ABOUT HIS BEING TOO OLD FOR YOU..

IN MANY WAYS, HE'S STILL QUITE YOUNG..

I MEAN, YOU SHOULD SEE HIM WITH HIS BLANKET.. AAUGH!

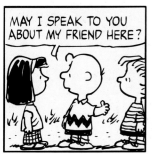
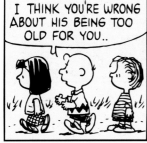
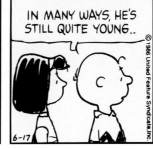
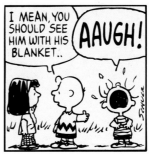

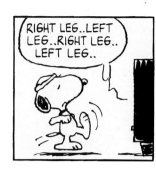
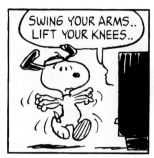
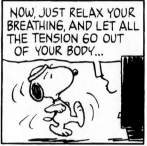

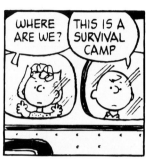

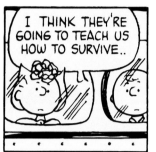

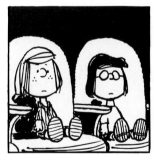

BEING A WORLD FAMOUS ATTORNEY MUST BE AN ENORMOUS RESPONSIBILITY...

I MEAN, YOU MUST HAVE CLIENTS COMING TO YOU EVERY DAY WHO NEED ADVICE..

DO YOU HAVE A TERRIBLE FEELING OF RESPONSIBILITY WHEN YOU TALK TO THEM?

NO, I'VE NEVER HAD A CLIENT LISTEN TO ME!

PEANUTS featuring "Good ol' Charlie Brown" by Schulz

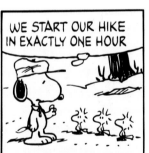

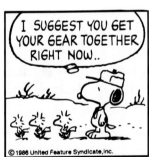

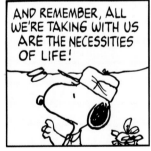

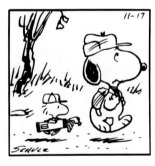
WE START OUR HIKE IN EXACTLY ONE HOUR

I SUGGEST YOU GET YOUR GEAR TOGETHER RIGHT NOW..

AND REMEMBER, ALL WE'RE TAKING WITH US ARE THE NECESSITIES OF LIFE!

Dear Gramma,

Thank you for the very nice Christmas present.

It was just what I wanted.

What was it?

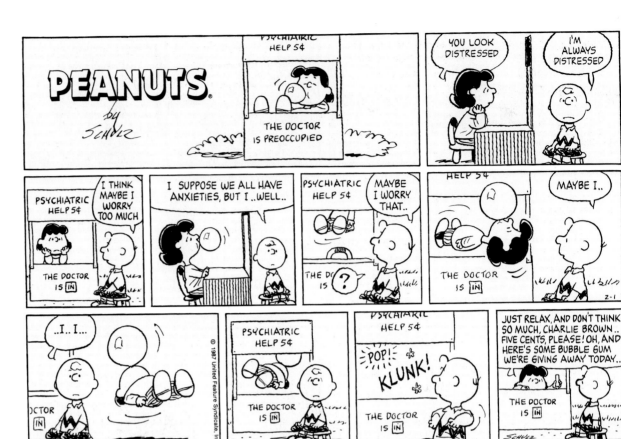

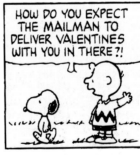

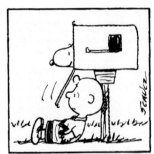

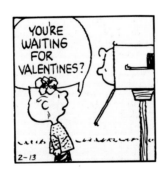

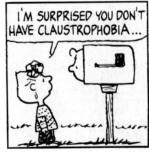

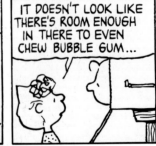

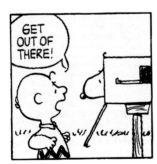

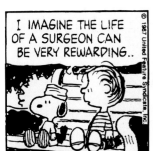

I IMAGINE THE LIFE OF A SURGEON CAN BE VERY REWARDING..

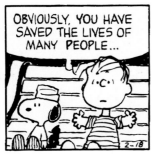

OBVIOUSLY, YOU HAVE SAVED THE LIVES OF MANY PEOPLE...

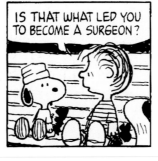

IS THAT WHAT LED YOU TO BECOME A SURGEON?

NO, I JUST LIKED THE LITTLE GREEN BOOTIES!

AS A WORLD FAMOUS SURGEON, DO OTHER DOCTORS OFTEN ASK FOR YOUR ADVICE?

OH, YES.. ALL THE TIME...

JUST THE OTHER DAY DR. WICK ASKED FOR MY ADVICE...

I SAID, "WELL, IT'S ABOUT A HUNDRED AND THIRTY YARDS..YOU'D BETTER HIT THE EIGHT IRON"

WHERE'S MY BASEBALL GLOVE? IT'S ALMOST BASEBALL TIME AGAIN..

I HOPE HE'S FORGOTTEN HE HUNG ME IN THE CLOSET...

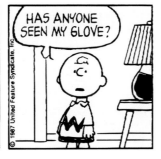

HAS ANYONE SEEN MY GLOVE?

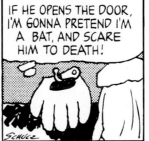

IF HE OPENS THE DOOR, I'M GONNA PRETEND I'M A BAT, AND SCARE HIM TO DEATH!

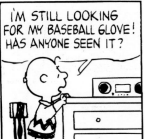

I'M STILL LOOKING FOR MY BASEBALL GLOVE! HAS ANYONE SEEN IT?

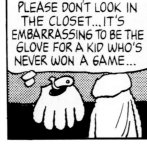

PLEASE DON'T LOOK IN THE CLOSET...IT'S EMBARRASSING TO BE THE GLOVE FOR A KID WHO'S NEVER WON A GAME...

AND MY BASEBALL CAP.. HAS ANYONE SEEN MY CAP?

SHH! DON'T TELL HIM I'M HERE UNDER THE COAT..

ALL RIGHT, MEN, THIS IS GOING TO BE A LONG HARD MARCH..

FORT ZINDERNEUF IS AT LEAST A HUNDRED MILES AWAY..ARE THERE ANY QUESTIONS?

WHY DON'T WE TAKE A 747?

SERGEANTS IN THE FOREIGN LEGION DON'T ANSWER QUESTIONS LIKE THAT!

LOOK WHAT YOU DID... YOU MADE FOOTPRINTS IN ALL THE SAND TRAPS!

JUST MARCHING THROUGH ONE WOULD HAVE BEEN BAD ENOUGH...

DID YOU HAVE TO MARCH THROUGH EVERY SAND TRAP ON THE GOLF COURSE?!

IT WAS A LONG WAY TO FORT ZINDERNEUF!

As I have said, the highlight of our lives was, of course, Saturday afternoons, going to the local movie theater. We would buy a box of popcorn for a nickel from a popcorn shop a few stores down from the theater and then we'd go to the afternoon matinee. A favorite movie, I still remember, was *The Lost Patrol* with Victor McLaglen. In another, he was the evil legionnaire post commandant in *Under Two Flags*. In the summertime we either played baseball in the schoolyard or used its sandy wastes as the Sahara Desert. That's why I liked to imagine Snoopy as the tough foreign legionnaire Sgt. Lejaune who always leads the birds through sand traps on the golf course.

153

HERE'S THE WORLD WAR I FLYING ACE LOOKING FOR HIS BROTHER...

SPIKE IS IN THE INFANTRY

I'M SURE HIS NATURAL COURAGE IS AN INSPIRATION TO EVERYONE AROUND HIM..

WHEN DO WE GO HOME?

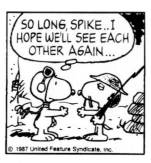
SO LONG, SPIKE..I HOPE WE'LL SEE EACH OTHER AGAIN...

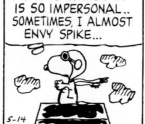
FIGHTING IN THE AIR IS SO IMPERSONAL.. SOMETIMES, I ALMOST ENVY SPIKE...

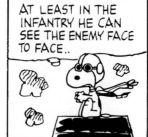
AT LEAST IN THE INFANTRY HE CAN SEE THE ENEMY FACE TO FACE..

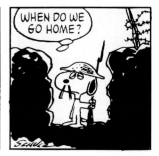
WHEN DO WE GO HOME?

IT'S HIM ALL RIGHT

PEANUTS

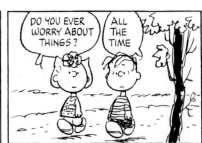
DO YOU EVER WORRY ABOUT THINGS? — ALL THE TIME

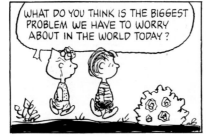
WHAT DO YOU THINK IS THE BIGGEST PROBLEM WE HAVE TO WORRY ABOUT IN THE WORLD TODAY?

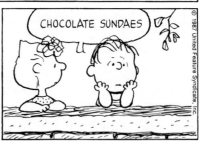
CHOCOLATE SUNDAES

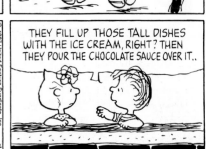
THEY FILL UP THOSE TALL DISHES WITH THE ICE CREAM, RIGHT? THEN THEY POUR THE CHOCOLATE SAUCE OVER IT..

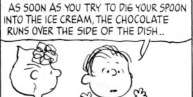
AS SOON AS YOU TRY TO DIG YOUR SPOON INTO THE ICE CREAM, THE CHOCOLATE RUNS OVER THE SIDE OF THE DISH..

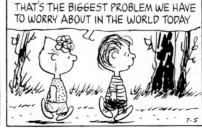
THAT'S THE BIGGEST PROBLEM WE HAVE TO WORRY ABOUT IN THE WORLD TODAY

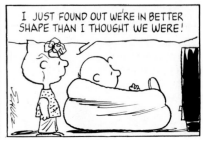
I JUST FOUND OUT WE'RE IN BETTER SHAPE THAN I THOUGHT WE WERE!

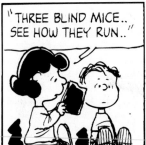
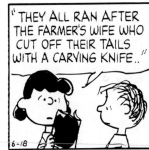
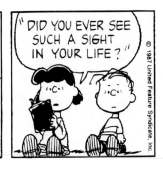
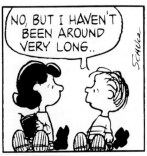

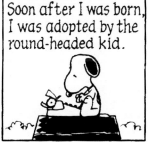
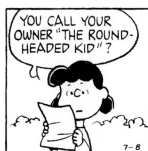
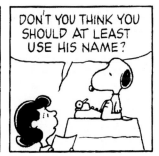
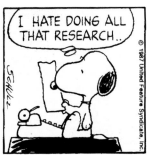

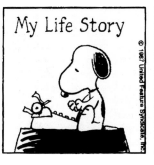
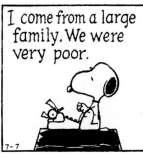
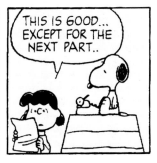

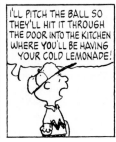
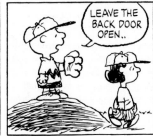

MR. BROWN, MY NAME IS LELAND..WE'D LIKE TO PLAY FOR YOUR FOOTBALL TEAM

I DON'T HAVE A FOOTBALL TEAM, LELAND

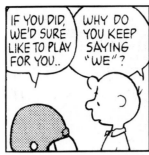

IF YOU DID, WE'D SURE LIKE TO PLAY FOR YOU..

WHY DO YOU KEEP SAYING "WE"?

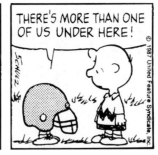

THERE'S MORE THAN ONE OF US UNDER HERE!

The 80s

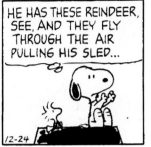

HE HAS THESE REINDEER, SEE, AND THEY FLY THROUGH THE AIR PULLING HIS SLED...

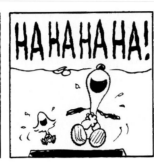

AND IF YOU BELIEVE THAT, I HAVE A GOLD BIRD NEST THAT I'LL SELL YOU FOR A DOLLAR!

HA HA HA HA!

MERRY CHRISTMAS, LITTLE FRIEND..

ROAD NARROWS

© 1987 United Feature Syndicate, Inc.

PEANUTS

PSST! BIG BROTHER! WAKE UP! THERE'S SOMEONE IN OUR BACK YARD!

THAT'S JUST A SNOWMAN..

WELL, I CAN'T SLEEP WITH HIM STANDING OUT THERE... IT MAKES ME NERVOUS..

BRING ME HIS HEAD SO I'LL KNOW HE'S NOT STILL ALIVE!

GOOD GRIEF!

 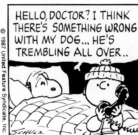

WHAT'S GOING ON? I HEAR PEOPLE TALKING...

OKAY, I FEEL BETTER NOW...

WHY DON'T YOU JUST THROW IT BACK OUT INTO THE YARD?

HELLO, DOCTOR? I THINK THERE'S SOMETHING WRONG WITH MY DOG... HE'S TREMBLING ALL OVER..

157

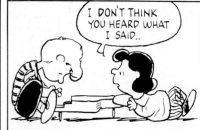

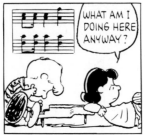

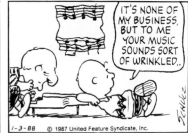

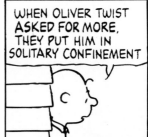
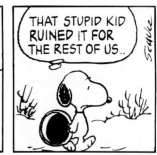

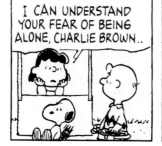
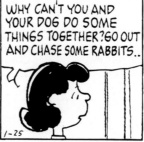
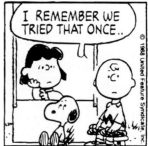
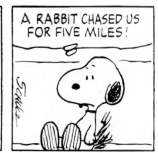

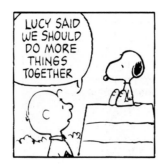
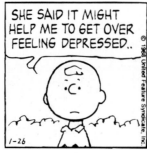
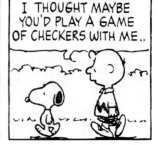
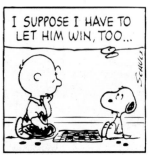

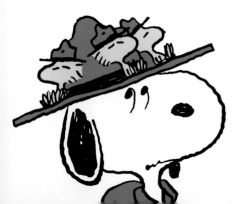

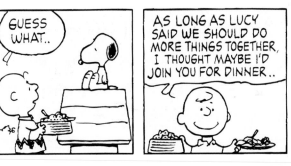

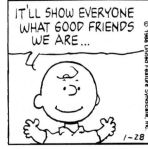
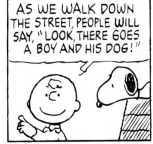
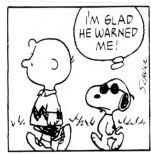

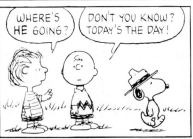
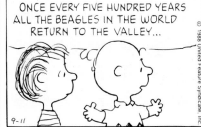
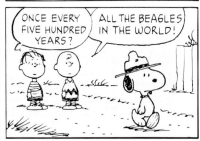

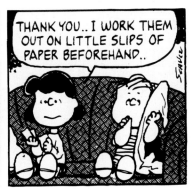

Over the years, mainly, I'm told, due to the cost of newsprint, the *Peanuts* strip, like all the others, has shrunk from at least four to mostly three columns. While some other cartoonists complain that it is becoming impossible to think out the plot of a strip in this decreasing space, there's the real challenge of fitting the story into the tiny rectangle.

For my part, it has made me more inventive in trying to make each day's story complete.

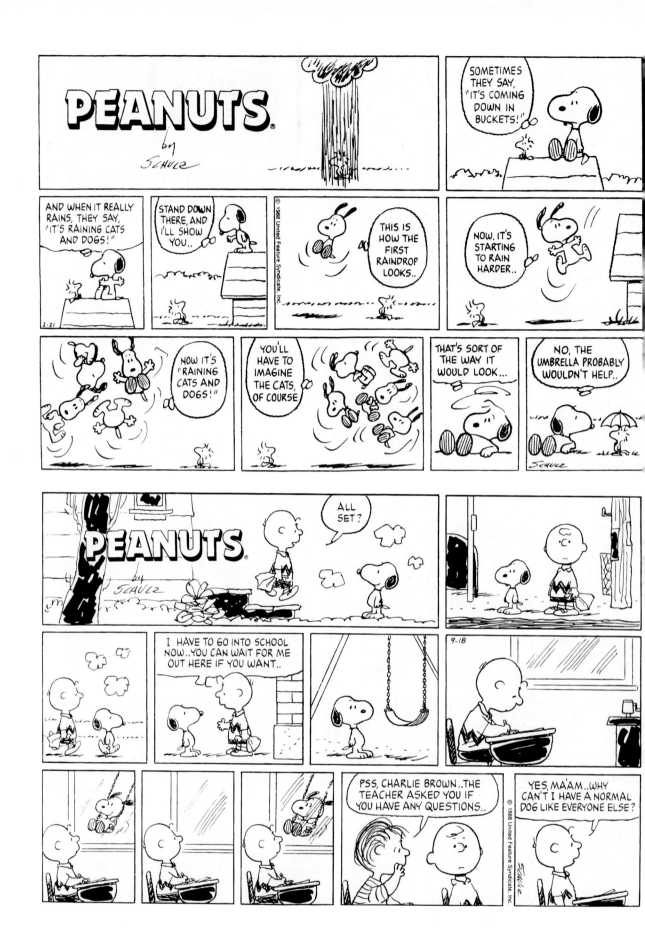

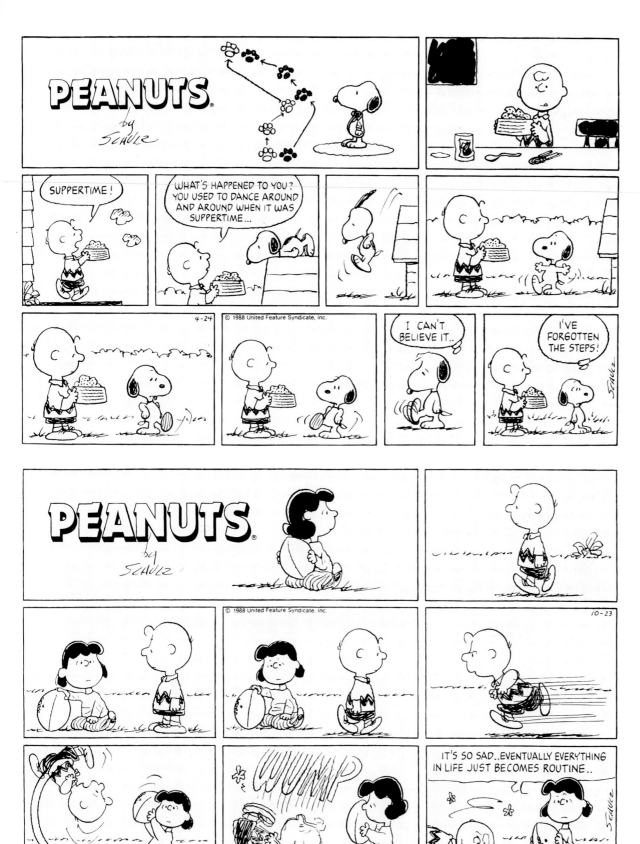

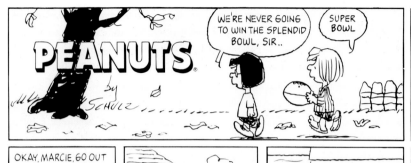

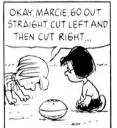

Editor's Note:

From here onward the reader will see several references to Bill Mauldin, Sparky's friend and the great cartoonist originator of Willie and Joe, the unshaven dogface heroes of World War II.

Mauldin said, "I rank Schulz with Ghandi in the scope and influence on people in this century. Sure, Ghandi spoke to multitudes, but has anybody counted Schulz's circulation? And the same message is conveyed: Love thy neighbor even when it hurts. Love even Lucy."

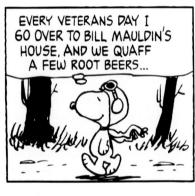
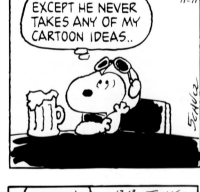

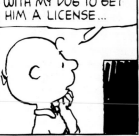

YES, MA'AM..WELL, ORIGINALLY, I CAME IN WITH MY DOG TO GET HIM A LICENSE...

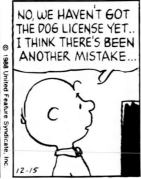

BY MISTAKE, I GUESS, HE GOT A TEMPORARY DRIVER'S PERMIT..

NO, WE HAVEN'T GOT THE DOG LICENSE YET.. I THINK THERE'S BEEN ANOTHER MISTAKE...

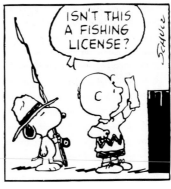

ISN'T THIS A FISHING LICENSE?

© 1988 United Feature Syndicate, Inc. 12-15

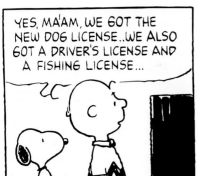

YES, MA'AM, WE GOT THE NEW DOG LICENSE..WE ALSO GOT A DRIVER'S LICENSE AND A FISHING LICENSE...

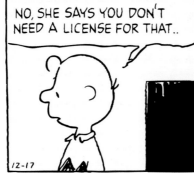

NO, SHE SAYS YOU DON'T NEED A LICENSE FOR THAT..

12-17

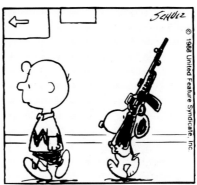

© 1988 United Feature Syndicate, Inc.

PEANUTS
by SCHULZ

1-15

© 1989 United Feature Syndicate, Inc.

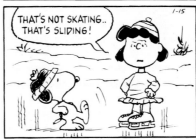

THAT'S NOT SKATING.. THAT'S SLIDING!

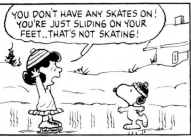

YOU DON'T HAVE ANY SKATES ON! YOU'RE JUST SLIDING ON YOUR FEET..THAT'S NOT SKATING!

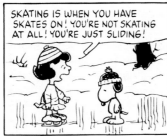

SKATING IS WHEN YOU HAVE SKATES ON! YOU'RE NOT SKATING AT ALL! YOU'RE JUST SLIDING!

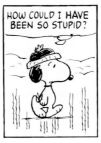

HOW COULD I HAVE BEEN SO STUPID?

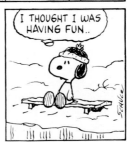

I THOUGHT I WAS HAVING FUN..

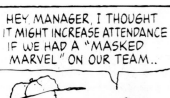
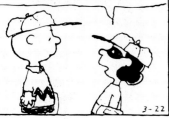

HEY, MANAGER, I THOUGHT IT MIGHT INCREASE ATTENDANCE IF WE HAD A "MASKED MARVEL" ON OUR TEAM..

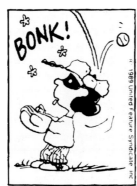

3-22

BONK!

© 1989 United Feature Syndicate, Inc.

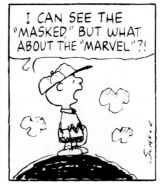

I CAN SEE THE "MASKED," BUT WHAT ABOUT THE "MARVEL"?!

163

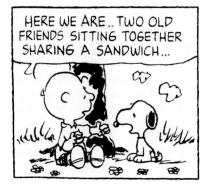

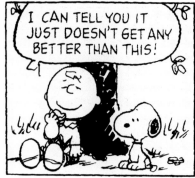

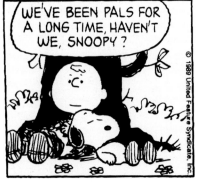

The 80s

Snoopy is a very contradictory character. In a way he's quite selfish. He likes to think of himself as independent, and he has dreams of doing great things. Without Charlie Brown, of course, he couldn't survive, but Snoopy won't even give Charlie Brown the love and affection he deserves.

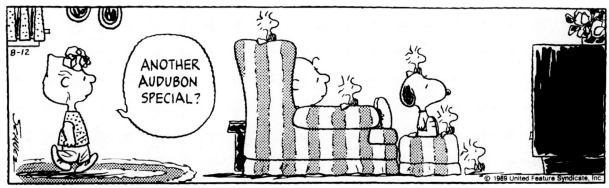

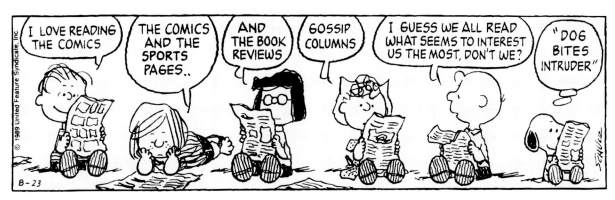

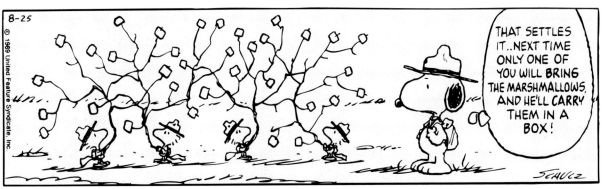

165

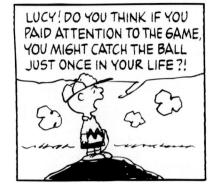

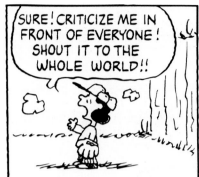

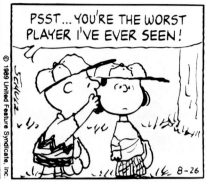

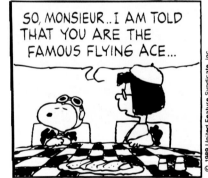

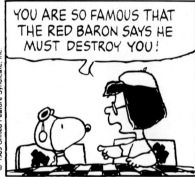

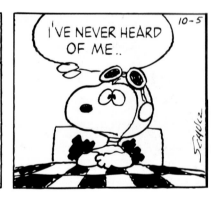

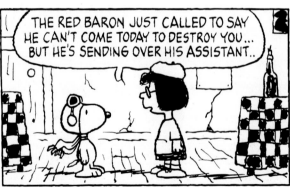

I'VE BEEN HAVING THE STRANGEST DREAMS LATELY...I'M PLAYING THE PIANO, AND ALL THE NOTES KEEP SORT OF FALLING AWAY...

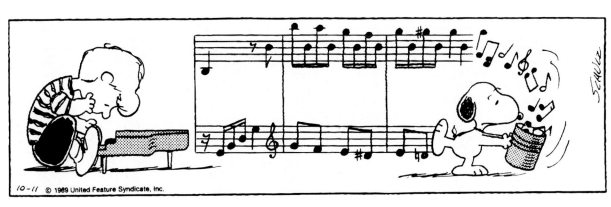

Schroeder and his love of playing Beethoven came from a music book I was looking at the very first year the strip began. I was looking through this book on music, and it showed a portion of Beethoven's Ninth in it, so I drew a cartoon of Charlie Brown singing it. This was a long time ago, and the humor was much different from what it is now. I thought it looked kind of neat, showing those complicated notes coming out of the mouth of this comic strip character, and I thought about it some more, and then I thought, why not have one of the little kids play a toy piano. As I have mentioned before, we had just bought a tiny piano for our young daughter, Meredith: she was then only two years old. And I thought, why not have Schroeder, who had just come into the strip as a baby, play the toy piano?

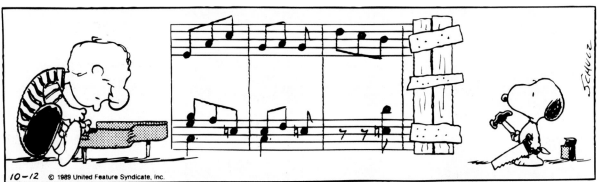

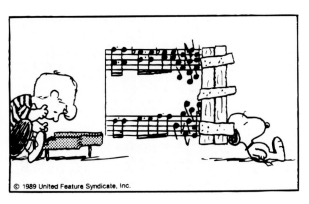

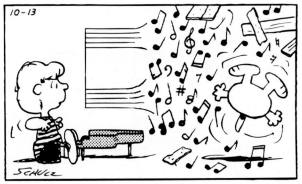

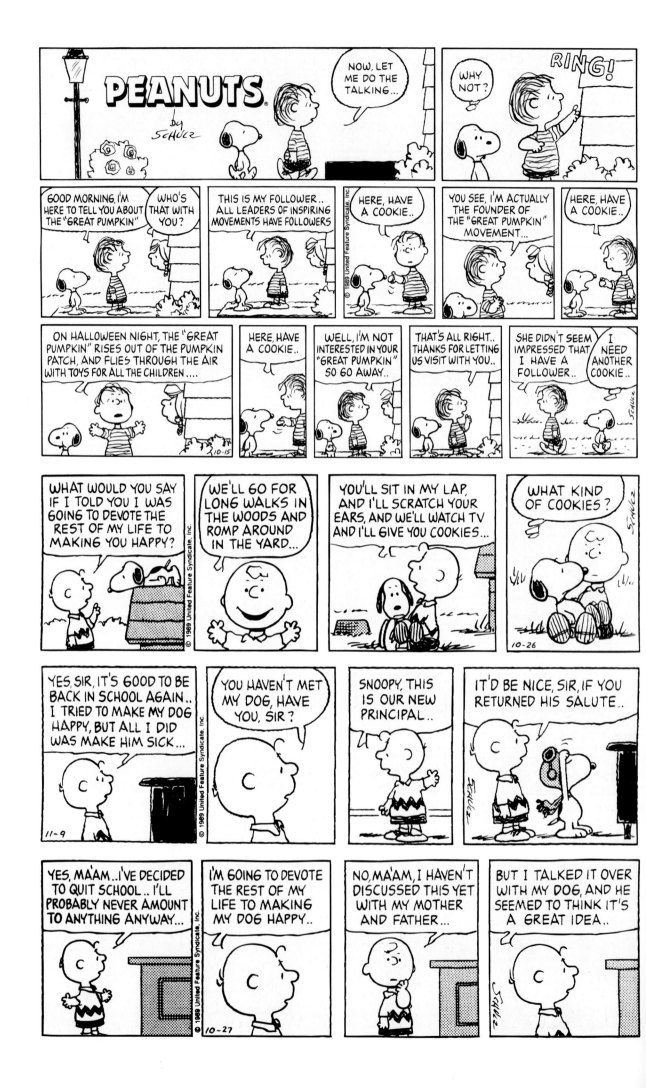

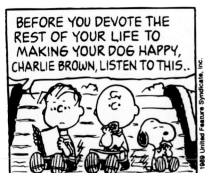

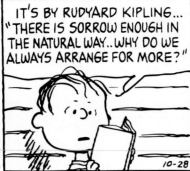

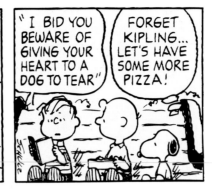

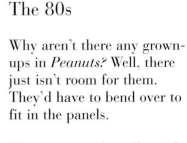

Why aren't there any grown-ups in *Peanuts?* Well, there just isn't room for them. They'd have to bend over to fit in the panels.

The answer isn't really a joke, as this is the only strip where you see the grass from a side view. You're down among the kids. If you added adults, you'd have to back off and it would change the whole perspective.

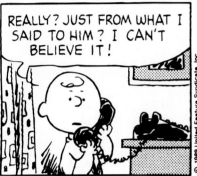

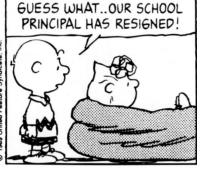

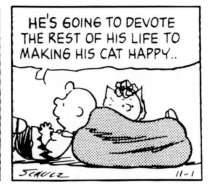

169

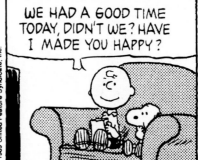

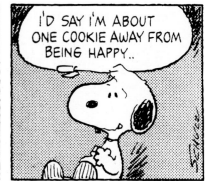

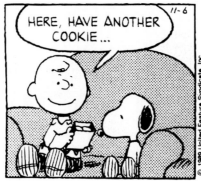

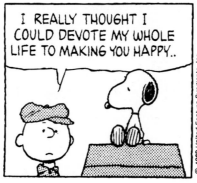

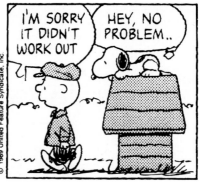

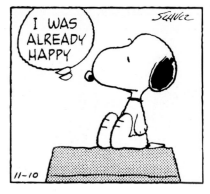

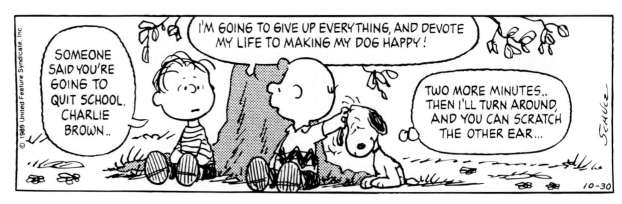

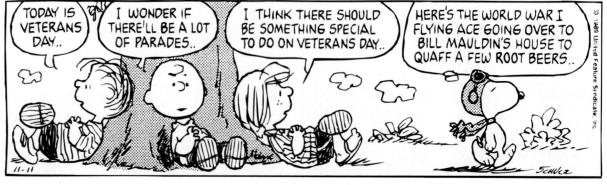

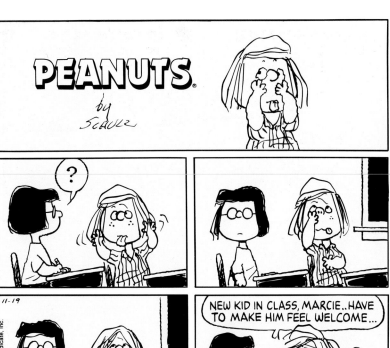

PEANUTS.
by Schulz

NEW KID IN CLASS, MARCIE..HAVE TO MAKE HIM FEEL WELCOME...

YOU'RE VERY THOUGHTFUL, SIR

IT'S THE ONLY WAY TO BE..

I ALWAYS THOUGHT SANTA CLAUS SAID, "HO, HO, HO!"

WOOF WOOF WOOF

HEE HEE HEE HEE

!

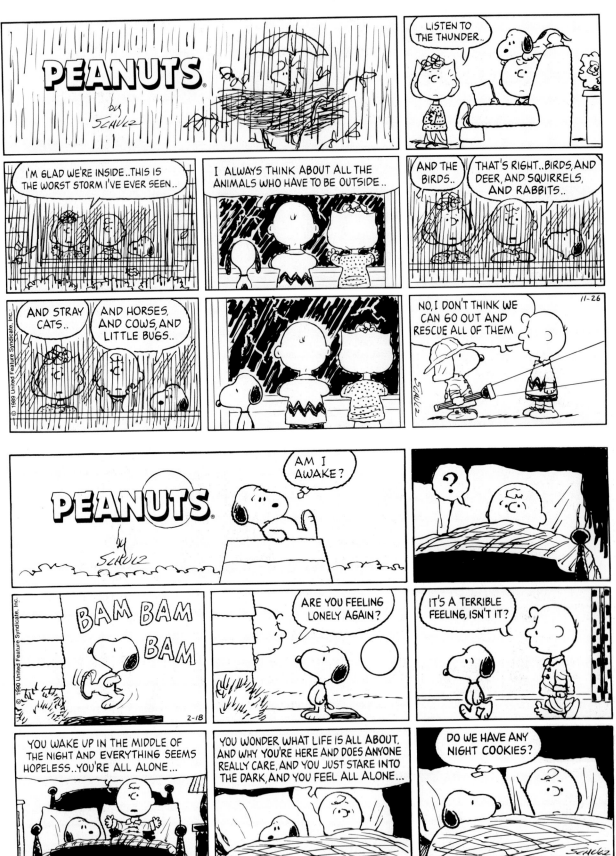

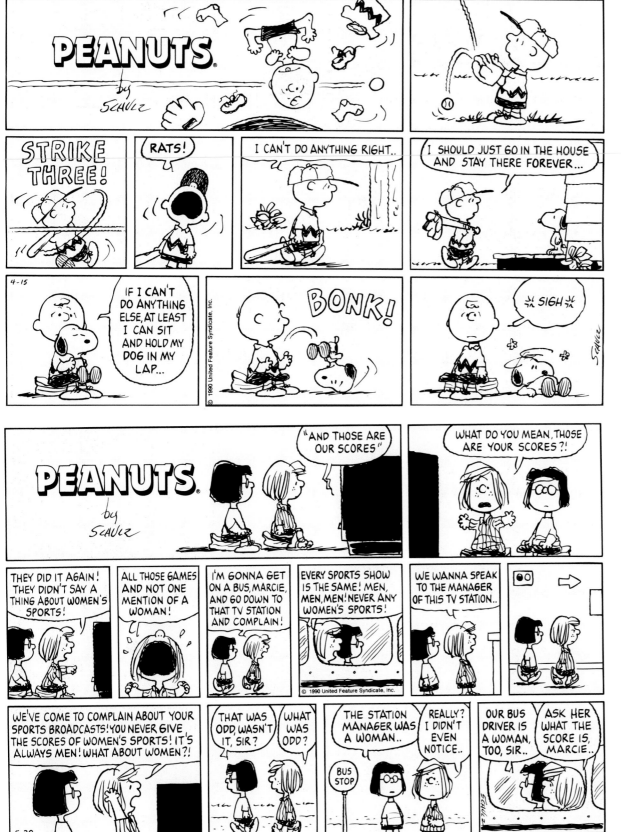

The last panel in a Sunday comic strip is especially important. When the reader first glances at the Sunday pages of his or her comics, it is very easy for her or his eye to drop to the lower right-hand corner and have the whole page spoiled for him. Thus, it is sometimes necessary to try not to attract attention to that panel, to make certain that the beginning panels are interesting enough to keep the reader from skipping to the end. There have been times, for instance, when I wanted to use large lettering in the last panel to emphasize something being said, but decided not to for fear that the reader would be directly attracted to it and see the punch line too soon.

The prophesying of the end of the world by some preachers, I think, is utter nonsense. So I expected complaining letters about this story when Peppermint Patty wakes up to the end of the world. To my surprise there was not a single letter. I guess they didn't understand it.

SHE'S THE PRETTIEST LITTLE GIRL I'VE EVER SEEN.. I WONDER WHAT I COULD SAY TO GET ACQUAINTED..

I DON'T SUPPOSE YOU HAPPEN TO HAVE ANY COOKIES WITH YOU, DO YOU SWEETIE?

7-23

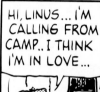
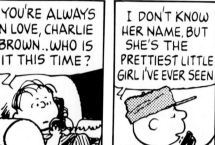
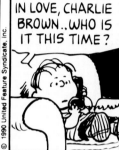
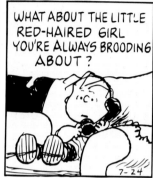

HI, LINUS... I'M CALLING FROM CAMP.. I THINK I'M IN LOVE...

YOU'RE ALWAYS IN LOVE, CHARLIE BROWN..WHO IS IT THIS TIME?

I DON'T KNOW HER NAME, BUT SHE'S THE PRETTIEST LITTLE GIRL I'VE EVER SEEN

WHAT ABOUT THE LITTLE RED-HAIRED GIRL YOU'RE ALWAYS BROODING ABOUT?

WHO?

7-24

WOULD YOU LIKE TO GET IN FRONT OF ME?

WHY, THANK YOU.. BUT IT'S NOT NECESSARY

I'M ALWAYS SORT OF NERVOUS AROUND PRETTY GIRLS...

BUT YOU MUST NEVER FEEL THAT WAY..

PRETTY GIRLS ARE HUMAN, TOO..

YOU ARE?

7-25

NOW THAT WE'VE HAD LUNCH TOGETHER, I CAN TELL YOU MY NAME IS PEGGY JEAN...

WELL, UH... UH...MY NAME IS...UH...UH..MY NAME IS.. UH.. BROWNIE CHARLES!

THAT'S CUTE.. I LIKE IT..

MAYBE I'LL JUST JUMP INTO THE LAKE RIGHT HERE

7-27

AND THEN, LINUS, I GOT SO NERVOUS TRYING TO TELL HER MY NAME, I SAID IT WAS "BROWNIE CHARLES"...

HA HA HA HA!! CHARLIE BROWN, YOU ARE REALLY SOMETHING!

NOW SHE CALLS ME "BROWNIE CHARLES" ALL THE TIME... BUT YOU KNOW WHAT?

I KIND OF LIKE IT..

7-28

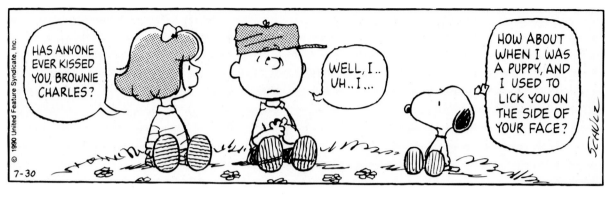

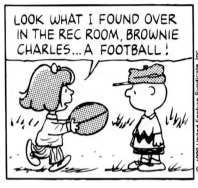 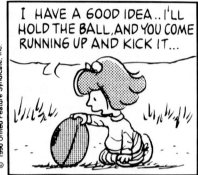

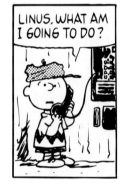 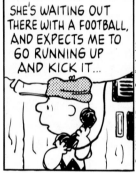 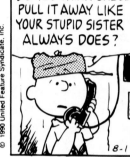 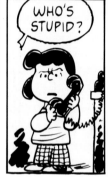

 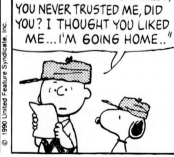 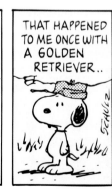

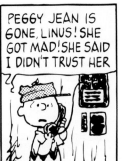
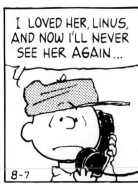

PEGGY JEAN IS GONE, LINUS! SHE GOT MAD! SHE SAID I DIDN'T TRUST HER

I LOVED HER, LINUS, AND NOW I'LL NEVER SEE HER AGAIN...

GOLF IS A CRUEL GAME, CHARLIE BROWN

WHAT'S THAT GOT TO DO WITH IT?

IT'S ALL I COULD THINK OF TO SAY..

HI, BROWNIE CHARLES!

I COULD NEVER BE MAD AT YOU, BROWNIE CHARLES

YOU'RE THE NICEST BOY I'VE EVER MET..

AND THEN SHE KISSED ME, LINUS!

WHAT IS THIS, AN OBSCENE PHONE CALL?!

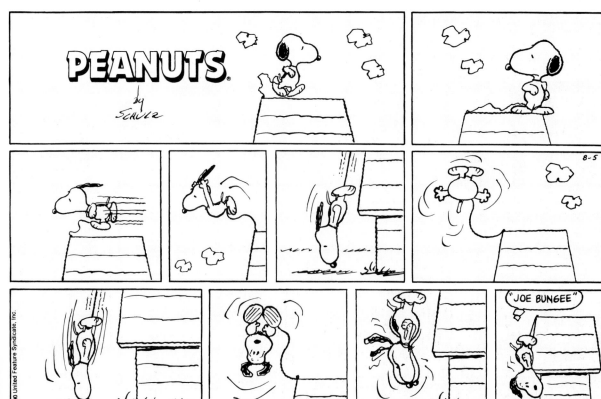

PEANUTS by Schulz

"JOE BUNGEE"

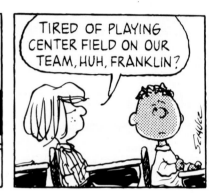

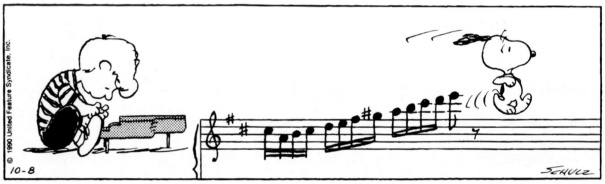

HI, CHUCK.. WHAT'S UP?

MARCIE'S OVER HERE.. SHE'S FALLEN ASLEEP IN ONE OF OUR CHAIRS...

SHE'S ALL STRETCHED OUT..

STRESSED OUT..

Z

WHATEVER

WHERE IS SHE, CHUCK? WHERE'S MARCIE?

SHE'S IN HERE SOUND ASLEEP...

SHE WAS TELLING US HOW MUCH STRESS SHE'S BEEN UNDER LATELY, AND THEN SHE JUST FELL ASLEEP...

POOR MARCIE.. SHE'S TOO HARD ON HERSELF

SHE PROBABLY NEEDS A DOG..

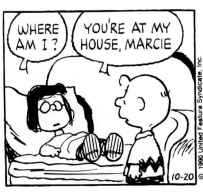
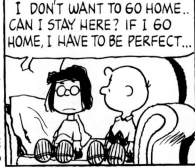
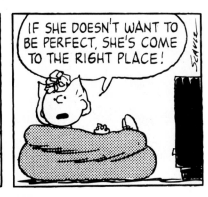

WHERE AM I?

YOU'RE AT MY HOUSE, MARCIE

I DON'T WANT TO GO HOME.. CAN I STAY HERE? IF I GO HOME, I HAVE TO BE PERFECT...

IF SHE DOESN'T WANT TO BE PERFECT, SHE'S COME TO THE RIGHT PLACE!

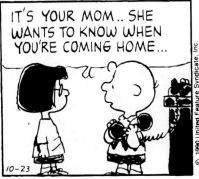

IT'S YOUR MOM.. SHE WANTS TO KNOW WHEN YOU'RE COMING HOME...

I KNEW SHE'D CALL... SOMETIMES I FEEL LIKE I'M ON A LEASH..

TELL ME ABOUT IT..

AS SOON AS I WALK IN THE DOOR, MY MOTHER WILL SAY, "HAVE YOU DONE YOUR HOMEWORK?"

ALL THEY CARE ABOUT IS AM I GETTING STRAIGHT "A'S"?

..JUST SO I CAN GO TO SOME COLLEGE THEY'VE ALREADY PICKED OUT FOR ME...

AND END UP MARRYING SOME NERD!

The 90s

There is something else worth mentioning here, I think, which also is important in building personalities and characters. Peppermint Patty calls Charlie Brown "Chuck." She's the only one in the strip who does that. Marcie calls him "Charles." Everybody else calls him "Charlie Brown." If you have enough of those little things, then I think you take on some kind of depth. I'm not a believer in funny names. I think a funny name is fine for one gag or one idea, but I don't think people are going to laugh at that funny name for long.

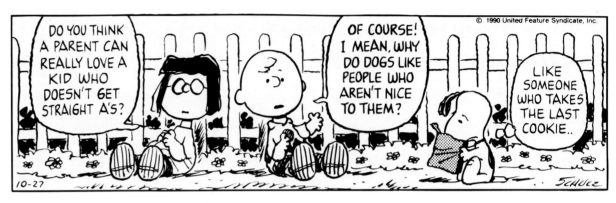

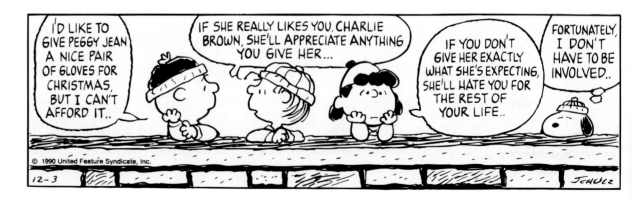

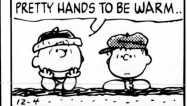

YOU KNOW WHY I WANT TO BUY PEGGY JEAN THOSE GLOVES FOR CHRISTMAS?

WHEN I FIRST MET HER THIS SUMMER AT CAMP, I NOTICED WHAT PRETTY HANDS SHE HAD... I WANT THOSE PRETTY HANDS TO BE WARM..

12-4

BUT I DON'T HAVE TWENTY-FIVE DOLLARS TO BUY THE GLOVES...

SEND HER A NICE CARD, AND TELL HER TO KEEP HER HANDS IN HER POCKETS!

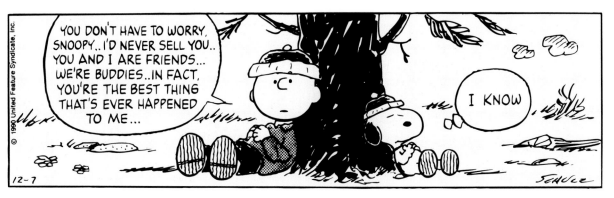

YOU DON'T HAVE TO WORRY, SNOOPY..I'D NEVER SELL YOU.. YOU AND I ARE FRIENDS... WE'RE BUDDIES..IN FACT, YOU'RE THE BEST THING THAT'S EVER HAPPENED TO ME...

I KNOW

12-7

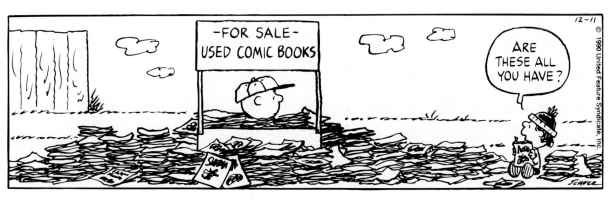

-FOR SALE- USED COMIC BOOKS

12-11

ARE THESE ALL YOU HAVE?

I used to own the very first copy of *Famous Funnies* that was ever published. I don't have the slightest idea what happened to it. Other comic magazines began to imitate *Famous Funnies*, and I bought every one that came out. One of the stores lost me as a customer, however, when the man behind the counter said to me once too often, "Going to do some heavy reading, eh?"

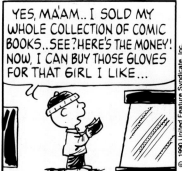

YES, MA'AM.. I SOLD MY WHOLE COLLECTION OF COMIC BOOKS..SEE? HERE'S THE MONEY! NOW, I CAN BUY THOSE GLOVES FOR THAT GIRL I LIKE...

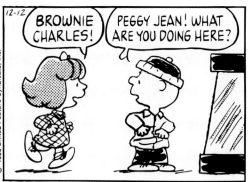

12-12

BROWNIE CHARLES!

PEGGY JEAN! WHAT ARE YOU DOING HERE?

I'VE BEEN SHOPPING WITH MY MOTHER..LOOK, I JUST BOUGHT THIS NEW PAIR OF GLOVES!

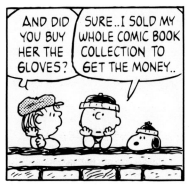

AND DID YOU BUY HER THE GLOVES?

SURE..I SOLD MY WHOLE COMIC BOOK COLLECTION TO GET THE MONEY..

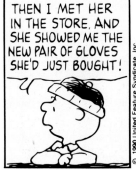

THEN I MET HER IN THE STORE, AND SHE SHOWED ME THE NEW PAIR OF GLOVES SHE'D JUST BOUGHT!

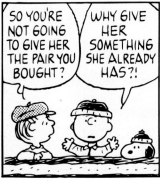

SO YOU'RE NOT GOING TO GIVE HER THE PAIR YOU BOUGHT?

WHY GIVE HER SOMETHING SHE ALREADY HAS?!

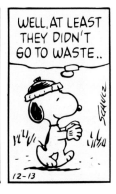

WELL, AT LEAST THEY DIDN'T GO TO WASTE..

12-13

181

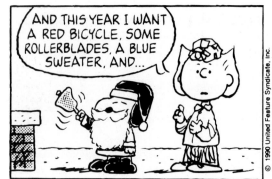

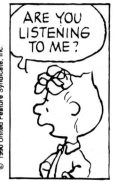

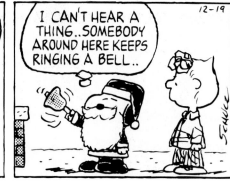

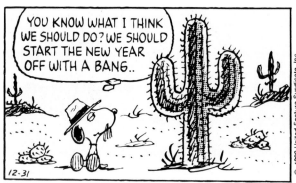

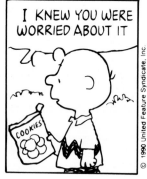

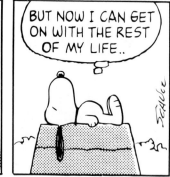

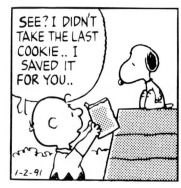

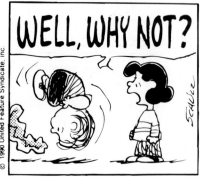

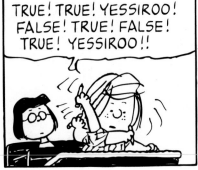

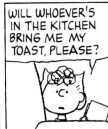
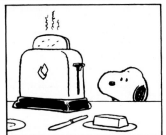
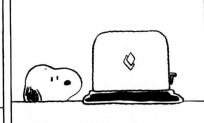
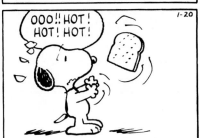
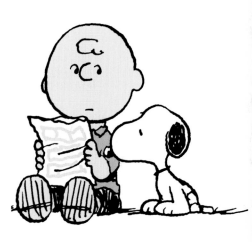

Some things happen in the strip simply because I enjoy drawing them. Rain is fun to draw. I pride myself on being able to make nice strokes with the point of the pen, and I also recall how disappointing a rainy day can be to a child. When I think back to those ball games that we looked forward to as teenagers, and how crushed we were if the game had to be postponed because of rain, it brings to mind emotions that can be translated into cartoon ideas.

At the beginning of my drawing career at the art correspondence school, my fellow instructors and I practiced on a little pen-and-ink exercise or demonstration that we sent out to the students. We would draw three sets of pen lines, starting with a very fine set, progressing to a medium set, then ending with a third set of very bold lines. It used to be challenging to see how close we could get those pen lines to each other without having them touch, and to see if we could draw a perfect set. Doing this exercise hundreds of times helped me to develop the pen technique that I now possess.

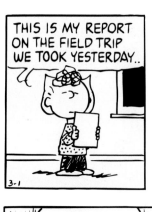

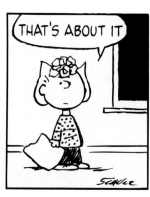

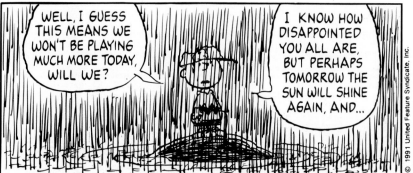
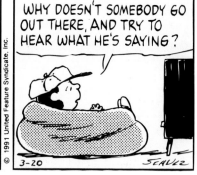

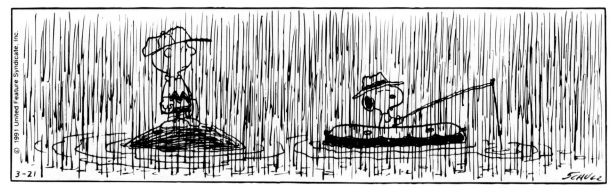

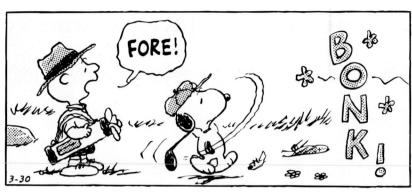

FORE!

B O N K *!

WE YELLED, "FORE!" AND THAT TREE DIDN'T EVEN MOVE..

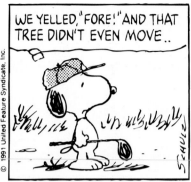

3-30

HERE'S THE WORLD WAR I FLYING ACE RETURNING TO THE AIRDROME IN HIS SOPWITH CAMEL..

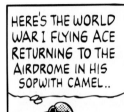

AS USUAL, HE GOES TO THE SMALL FRENCH CAFE WHERE HE CAN FORGET HIS TROUBLES, THE WAR..EVERYTHING!

4-9

BON SOIR, MONSIEUR FLYING ACE..WHAT IS YOUR NAME?

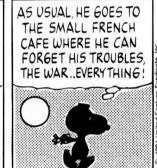

I FORGOT

WHAT'S GOING ON HERE?

THIS IS THE FAMOUS FLYING ACE OF WORLD WAR I...

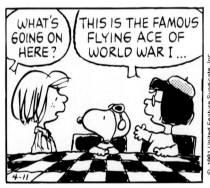

4-11

HE COMES TO MY SMALL FRENCH CAFE EVERY NIGHT TO FORGET THE WAR..

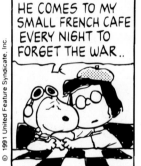

YOU'RE REALLY WEIRD, MARCIE

SO WHAT ARE YOU, A SPY?

WHAT WOULD HAPPEN IF WE PUT A LITTLE ICE CREAM IN THIS ROOT BEER?

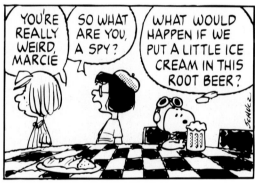

PEPPERMINT PATTY'S ON THE PHONE..SHE SAYS YOUR STUPID DOG IS OVER AT MARCIE'S AGAIN DRINKING ROOT BEER...

WHO AM I TO STAND IN THE WAY OF A WORLD WAR I FLYING ACE IF HE WANTS TO HAVE A GOOD TIME?

4-16

NO, HE'S NOT GOING TO DO ANYTHING..HE'S JUST AS CRAZY AS HIS DOG..

GOOD MORNING, CLASS.. MY NAME IS CHARLIE BROWN... WELCOME TO BIBLE SCHOOL..

WILL WE BE ABLE TO ASK QUESTIONS IN THIS CLASS?

ABSOLUTELY! WHAT IS YOUR QUESTION?

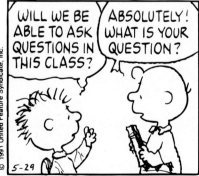

5-29

I JUST ASKED IT

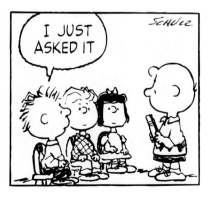

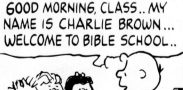

ALL RIGHT, CLASS..JUST TO GET US STARTED HERE IN OUR BIBLE STUDY...

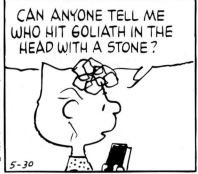

CAN ANYONE TELL ME WHO HIT GOLIATH IN THE HEAD WITH A STONE?

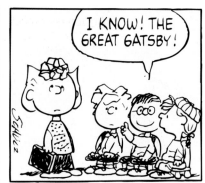

I KNOW! THE GREAT GATSBY!

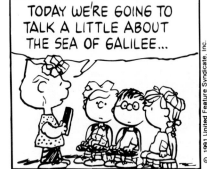

TODAY WE'RE GOING TO TALK A LITTLE ABOUT THE SEA OF GALILEE...

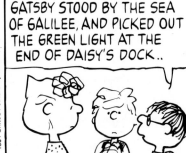

GATSBY STOOD BY THE SEA OF GALILEE, AND PICKED OUT THE GREEN LIGHT AT THE END OF DAISY'S DOCK..

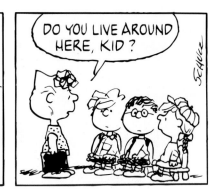

DO YOU LIVE AROUND HERE, KID?

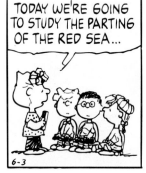

TODAY WE'RE GOING TO STUDY THE PARTING OF THE RED SEA...

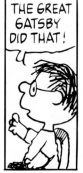

THE GREAT GATSBY DID THAT!

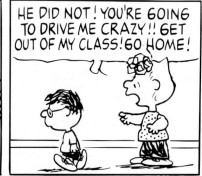

HE DID NOT! YOU'RE GOING TO DRIVE ME CRAZY!! GET OUT OF MY CLASS! GO HOME!

WELL, WHAT ARE YOU WAITING FOR?

I CAN'T REACH THE DOORKNOB..

HOW CAN YOU TEACH SOMEONE WHO THINKS THE GREAT GATSBY WAS IN THE OLD TESTAMENT?

I HEARD YOU KICKED HIM OUT OF YOUR CLASS.. WHAT WAS HIS NAME?

LARRY... WHY?

HE'S THE MINISTER'S SON!

GOOD MORNING, MA'AM.. I CAME TO APOLOGIZE... I DIDN'T MEAN TO SPOIL YOUR BIBLE CLASS..

ACTUALLY, MA'AM, I'VE FALLEN IN LOVE WITH YOU...

I'D LIKE TO GIVE YOU SOMETHING THAT HAS ALWAYS MEANT A LOT TO ME...

HOW ROMANTIC

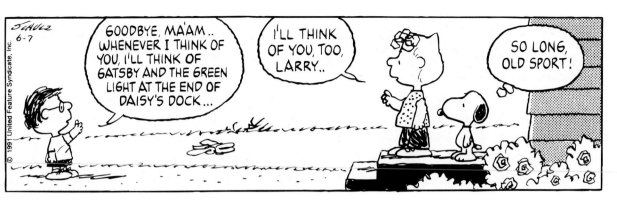

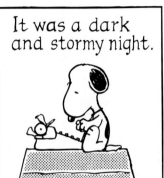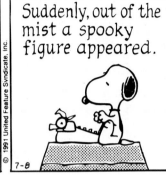

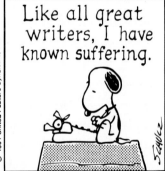

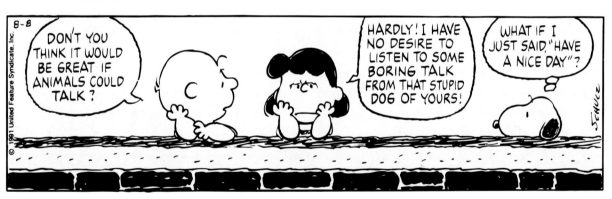

I have been able to do things with Snoopy that others hadn't been able to do. It really grew out of the business of people actually talking to their dogs—even answering for them in a form of baby talk. I put in Snoopy's mind the thoughts we sometimes think the dog might be thinking.

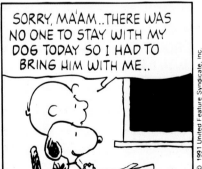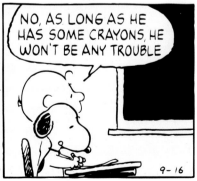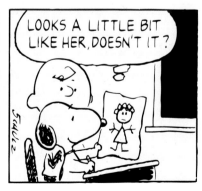

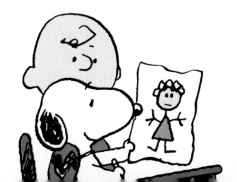

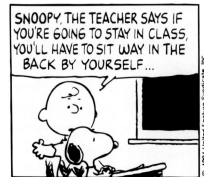

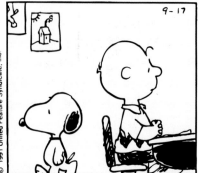

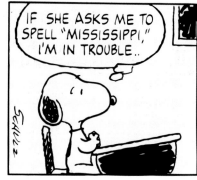

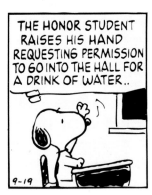

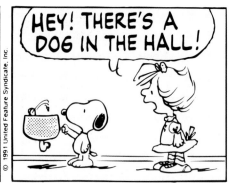

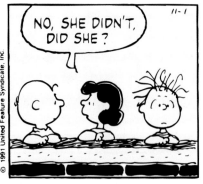

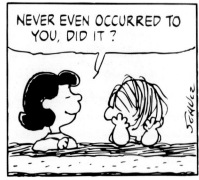

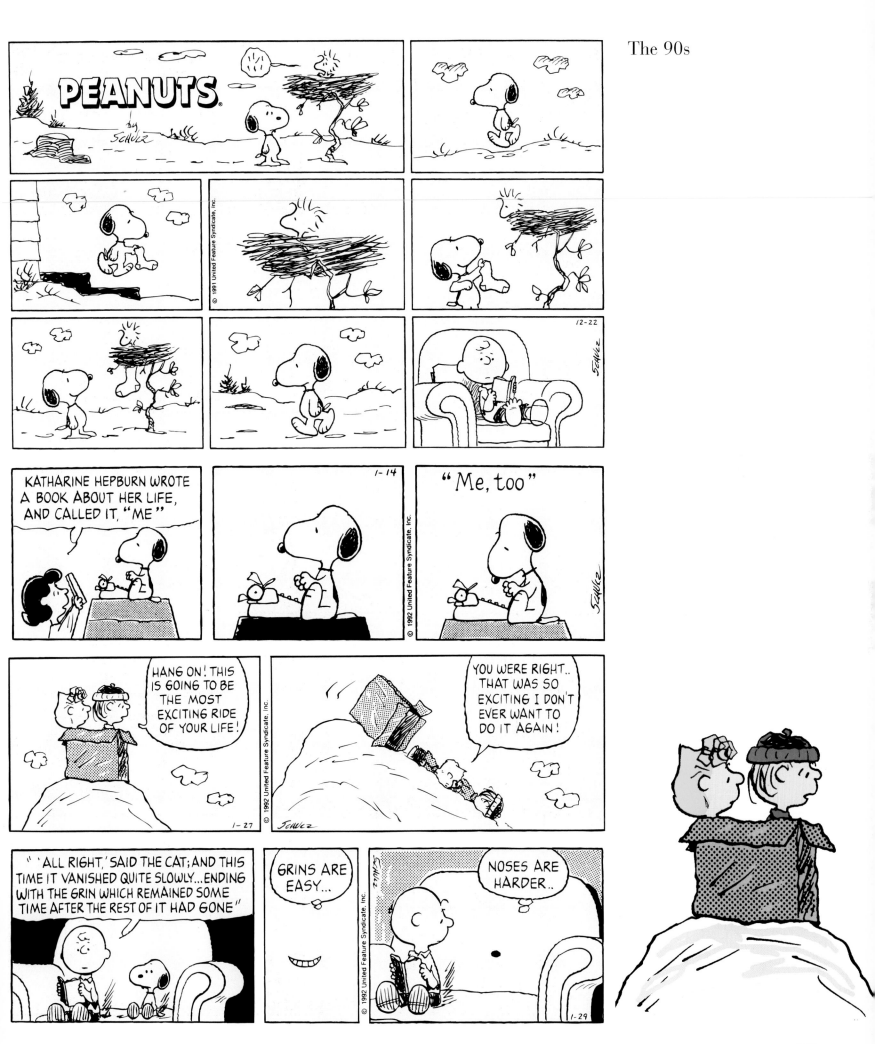

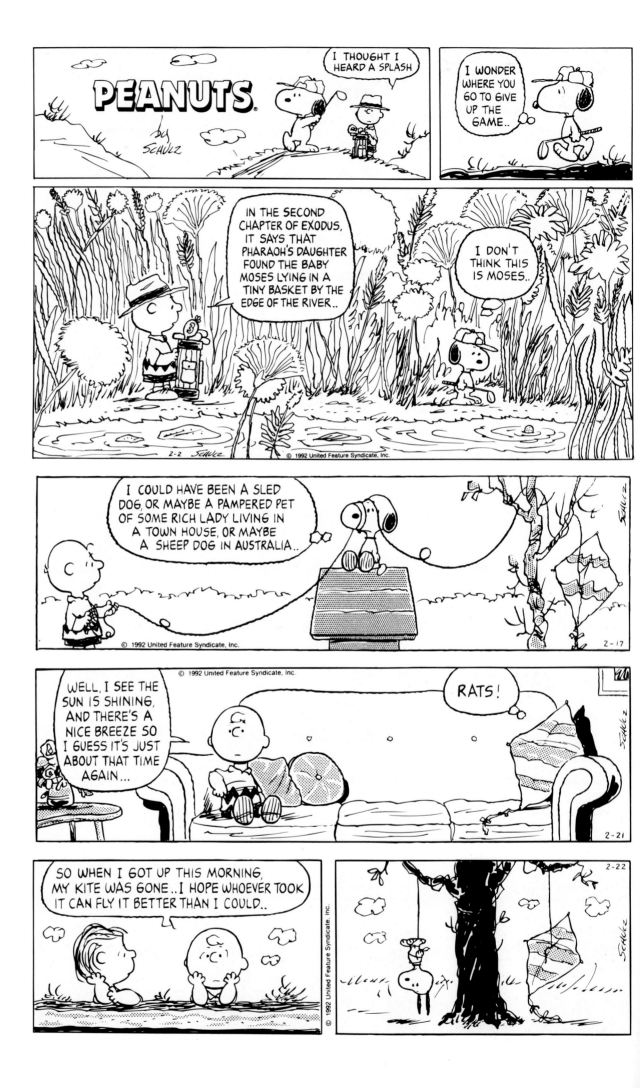

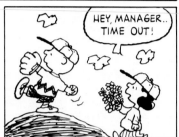
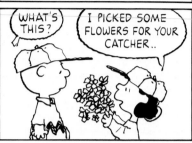

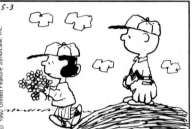
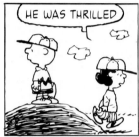
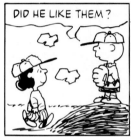

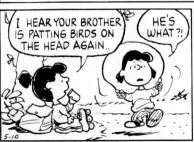
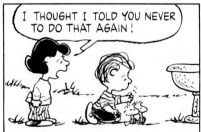
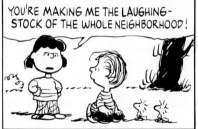

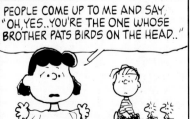
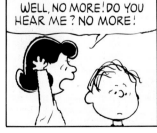

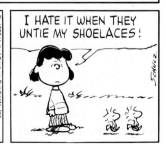

191

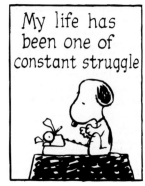

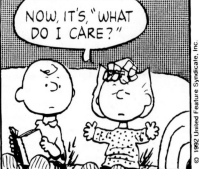
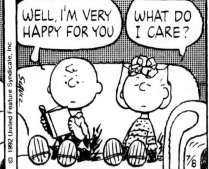

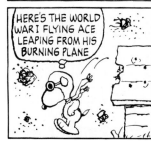
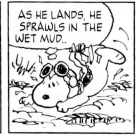
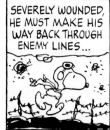
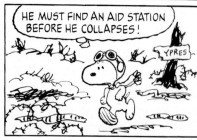

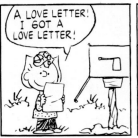
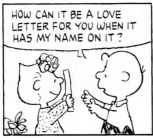
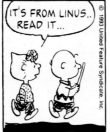
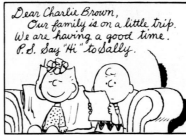

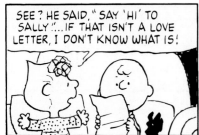
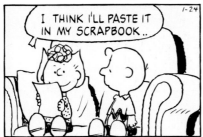
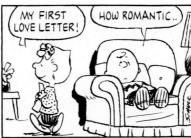

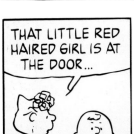
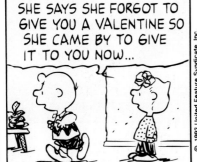
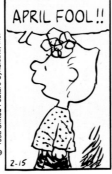
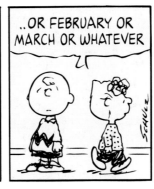

I don't know why there's so much unrequited love in my strip. I seem to be fascinated by unrequited love, if not obsessed by it: Sally loves Linus, but Linus can't stand her; Lucy loves Schroeder, but Schroeder can't stand her; Charlie Brown loves the red-haired girl, but doesn't even dare to go near her.

There's something funny about unrequited love—I suppose it's because we can all identify with it. We've all been turned down by someone we love, and it's probably the most bitter blow in life.

193

I once read a newspaper article that labeled Charlie Brown "a loser." That never occurred to me. A real loser would stop trying. Comedy has always revolved around characters who are "losers." Look at Charlie Chaplin or Laurel and Hardy.

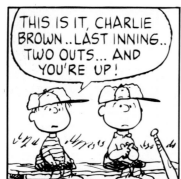
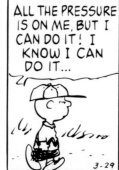
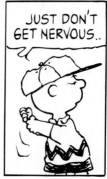
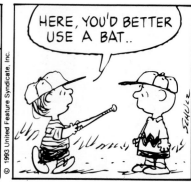

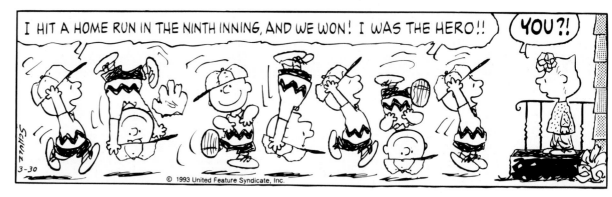

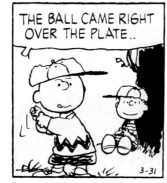
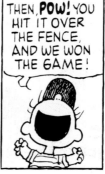
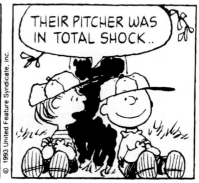
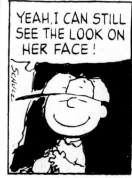

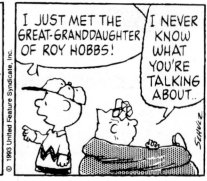

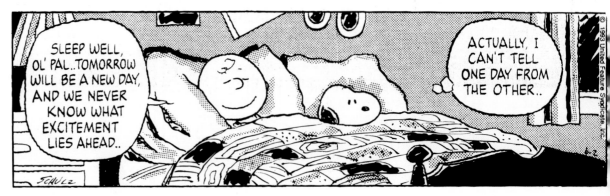

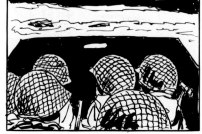

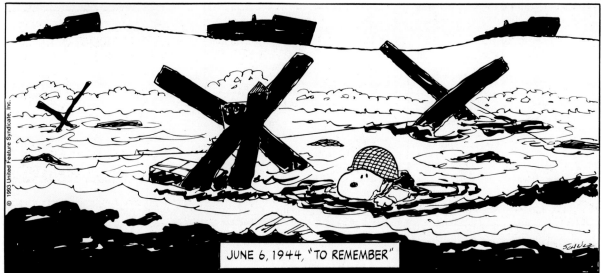

JUNE 6, 1944, "TO REMEMBER"

Editor's Note:

In 1993, Schulz created a special strip to commemorate D-Day, the World War II invasion of Normandy. The response Sparky received from the veterans and families of veterans was overwhelmingly appreciative. For several years he continued to mark the anniversary of D-Day in the Peanuts strip. Sparky is also the Capital Campaign Chairman for the National D-Day Memorial.

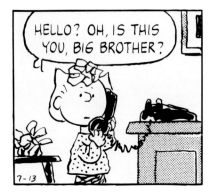

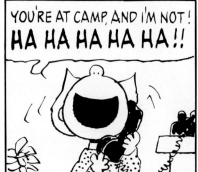

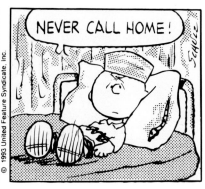

I had observed that there were many neighborhood dogs that seemed almost smarter than the children who were their masters. The dogs seemed to tolerate the silly things the kids did; they seemed to be very wise. This was one of the initial themes of Snoopy which I have built upon in many ways.

Snoopy refuses to be caught in the trap of doing ordinary things like chasing and retrieving sticks, and he refuses to take seriously his role as the devoted dog who greets his master when he returns home from school.

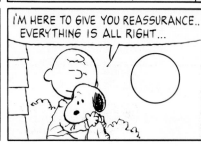

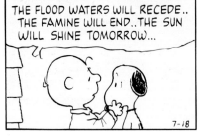

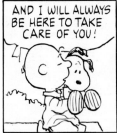

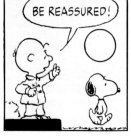

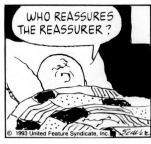

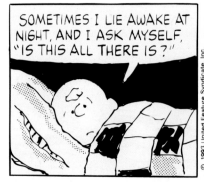

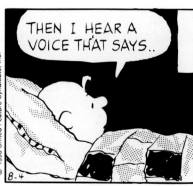

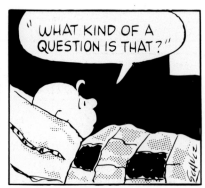

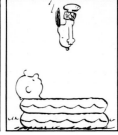
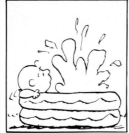

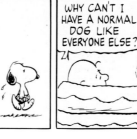

I like Snoopy and probably wouldn't mind having him for my own dog, although I sometimes feel as Charlie Brown does when he says, "Why can't I have a normal dog like everyone else?"

The 90s

I show my fondness for the the great paintings of Edward Hopper by turning Woodstock and pals into "Nighthawks."

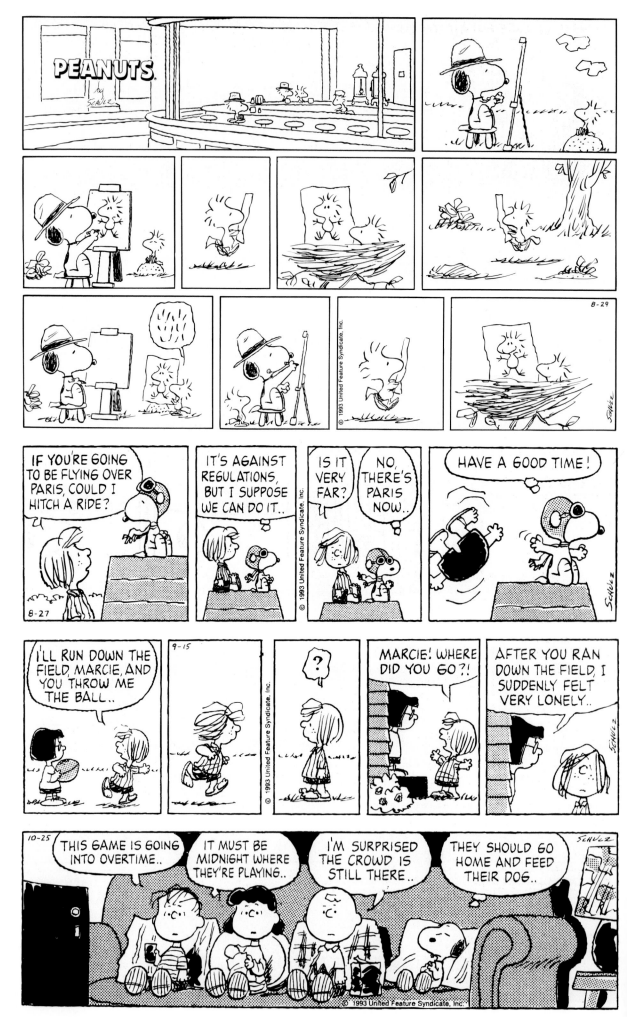

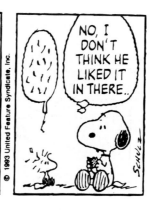

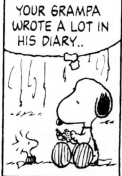
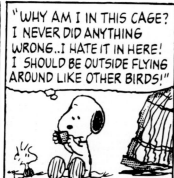

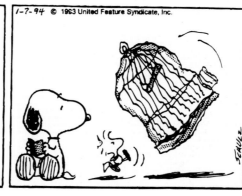

Different Views of *Peanuts*

Over the years, I have been blessed with the cameraderie of fellow cartoonists. Whether it's genetic engineering, airline strikes, political appointees with almost similiar names, absentee parents, a new pet at the White House, or the frustrations of everyday life, Charlie Brown and his friends come up with a solution or a comment. I am very grateful to the artists for sending me the originals which have honored places on the walls of my gallery.

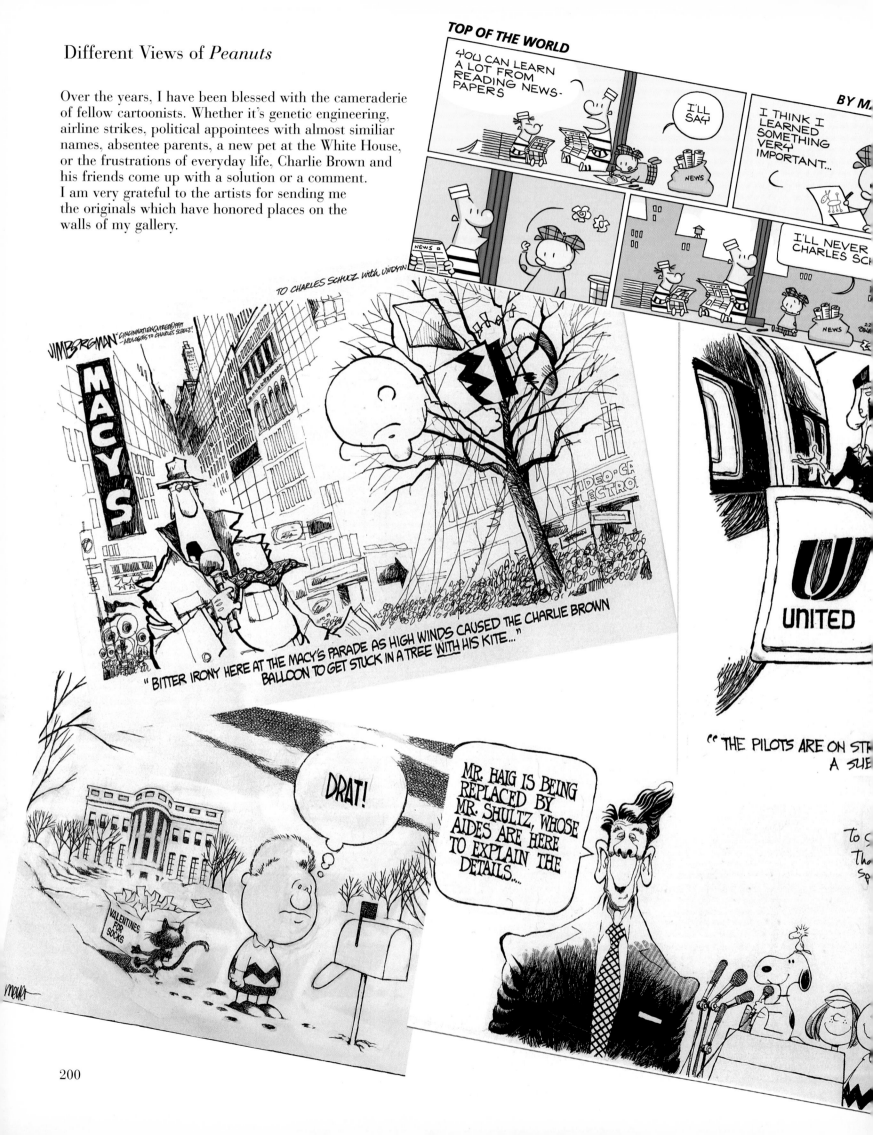

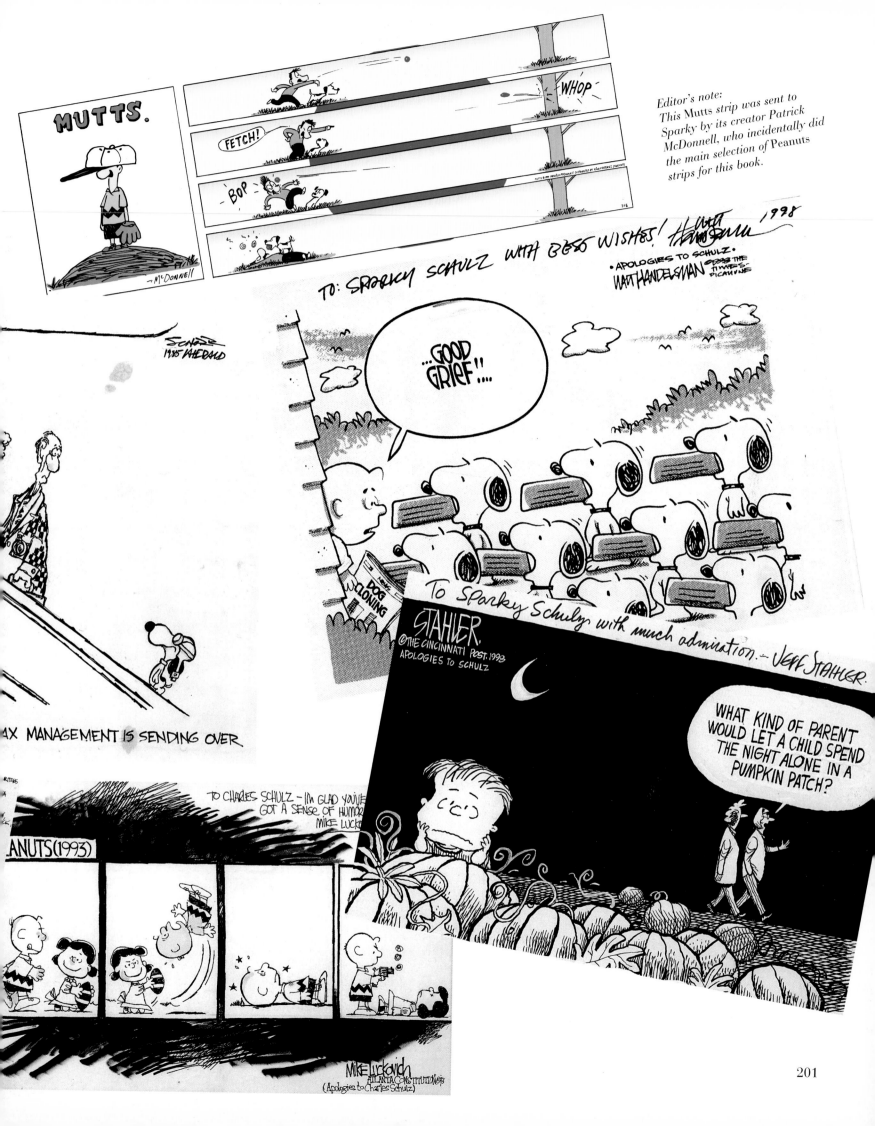

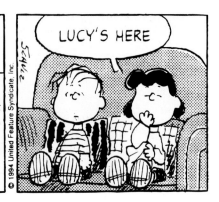

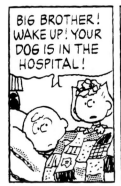

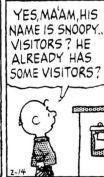

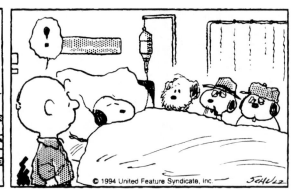

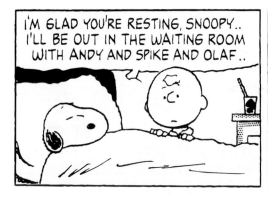

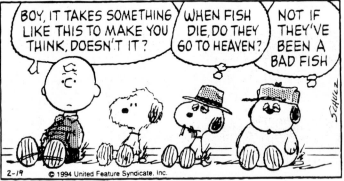

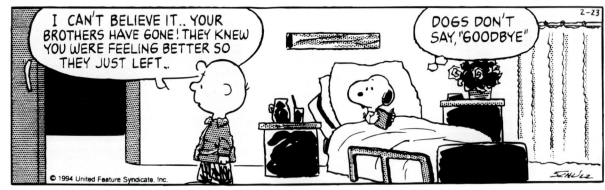

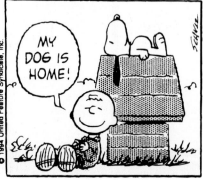

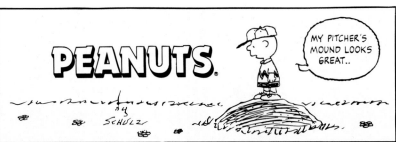

MY PITCHER'S MOUND LOOKS GREAT..

IT'S GOING TO BE A GOOD SEASON, CHARLIE BROWN!

OUR OL' BACKSTOP SEEMS TO BE IN GOOD SHAPE..

HOW ABOUT THE OUTFIELD?

ALL MOWED, CHARLIE BROWN..IT'S BEAUTIFUL!

AND WE'VE RAKED THE INFIELD SO IT LOOKS BETTER THAN EVER..

© 1994 United Feature Syndicate, Inc.

3-20

THEN ALL WE HAVE TO WORRY ABOUT IS THE SOUND SYSTEM..

THE SOUND SYSTEM?

THIS YEAR LET'S TRY TO GET THE BALL OVER THE PLATE, YOU BLOCKHEAD!

THE SOUND SYSTEM IS STILL WORKING..

ANOTHER ROOT BEER, PLEASE..

THIS IS MY REPORT ON "D-DAY," JUNE 6,1944..

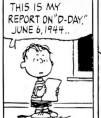

FIFTY YEARS AGO THE ALLIES WERE POISED TO BEGIN THE INVASION OF NORMANDY..

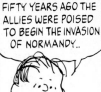

NO ONE, HOWEVER, KNEW WHEN THAT DAY WOULD BE..

NO ONE BUT AN UNKNOWN SOLDIER SITTING IN A TINY PUB DRINKING ROOT BEER WHO CAME TO A STARTLING CONCLUSION..

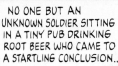

"FELDMARSCHALL" ROMMEL IS IN CHARGE OF DEFENDING THE BEACHES OF NORMANDY..

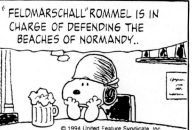

© 1994 United Feature Syndicate, Inc.

BUT HIS WIFE'S BIRTHDAY IS JUNE 6 !! HE'S SURE TO GO HOME FOR HER BIRTHDAY! HE WON'T BE IN NORMANDY!!

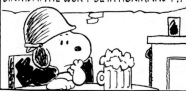

THE UNKNOWN UNSUNG HERO RUSHED TO A PHONE TO CALL GENERAL EISENHOWER

"D-DAY HAS TO BE JUNE 6!

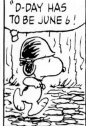

SPEAKING IN CODE, THE SIMPLE SOLDIER MADE A PHONE CALL THAT CHANGED THE COURSE OF HISTORY..

WOOF!

6-5

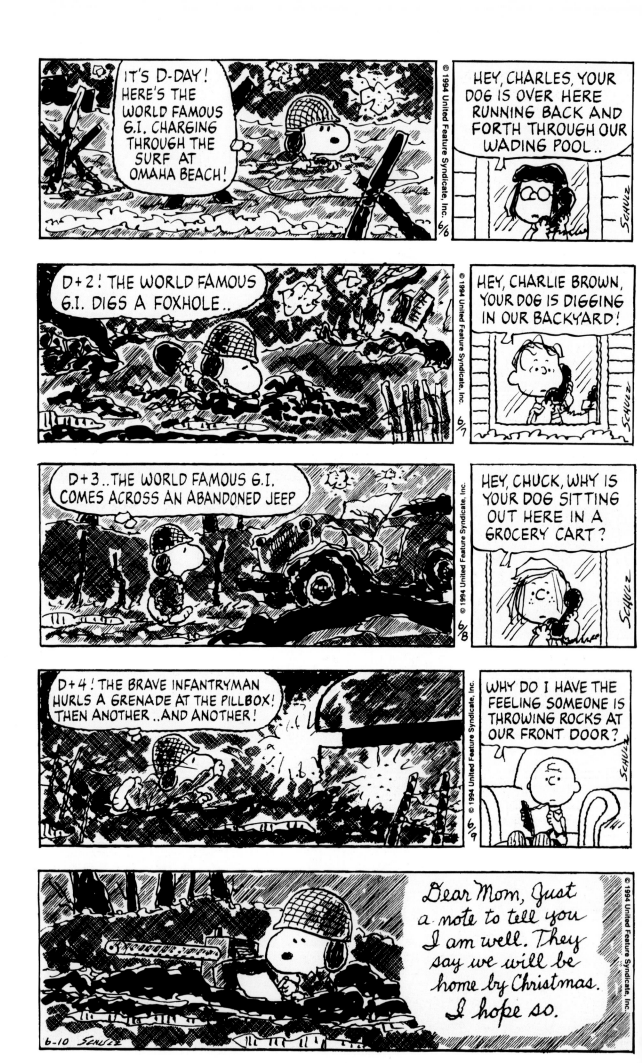

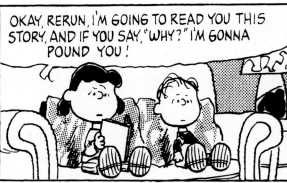

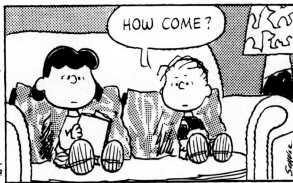

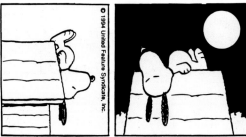

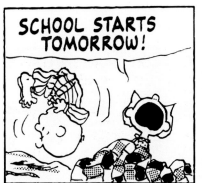

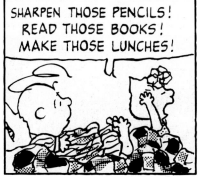

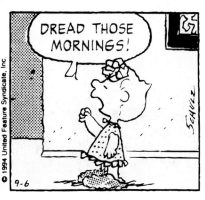

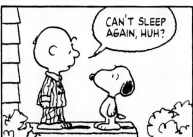

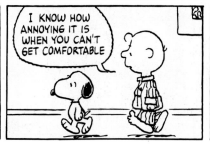

The more Snoopy moved into his life of fantasy, the more important it became for his doghouse to remain in side view. You simply cannot have a dog doing and thinking the things that Snoopy does on a realistic doghouse. The image is much more acceptable when the doghouse is drawn only from the side. When necessary, it almost loses its identity completely. Snoopy's typewriter could never balance on the peak the way it does and, of course, Snoopy himself is somewhat of a mystery when one examines his sleeping pose closely.

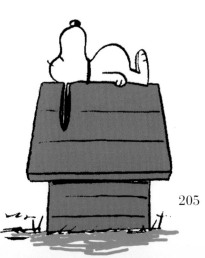

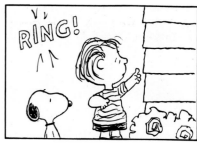

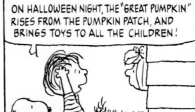

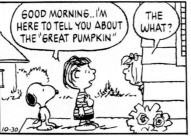

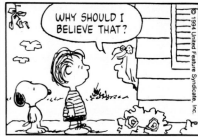

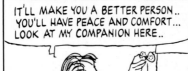

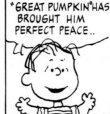

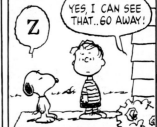

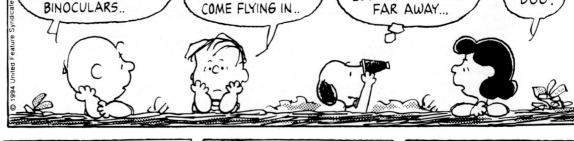

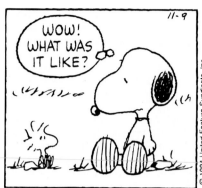

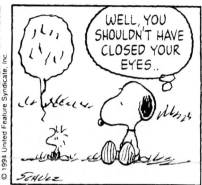

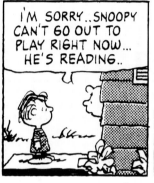

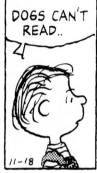

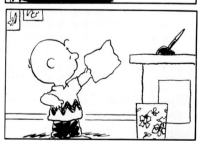

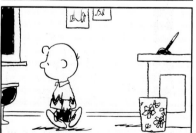

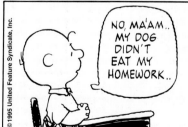

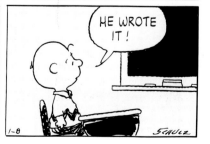

207

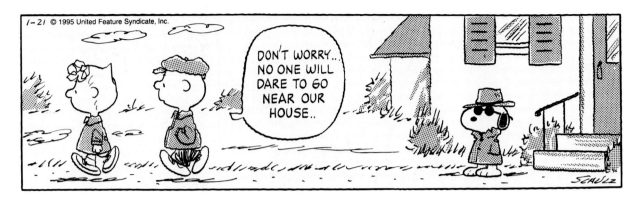

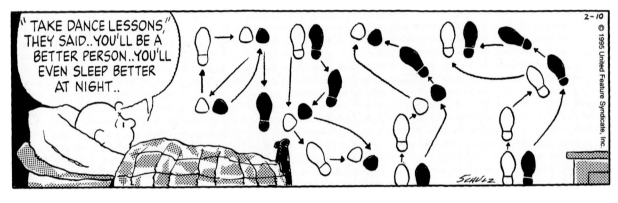

In the beginning of the strip Charlie Brown used to be a little more flippant, but then he fell into place. I like Charlie Brown for his kindness and gentleness. He's certainly the only character who's all one thing. He's a caricature. We all know what it's like to lose, but Charlie Brown keeps losing outrageously. It's not that he's a loser; he's really a decent little sort. But nothing seems to work out right. I used to say he tried too hard, and that he wanted everyone to like him too much, but I've grown away from that.

2-17

EMILY! IT'S SO NICE TO BE DANCING WITH YOU AGAIN!

JUST TO SEE YOU, AND TO HOLD YOU, AND..

MA'AM? WHO AM I DANCING WITH?

WHO AM I TALKING TO? WHO...

OH, GOOD GRIEF!

I CAN'T BELIEVE IT! I'M POSITIVE THERE WAS A GIRL NAMED EMILY, AND THAT SHE ASKED ME TO DANCE..

YOU'VE FOOLED YOURSELF BEFORE, CHARLIE BROWN, BUT YOU'RE NOT THE ONLY ONE, YOU KNOW..LOTS OF PEOPLE FOOL THEMSELVES..

2-18

I SHOULD HAVE DANCED WITH THEM..

WELL, GO AHEAD AND SHOOT.. WHAT ARE YOU WAITING FOR?

GROWING..

6-7

6-26

YOU'RE EMOTIONALLY BANKRUPT... SCOTT FITZGERALD WAS EMOTIONALLY BANKRUPT...WE'RE ALL EMOTIONALLY BANKRUPT...

OKAY, HERE WE GO...UP THROUGH THE OL' HOOP!

7-6

WE DON'T AGREE ABOUT ANYTHING, DO WE?

209

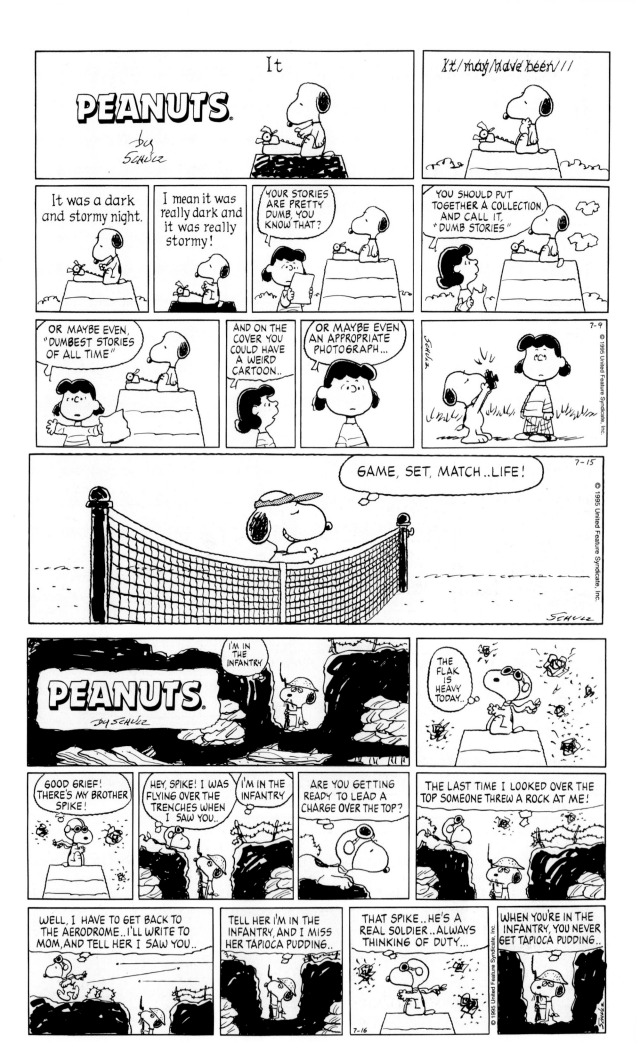

 HOW LONG IS IT GOING TO TAKE BEFORE YOU REALIZE I'M IN NO POSITION RIGHT NOW TO FEED YOU?

 I'M A QUICK LEARNER

 IS THE WORLD FAMOUS ATTORNEY ON HIS WAY TO COURT?

A VERY IMPORTANT CASE..

YES, YOUR HONOR..WE SHALL PROVE THAT MY CLIENT NEVER INTENDED TO GO INTO THE GARDEN OF MR. McGREGOR..

WHAT I'M TRYING TO SAY, YOUR HONOR, IS THAT MY CLIENT WAS SEVERELY WRONGED BY MR. McGREGOR

WHEN MR. McGREGOR CHASED MY CLIENT, THIS INNOCENT LITTLE BUNNY, WITH A RAKE, HE CAUSED HIM GREAT EMOTIONAL DISTRESS..

SNIF SNIF

YOUR HONOR, MAY WE HAVE A TEN MINUTE RECESS?

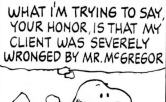
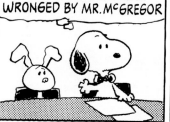
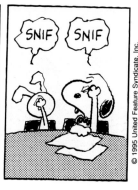
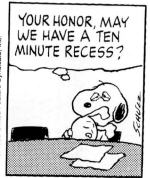

AND WHEN MY CLIENT FLED FROM THE GARDEN, HE LEFT BEHIND THE LITTLE BLUE JACKET HIS MOTHER HAD MADE FOR HIM

DID MR. McGREGOR RETURN IT? NO! HE USED THE JACKET TO DRESS HIS SCARECROW

MY CLIENT HAS SUFFERED IMMEASURABLY, YOUR HONOR..

THEREFORE, WE ARE REQUESTING REASONABLE FINANCIAL DAMAGES, LIKE MAYBE, HOW ABOUT TWO DOLLARS?

I LOST MY CASE! CAN YOU BELIEVE IT?

OF COURSE, MY STUPID CLIENT NEVER SHOULD HAVE BEEN IN MR. McGREGOR'S GARDEN

ON TOP OF THAT, THE JUDGE HATED ME..I'VE NEVER BEEN SO DEPRESSED IN MY LIFE..

HAPPY BIRTHDAY, AMY.

NO, I DON'T WANT TO HEAR A FUNNY NEW ATTORNEY JOKE!

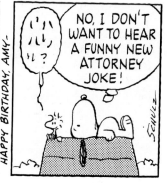

PEANUTS

JUST WAIT 'TIL I FINISH THIS CHAPTER, OKAY?

8-20

I'VE BECOME OBSOLETE!

HEY, MARCIE..LET'S GO DO SOME SHOPPING FOR SCHOOL SUPPLIES..

I DID THAT A MONTH AGO, SIR

SURE, MARCIE..AND I SUPPOSE YOU ALREADY KNOW WHICH COLLEGE YOU'RE GOING TO!

AND I'VE ENROLLED MY THREE KIDS IN PRE-SCHOOL!

9-1

THE BASES ARE LOADED AGAIN, AND THERE'S STILL NOBODY OUT..

SO WHAT DO YOU THINK?

WE LIVE IN DIFFICULT TIMES..

9-19

SO YOU'RE REALLY GOING TO THE MOON..

I'M SURPRISED

I HOPE YOU REALIZE THAT WHEN YOU GET THERE, YOU'RE GOING TO BE ALL ALONE..

10-3

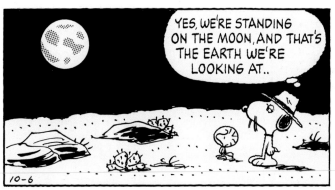
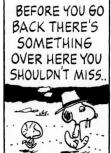
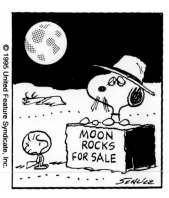

YES, WE'RE STANDING ON THE MOON, AND THAT'S THE EARTH WE'RE LOOKING AT..

BEFORE YOU GO BACK THERE'S SOMETHING OVER HERE YOU SHOULDN'T MISS..

MOON ROCKS FOR SALE

10-6

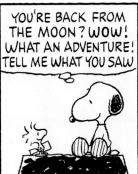
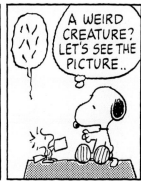
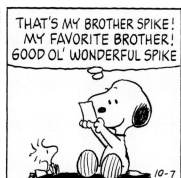
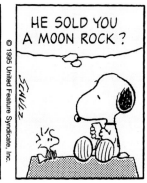

YOU'RE BACK FROM THE MOON? WOW! WHAT AN ADVENTURE! TELL ME WHAT YOU SAW

A WEIRD CREATURE? LET'S SEE THE PICTURE..

THAT'S MY BROTHER SPIKE! MY FAVORITE BROTHER! GOOD OL' WONDERFUL SPIKE

HE SOLD YOU A MOON ROCK?

10-7

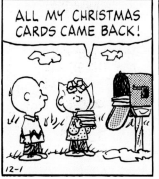
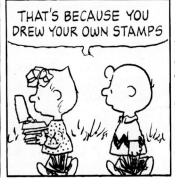
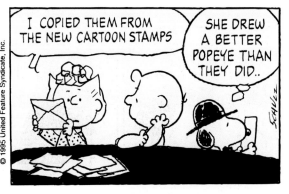

ALL MY CHRISTMAS CARDS CAME BACK!

THAT'S BECAUSE YOU DREW YOUR OWN STAMPS

I COPIED THEM FROM THE NEW CARTOON STAMPS

SHE DREW A BETTER POPEYE THAN THEY DID..

12-1

PEANUTS by SCHULZ

12-3

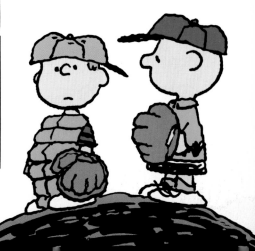

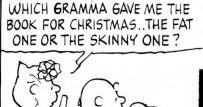
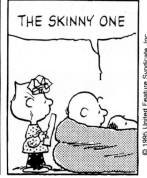

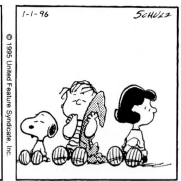

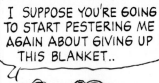

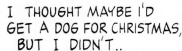
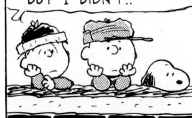

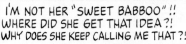

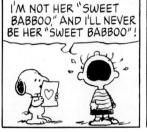

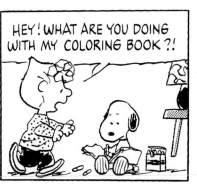

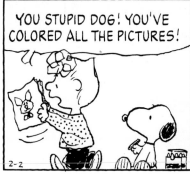

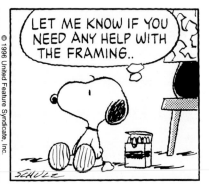

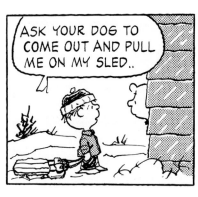

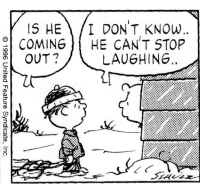

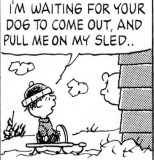

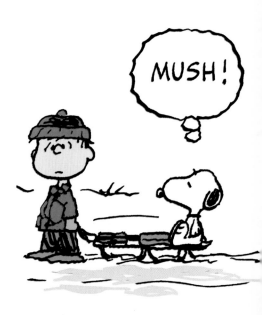

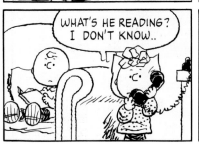

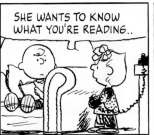

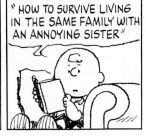

I have to admit that I don't like it when people come up to me with a three-year-old in their arms, point me out to the child and say, "Do you know who this is? This is Snoopy's father!"

An elderly couple was sitting at the table next to me in the ice arena coffee shop one morning. I noticed that she kept glancing at me, and finally she said, "I don't want to bother you, but I think I recognize you. Aren't you Snoopy's father?"

"No," I said.

"Oh, I'm sorry. You looked familiar."

"I'm Charles Schulz," I said. "And I draw Snoopy, but I'm not his father."

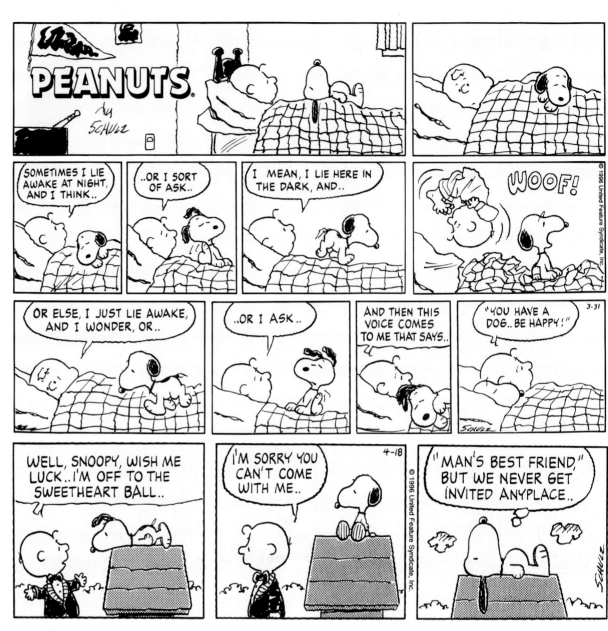

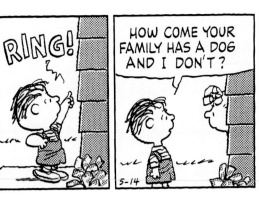

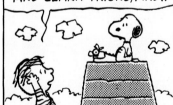
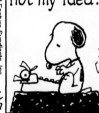

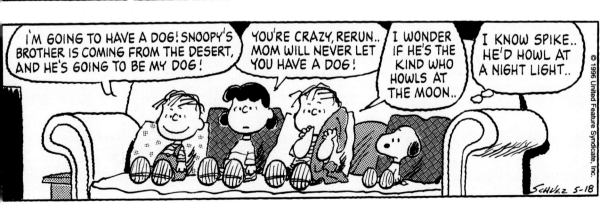

WHAT ARE YOU DOING OUT HERE?

WAITING FOR MY NEW DOG..
HOW DO YOU THINK HE'S EVER GOING TO FIND YOU?

DOGS ARE SMART.. THEY CAN FIND THEIR WAY ANYPLACE..THEY ALWAYS KNOW WHERE THEY ARE..

I THINK I LIVE AROUND HERE SOMEPLACE..
5-21

RERUN! YOUR DOG IS HERE!

WHERE?
5-23

HERE'S THE WORLD WAR I FLYING ACE CROSSING NO MAN'S LAND TO VISIT HIS BROTHER IN THE TRENCHES..
7-22

HI, SPIKE! HOW'S EVERYTHING GOING?
I'M IN THE INFANTRY

WELL, I HAVE TO GET BACK TO THE AERODROME.. HAVE A NICE DAY..

NEVER TELL AN INFANTRYMAN TO HAVE A NICE DAY..

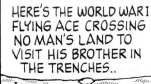

LISTEN TO THIS, SPIKE..
7-24

"TROOPSHIP 'LEVIATHAN' DOCKS AT BREST... 10,000 ABOARD.. 4,000 HAVE THE FLU"

"65,000 SOLDIERS AT CAMP PONTANEAEN HAVE THE FLU"

MY NOSE FEELS WARM..

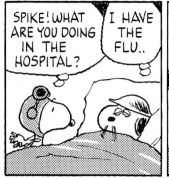
SPIKE! WHAT ARE YOU DOING IN THE HOSPITAL?
I HAVE THE FLU..

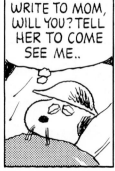
WRITE TO MOM, WILL YOU? TELL HER TO COME SEE ME..

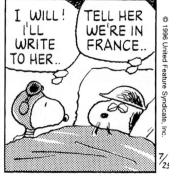
I WILL! I'LL WRITE TO HER..
TELL HER WE'RE IN FRANCE..

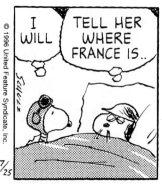
I WILL
TELL HER WHERE FRANCE IS..
7/25

Snoopy's appearance and personality have changed probably more than those of any of the other characters. As my drawing style loosened, Snoopy was able to do more things, and when I finally developed the formula of using his imagination to dream of being many heroic figures, the strip took on a completely new dimension.

 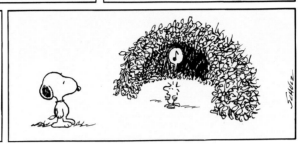

GUESS WHAT, SPIKE.. I WROTE TO MOM, AND SHE'S COMING OVER HERE ON A TROOPSHIP TO SEE YOU..

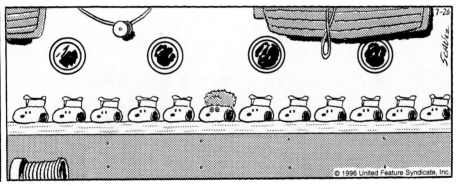

 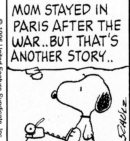

And when Spike saw his mom, he immediately **felt better.**

"I brought you some tapioca pudding," she said. "You're the best mom in the world," said Spike.

THAT'S THE DUMBEST STORY I'VE EVER READ! HOW DID SHE EVER GET HOME?

MOM STAYED IN PARIS AFTER THE WAR..BUT THAT'S ANOTHER STORY..

 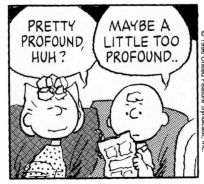 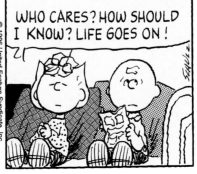

I NOW HAVE THREE PHILOSOPHIES..."LIFE GOES ON," "WHO CARES?" AND "HOW SHOULD I KNOW?"

PRETTY PROFOUND, HUH? | MAYBE A LITTLE TOO PROFOUND..

WHO CARES? HOW SHOULD I KNOW? LIFE GOES ON !

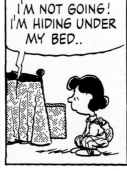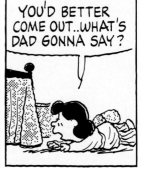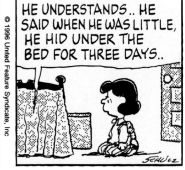

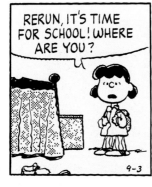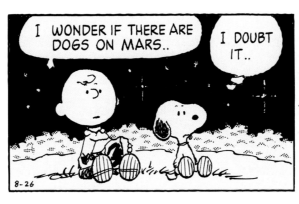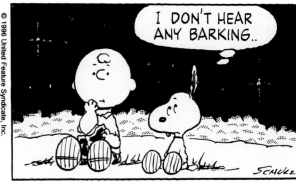

When characters work in a comic strip it is because one thing leads to another, and the very personality that you have given him or her starts to provide you with more ideas. The fussier Lucy became, the more ideas she gave me. Her persecution of poor Linus, after he came along, accounted for years and years of ideas. Then came their little brother, Rerun. At first I was sorry I had brought him in. All I could think of doing with him was placing him on the back of his mother's bicycle. Lately, however, I have put him in kindergarten, which was probably inspired by our own grandchildren. Suddenly Lucy's personality has mellowed, and she has become the only *Peanuts* character to pay much attention to him. We have seen her playing games with Rerun and actually trying to teach him a few things, but directly opposite of the outrageous teachings she used to push upon Linus.

This, then, is the problem— what do we do with Lucy? She seems no longer to be a fussbudget, but we also don't want her to be too nice. Anyway, comic strips go along from day to day and fortunately it is nothing too serious to worry about.

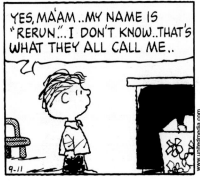

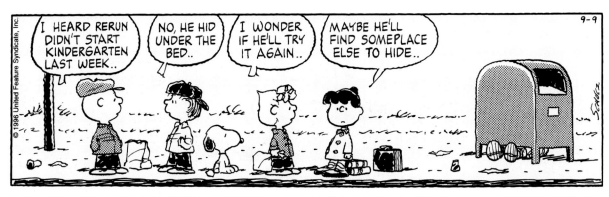

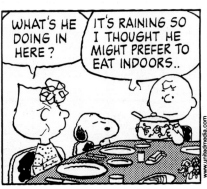
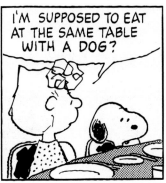
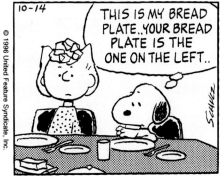

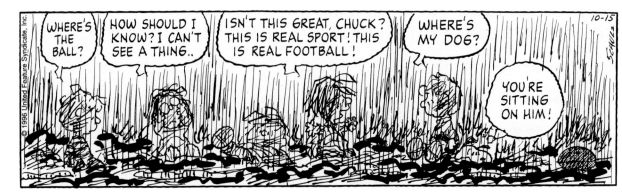

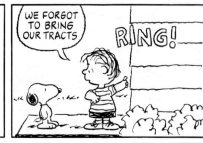

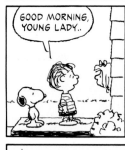
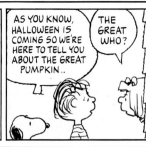
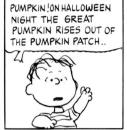
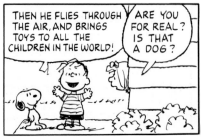

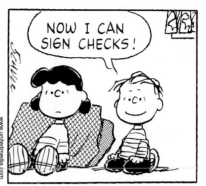

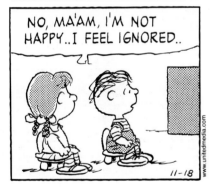
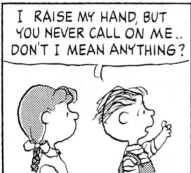
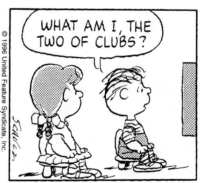

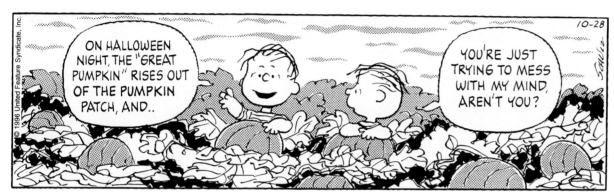

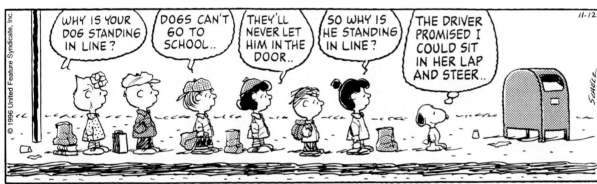

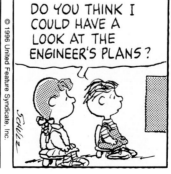

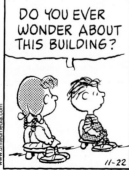

223

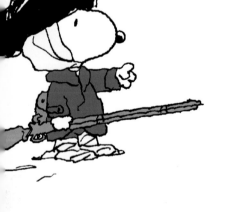

Strip 1 (11-23):

WE DON'T HAVE HOMEWORK IN KINDERGARTEN..

I KNOW.. YOU'RE LUCKY.. WHEN WE DO, I'LL TELL THE TEACHER MY DOG ATE MY HOMEWORK..

YOU DON'T HAVE A DOG.. I'LL BORROW A DOG.. WRITE YOUR HOMEWORK ON A DOUGHNUT, AND I'LL EAT IT..

Sunday strip:

PEANUTS BY SCHULZ

"DEAR MOM, I'VE NEVER BEEN SO COLD IN MY LIFE"

AT LEAST IT'S STOPPED SNOWING..

HERE'S THE WORLD FAMOUS REVOLUTIONARY WAR PATRIOT STANDING GUARD AT VALLEY FORGE..

TELL GENERAL WASHINGTON ONE OF HIS MEN WANTS TO SEE HIM..

YES, SIR..I HAVE A LITTLE SUGGESTION..

YOU MAY OR MAY NOT HAVE NOTICED THAT THERE'S A LOT OF SNOW HERE..

MY IDEA IS WE BUILD A SKATING RINK OUT THERE..WE COULD ORGANIZE A HOCKEY TEAM..

MAYBE EVEN START SOME KIND OF A FIGURE SKATING CLUB..

WE COULD EVEN INVITE SOME OF THE CHICKS FROM TOWN FOR A SKATING PARTY..

I DIDN'T GET A CHANCE TO TELL HIM HE COULD DRIVE THE ZAMBONI..

Strip (1-13):

I'M TIRED OF ALL THIS KINDERGARTEN STUFF.. WHY DON'T WE RUN AWAY TO PARIS?

IF WE GOT ON A PLANE AT MIDNIGHT, WE COULD BE IN PARIS TOMORROW..

DO YOU HAVE ANY MONEY? I HAVE FIFTY CENTS..MAYBE WE COULD GET UPGRADED TO BUSINESS CLASS

Strip (1-16):

YES, SIR, MR. PRINCIPAL... WHO? THE LITTLE GIRL WITH THE BRAIDS? SURE, WE'RE IN THE SAME KINDERGARTEN CLASS..

DID I ASK HER TO GO TO PARIS?

WELL, SURE, BUT THAT WAS JUST A JOKE..

I MEAN, HOW...

HARASSMENT?!!

IT'S ONLY ME! I'M HOME EARLY..

I'VE BEEN FIRED!

THIS LITTLE GIRL IN MY CLASS WAS SORT OF DEPRESSED, SEE, SO I SAID, "WHY DON'T WE RUN AWAY TO PARIS?" IT WAS A JOKE

SHE THOUGHT IT WAS FUNNY SO SHE TOLD HER MOTHER, WHO TOLD OUR TEACHER, WHO TOLD THE PRINCIPAL, AND I GOT FIRED!

SUSPENDED. I GUESS SO..

HARASSMENT?

STUPIDITY!

PEANUTS by SCHULZ

HERE, YOU GOT SOME MORE LETTERS FROM EDITORS..

DO THEY LIKE MY STORIES?

"DEAR CONTRIBUTOR, WHO TOLD YOU THAT YOU COULD WRITE, YOUR MOTHER?"

"DEAR CONTRIBUTOR, WE'VE SEEN BETTER WRITING ON LICENSE PLATES.."

"DEAR CONTRIBUTOR, IF YOU SEND US ANY MORE STORIES, WE'RE COMING TO YOUR HOUSE AND PUNCH YOU OUT!"

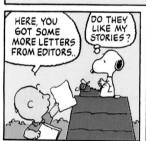
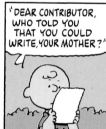
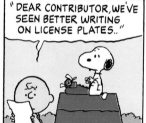

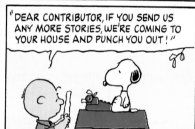

"DEAR CONTRIBUTOR, IF YOU SEND US ONE MORE DUMB STORY, WE'RE GOING TO HAVE TO NAIL OUR MAILBOX SHUT!"

I FILED THEM WITH ALL THE OTHERS..

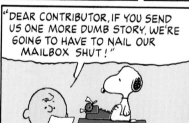

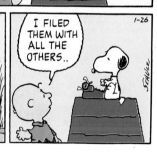

I THINK I'VE DISCOVERED THE SECRET TO LIFE..

YOU JUST HANG AROUND UNTIL YOU GET USED TO IT..

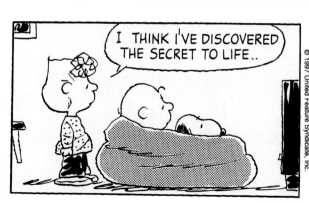
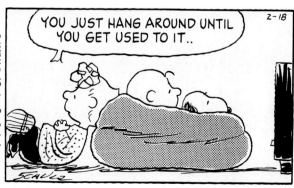

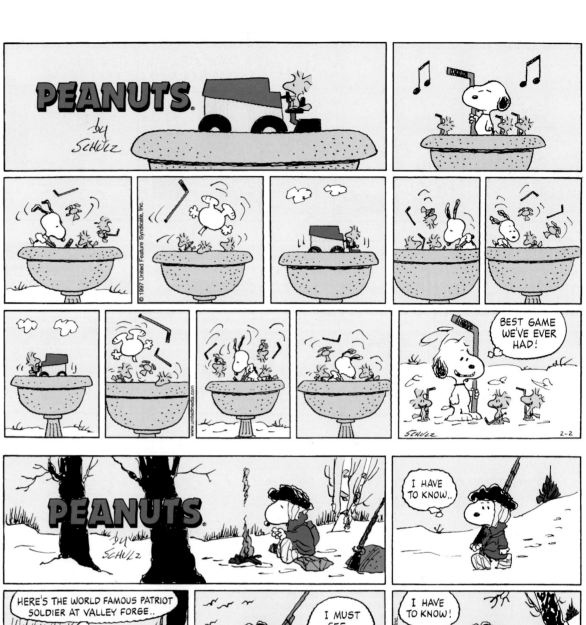

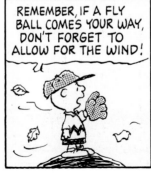

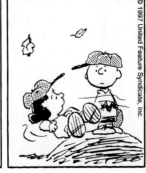

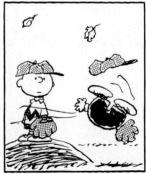

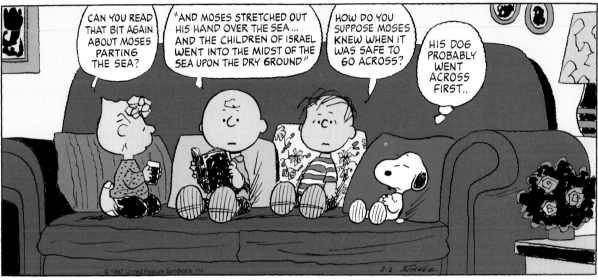

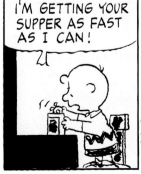

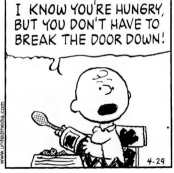

Rerun Van Pelt is often mistaken for Linus even though he's his little brother. He can always be recognized in his trademark overalls. Rerun is more skeptical than his brother, much harder to convince, and always gets around Lucy where Linus gives in. His only fear is being the passenger on one of his mother's bicycle-riding errands. Somehow, Rerun is the only witness to her riding into grates and potholes. Luckily, he now always wears a helmet. Rerun also longs for a dog of his own, but since his parents won't let him have one, he tries to "borrow" Snoopy from Charlie Brown. Snoopy won't have any part of it unless Rerun brings cookies.

I went to a concert given by the local symphony orchestra during which it performed a new compostion by Ellen Zwilich. It gave me an idea for a cartoon, and so I used her name one day in the strip. She very kindly wrote to me, and we became acquainted. Apparently, Carnegie Hall had a series of family concerts, and someone proposed that she compose something special for one of them, so she looked at the *Peanuts* characters and wrote a 12-minute piano concerto.

I was very flattered because this is a very wonderful piece and written by a truly classical composer. Now of course, it's not the first music inspired by Charlie Brown and his friends. There is the famous song on Linus and Lucy by Vince Guaraldi, and of course there were the musicals *You're a Good Man Charlie Brown* and *Snoopy*.

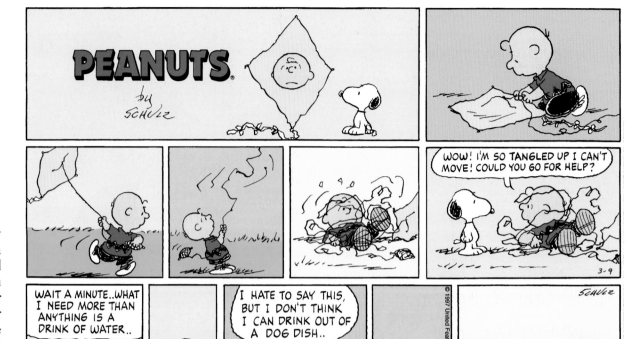

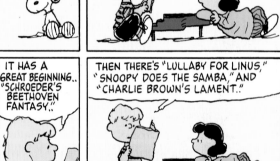

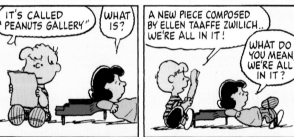

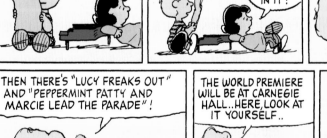

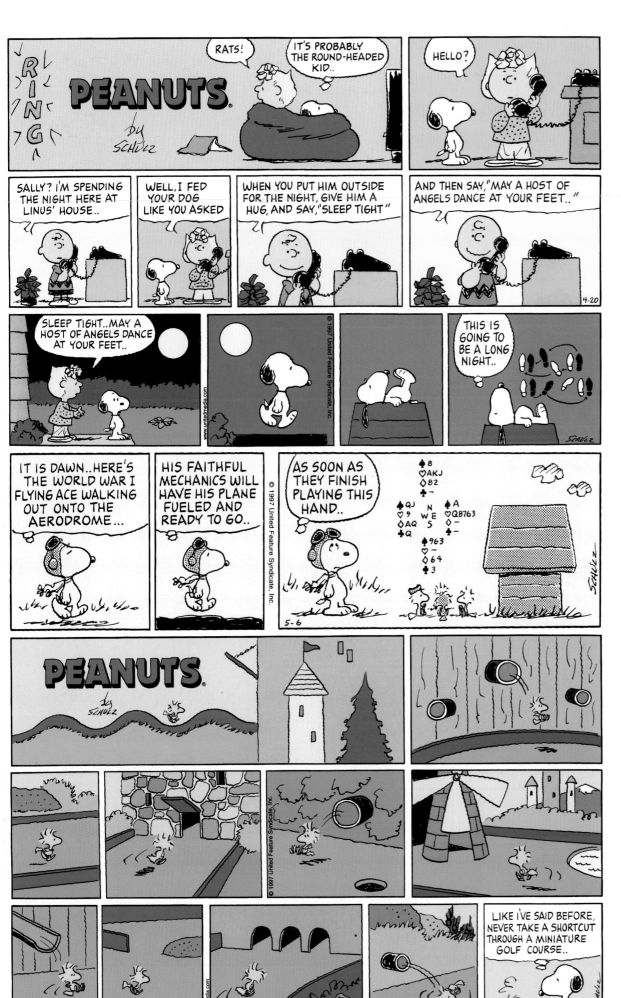

YOU GOT HERE FAST.. WHEN DID YOU LEAVE?

THE BIG WING WAS ON TWO, AND THE SMALL WING WAS ON NINE?

SOMEDAY YOU SHOULD LEARN TO TELL TIME..

5-1

MORALE IS LOW AT VALLEY FORGE..

THE TROOPS ARE HUNGRY.. NOTHING TO EAT BUT FIRECAKE AND WATER..

AND THIS MORNING GENERAL WASHINGTON GAVE US MORE BAD NEWS...

WE'RE ALL OUT OF GRAPE JELLY!

5-22

7-10

HAVING AN OLDER SISTER IS LIKE HAVING A COMPASS TO GUIDE YOU THROUGH LIFE..

IS THAT TRUE?

I'M NOT HERE..

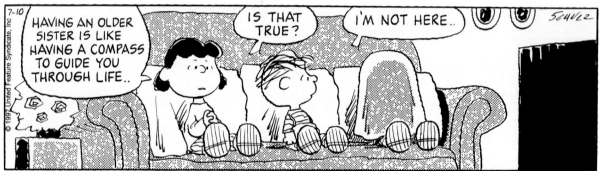

ASK YOUR DAD IF HE WANTS ME TO RAKE YOUR LEAVES..

OUR LEAVES ARE STILL ON THE TREES..

YOU'RE RIGHT..

SHOULD I COME BACK TOMORROW?

8/12

ASK YOUR DOG IF HE WANTS TO COME OUT AND PLAY..

8-20

THERE'S A STUPID KID OUT FRONT WHO WANTS TO PLAY..

ASK HIM IF HE KNOWS "GO FISH"

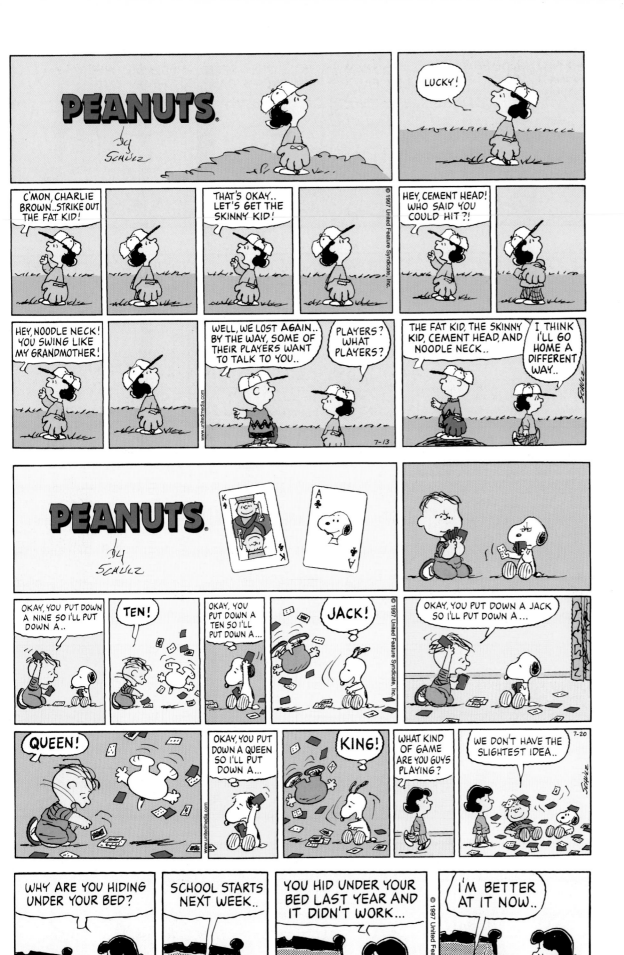

YES, SIR..MY DOG NEEDS A NEW SUPPER DISH..

HE WEARS THEM OUT VERY FAST..

NO, I ONLY FEED HIM ONCE A DAY..

PLEASE! JUST PAY HIM, AND LET'S GET OUT OF HERE..

THE MAN AT THE STORE THOUGHT IT WAS VERY FUNNY THAT YOU WEAR OUT SO MANY SUPPER DISHES..

HE SAID HIS DOG HAS HAD THE SAME DISH ALL HIS LIFE..

HE PROBABLY NEVER LICKS THE BOTTOM OF THE DISH..

YES, SIR..WE NEED ANOTHER NEW SUPPER DISH..

THE OTHER ONE DIDN'T LAST LONG..SEE? HE ATE RIGHT THROUGH THE BOTTOM

WE BOUGHT IT HERE YESTERDAY, REMEMBER?

NO, I THINK HE ATE THE SALES SLIP..

MY DAD SAYS WE CAN'T AFFORD TO KEEP BUYING YOU NEW SUPPER DISHES..

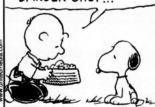
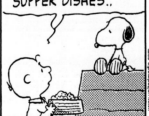

HE SAYS HE MAY HAVE TO REMORTGAGE OUR HOUSE AND HIS BARBER SHOP...

I DON'T KNOW.. HE MAY JUST BE JOKING..

I CAN'T LAUGH WHILE I'M EATING..

YES, MA'AM..THAT'S MY DOG OUTSIDE..

WELL, HE DOESN'T LIKE BEING ALONE ALL DAY...

NO, HE'LL JUST WAIT FOR ME OUT THERE ON THE FRONT STEPS..HE'LL FIND SOMETHING TO DO..

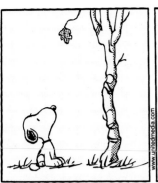
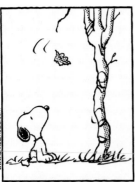
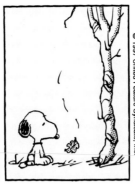
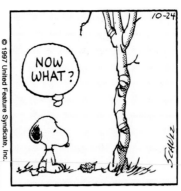

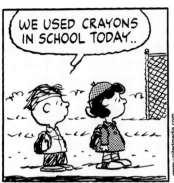
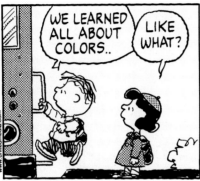
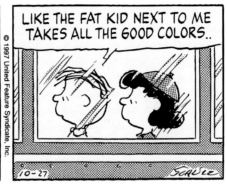

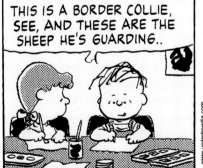
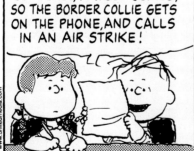
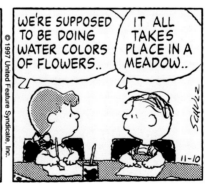

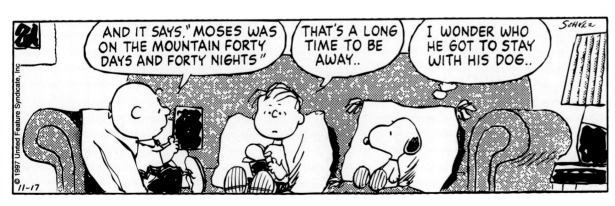

The Sunday Colors

Editor's Note:

Today, the Sunday strips are colored on computer.

After Sparky draws the strip, a photocopy

of it is hand colored and numbered according

to the printer's color charts. The black-and-white

line art, along with the color guide,

are sent to the syndicate for editing

before going to the printer.

The printer uses a scanned

image of the line art,

adding color according

to the color guide.

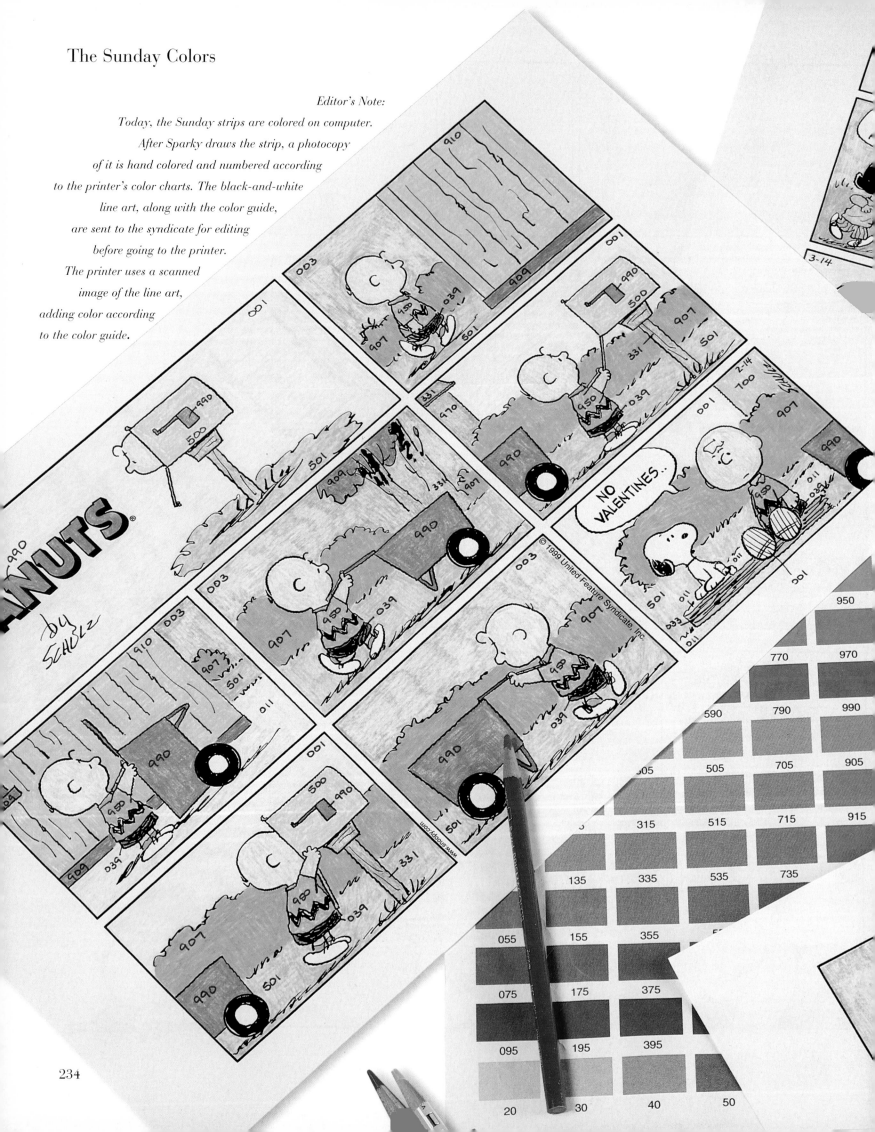

234

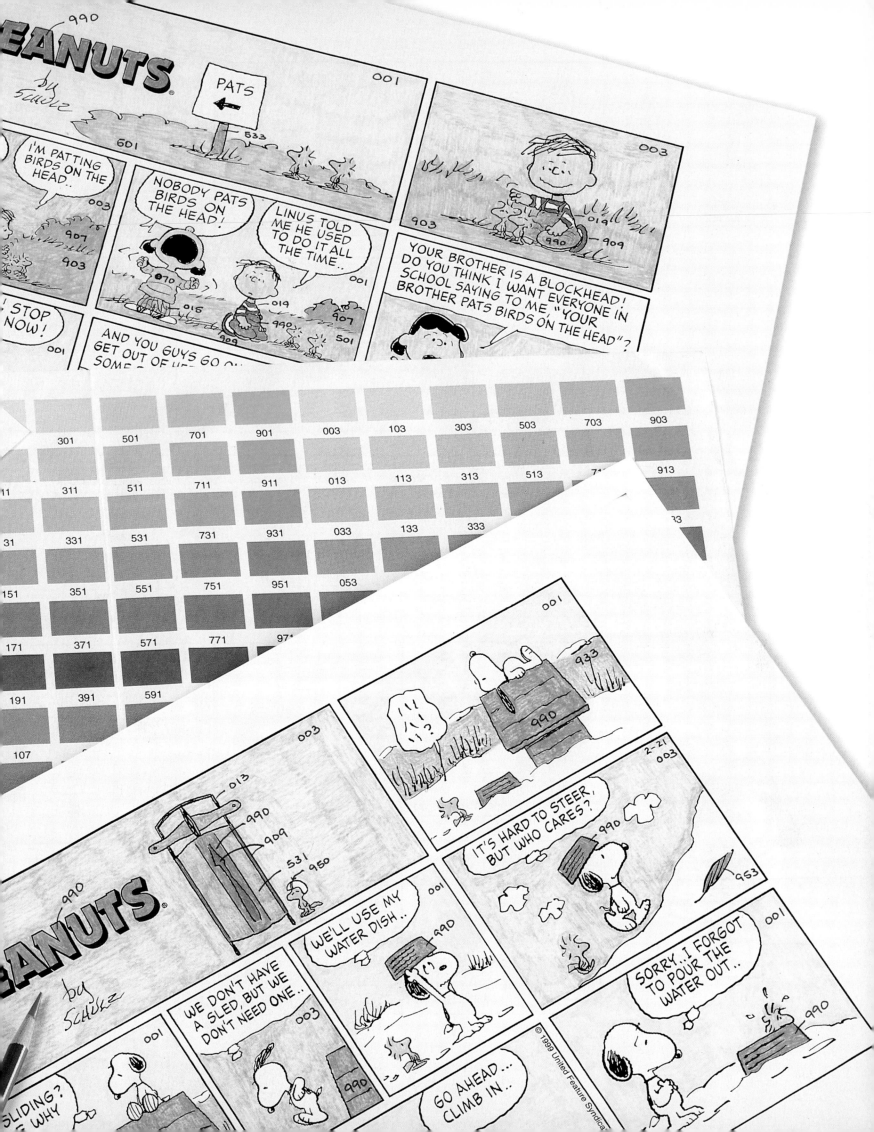

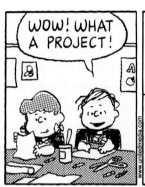

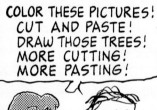

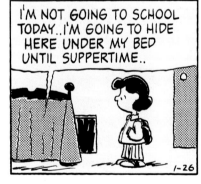

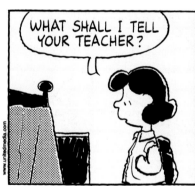

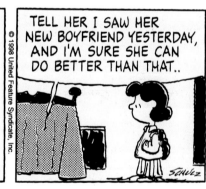

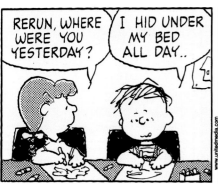

RERUN, WHERE WERE YOU YESTERDAY?

I HID UNDER MY BED ALL DAY..

I THINK IT'S SOMETHING EVERYONE SHOULD DO ONCE IN A WHILE..

WHAT DOES YOUR DAD THINK ABOUT ALL THIS?

HE DIDN'T GO TO WORK TODAY... HE'S HIDING UNDER THE BED..

1-28

© 1998 United Feature Syndicate, Inc.

SCHULZ 2-23

WHAT ARE THE WORDS YOU HATE MOST TO HEAR?

"YOU STAY HOME NOW, AND BE A GOOD DOG"

WHAT ARE YOU PAINTING?

THIS IS GOING TO BE MY GREATEST WORK..

I'M PAINTING A HUGE LANDSCAPE WITH TWO MIGHTY ARMIES FACING EACH OTHER ACROSS AN ENORMOUS VALLEY BENEATH A WIDE SKY WITH DARK STORM CLOUDS GATHERING IN THE DISTANCE..

2-24

IT LOOKS MORE LIKE A DUCK LANDING ON THE WATER..

THAT'S WHAT I CALL IT... "DUCK LANDING ON THE WATER"

EVERYBODY IN THE WORLD HAS A DOG..WHY WON'T MOM LET ME HAVE A DOG?

A LOT OF PEOPLE IN THE WORLD DON'T HAVE DOGS..

WHY WON'T MOM LET THEM HAVE A DOG?

3-26

WHAT I THINK I'LL DO TODAY IS TAKE SOME MONEY OUT OF MY COLLEGE TRUST FUND, AND GO BUY A DOG..

YOU DON'T HAVE A COLLEGE TRUST FUND

I DON'T?

PLEASE PASS THE GRAPE JELLY..

WE'RE ALL OUT OF GRAPE JELLY..

3-27

HOW CAN ANYONE NOT HAVE A DOG, A COLLEGE TRUST FUND AND GRAPE JELLY?

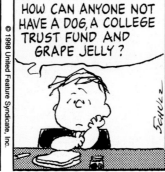

© 1998 United Feature Syndicate, Inc.

237

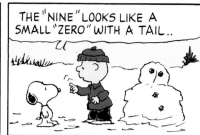

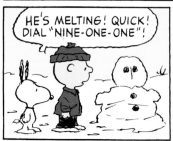

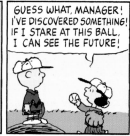
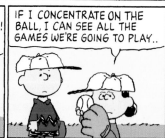
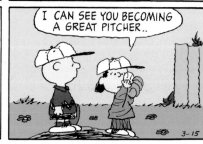

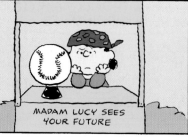
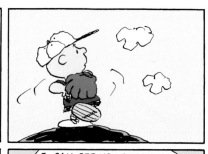

READY TO GO..

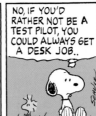
NO, IF YOU'D RATHER NOT BE A TEST PILOT, YOU COULD ALWAYS GET A DESK JOB..

THERE'S A GREAT BIG ALLIGATOR SNEAKING UP BEHIND YOU..

"APRIL FOOL!" **"APRIL FOOLS' DAY" WAS YESTERDAY..**

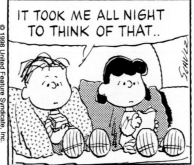
IT TOOK ME ALL NIGHT TO THINK OF THAT..

LUNCH TIME?

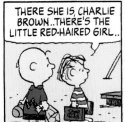
THERE SHE IS, CHARLIE BROWN..THERE'S THE LITTLE RED-HAIRED GIRL..

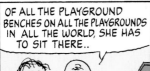
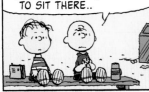
OF ALL THE PLAYGROUND BENCHES ON ALL THE PLAYGROUNDS IN ALL THE WORLD, SHE HAS TO SIT THERE..

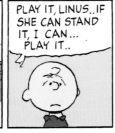
PLAY IT, LINUS..IF SHE CAN STAND IT, I CAN... PLAY IT..

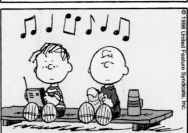

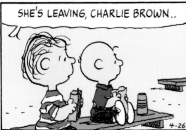
SHE'S LEAVING, CHARLIE BROWN..

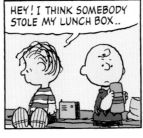
HERE'S LOOKING AT YOU, KID..

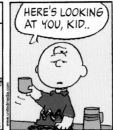
HEY! I THINK SOMEBODY STOLE MY LUNCH BOX..

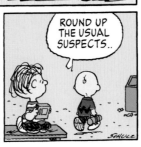
ROUND UP THE USUAL SUSPECTS..

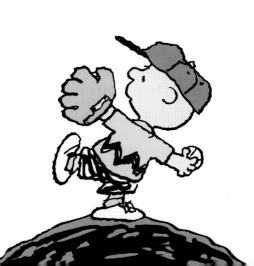

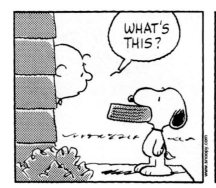
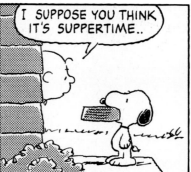
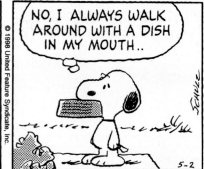

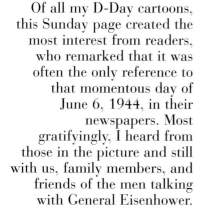

Of all my D-Day cartoons, this Sunday page created the most interest from readers, who remarked that it was often the only reference to that momentous day of June 6, 1944, in their newspapers. Most gratifyingly, I heard from those in the picture and still with us, family members, and friends of the men talking with General Eisenhower.

The photograph itself was taken just before these men of the 101st Airborne Division parachuted into Normandy. According to Wallace Strobel, who was the young lieutenant with the number 23 on his chest, he had just been asked by Ike where he was from. "Michigan, Sir." Ike brought up his thumb and said "Go get 'em, Michigan."

I was glad to sign copies of the cartoon for Mr. Strobel, his family, and for others related to the men in the picture.

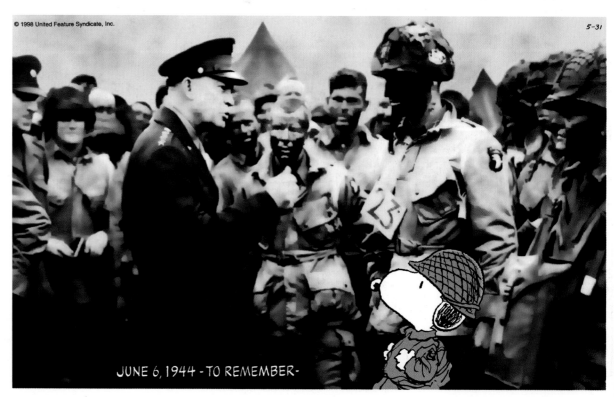

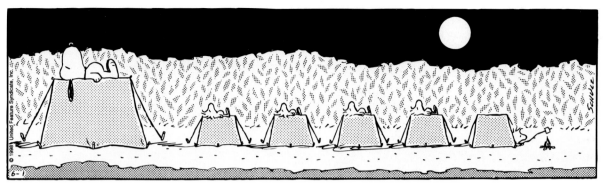

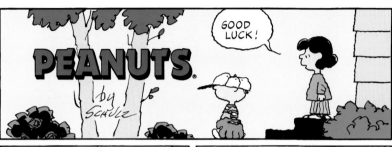

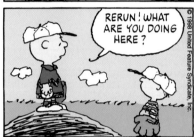

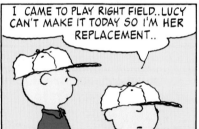

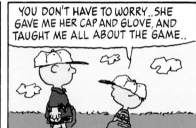

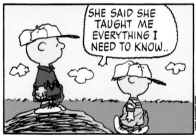

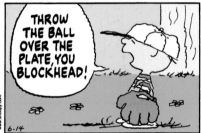

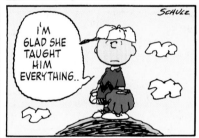

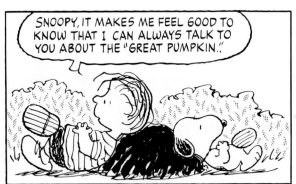

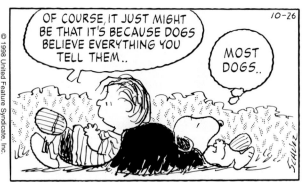

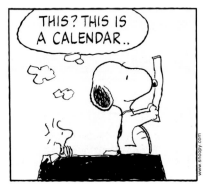

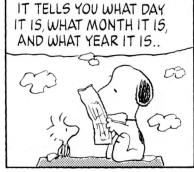

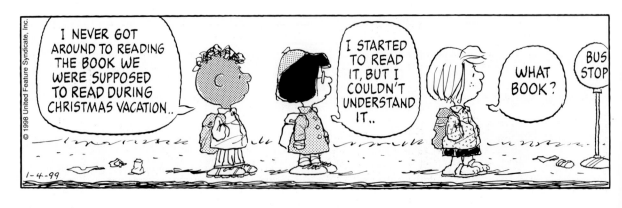

PEANUTS by SCHULZ

DO NOT OPEN UNTIL SOMEDAY

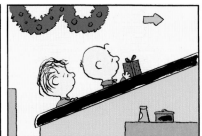

YES, MA'AM..I'D LIKE TO RETURN SOMETHING I BOUGHT HERE..

IT'S A CHRISTMAS PRESENT FOR A GIRL, BUT HE WAS TOO SHY TO GIVE IT TO HER..

IT WAS NEVER OPENED..

YES, I WAS GOING TO GIVE IT TO A LITTLE RED-HAIRED GIRL IN OUR CLASS..

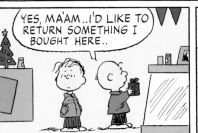

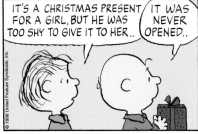

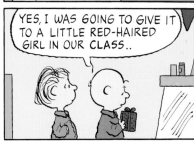

YOU KNOW HER?

YOU'RE HER MOM?

YOU WORK HERE? IN THIS STORE? YOU'RE HER MOM, AND YOU WORK HERE?

WHEN WE FIRST SAW YOU, WE THOUGHT YOU WERE HER OLDER SISTER..

WHY DID YOU TELL HER THAT?

SHE LET YOU RETURN THE PRESENT, DIDN'T SHE?

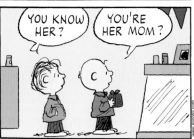

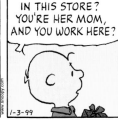

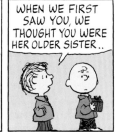

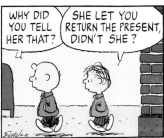

1-3-99

1-5-99

I HOPE YOU APPRECIATED THE GOOD SERVICE..

THE UMBRELLA WAS THE WRONG COLOR..

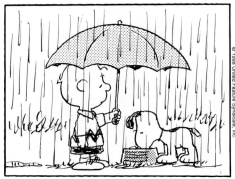

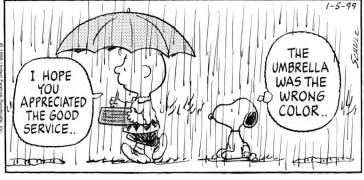

"What do dogs think about?" she wondered.

"Someday," thought the dog, "someone is going to leave the gate open, and I'll be out of here like a rocket."

"I suppose," she said, "all they think about is eating."

"Just don't stand too close to that gate," the dog chuckled.

1-7-99

NO, I HAVEN'T HEARD ANY DOUGHNUTS CALLING YOU..DOUGHNUTS CAN'T TALK..

MAYBE SO, BUT I'VE HEARD THEM TELL SOME PRETTY FUNNY STORIES

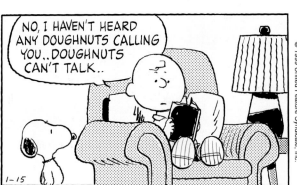

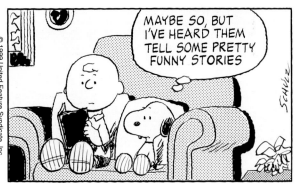

1-15

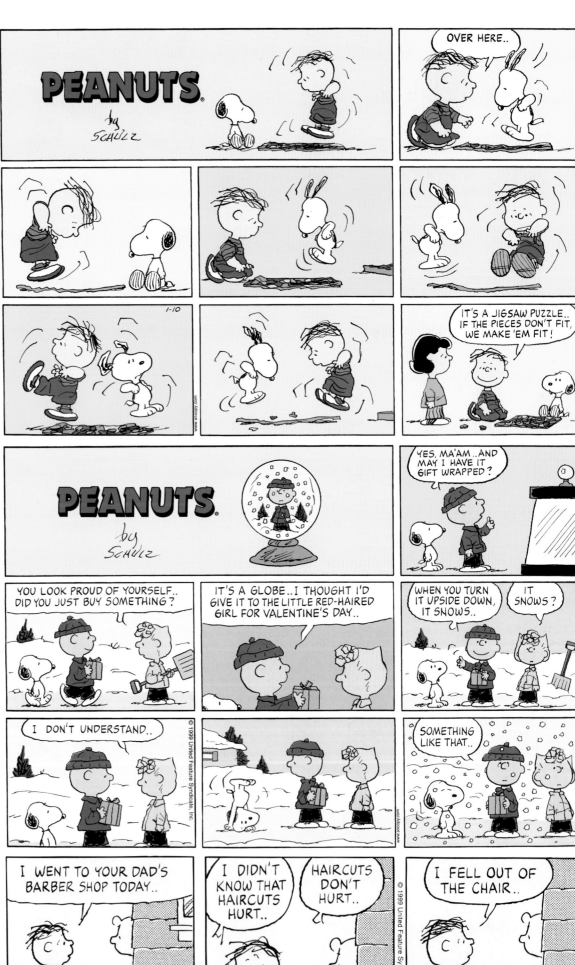

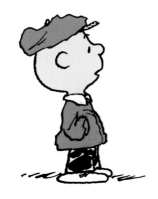

YES, SIR..I'D LIKE TO BUY A NEW KITE..

OH, RED, BLUE, YELLOW... I DON'T CARE..THE COLOR DOESN'T MATTER..

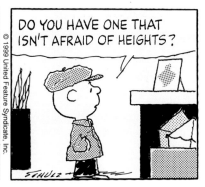

DO YOU HAVE ONE THAT ISN'T AFRAID OF HEIGHTS?

PEANUTS

PATS

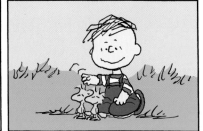

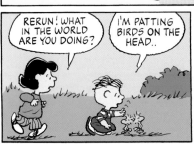

RERUN! WHAT IN THE WORLD ARE YOU DOING?

I'M PATTING BIRDS ON THE HEAD..

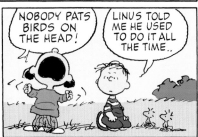

NOBODY PATS BIRDS ON THE HEAD!

LINUS TOLD ME HE USED TO DO IT ALL THE TIME..

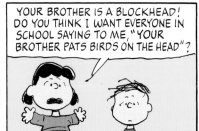

YOUR BROTHER IS A BLOCKHEAD! DO YOU THINK I WANT EVERYONE IN SCHOOL SAYING TO ME, "YOUR BROTHER PATS BIRDS ON THE HEAD"?

STOP IT! STOP IT RIGHT NOW!

AND YOU GUYS GO ON HOME! GET OUT OF HERE! GO FLY WITH SOME DUCKS OR SOMETHING!

I CAN'T HELP IT.. HE ALREADY HAD AN APPOINTMENT..

SO HERE'S THE LIST OF PLAYERS WHO ARE ON OUR TEAM THIS YEAR..

HOW ABOUT "YOU KNOW WHO"?

"YOU KNOW WHO" IS IN RIGHT FIELD AGAIN..

I AM?

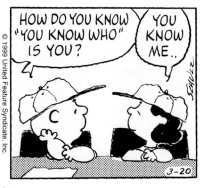

HOW DO YOU KNOW "YOU KNOW WHO" IS YOU?

YOU KNOW ME..

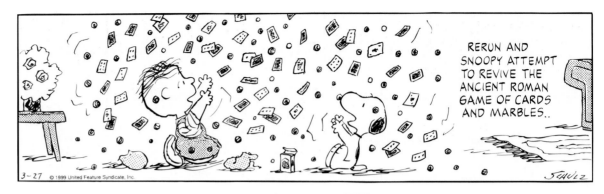

RERUN AND SNOOPY ATTEMPT TO REVIVE THE ANCIENT ROMAN GAME OF CARDS AND MARBLES..

PEANUTS by SCHULZ

 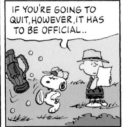 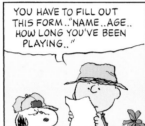 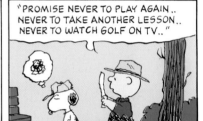

READY TO QUIT THE GAME, HUH? WELL, I DON'T BLAME YOU..

IF YOU'RE GOING TO QUIT, HOWEVER, IT HAS TO BE OFFICIAL..

YOU HAVE TO FILL OUT THIS FORM.."NAME..AGE.. HOW LONG YOU'VE BEEN PLAYING.."

"PROMISE NEVER TO PLAY AGAIN.. NEVER TO TAKE ANOTHER LESSON.. NEVER TO WATCH GOLF ON TV.."

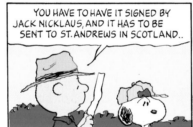 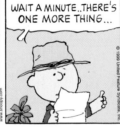 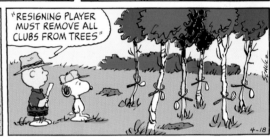

YOU HAVE TO HAVE IT SIGNED BY JACK NICKLAUS, AND IT HAS TO BE SENT TO ST. ANDREWS IN SCOTLAND..

WAIT A MINUTE..THERE'S ONE MORE THING...

"RESIGNING PLAYER MUST REMOVE ALL CLUBS FROM TREES"

PEANUTS by SCHULZ

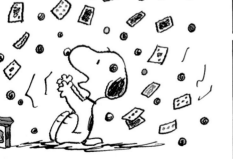

YOU SEE, THE PROBLEM IS I'M TOO YOUNG... I'M TOO SMALL..

IT ISN'T AS THOUGH THEY THINK I'M INFERIOR.. LIKE MAYBE I'M A DOG OR SOMETHING..

OKAY, WHERE'S OUR SHORTSTOP?

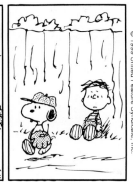
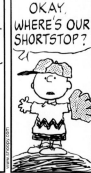
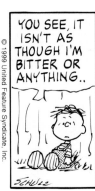

YOU SEE, IT ISN'T AS THOUGH I'M BITTER OR ANYTHING..

4-27

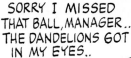
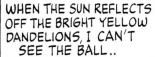

SORRY I MISSED THAT BALL, MANAGER.. THE DANDELIONS GOT IN MY EYES..

WHEN THE SUN REFLECTS OFF THE BRIGHT YELLOW DANDELIONS, I CAN'T SEE THE BALL..

THAT'S THE WORST EXCUSE I'VE EVER HEARD!

BE PATIENT.. I HAVE TWENTY-THREE NEW ONES!

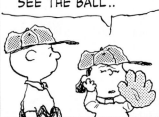
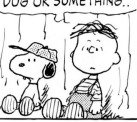
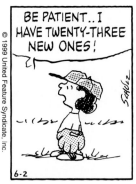

6-2

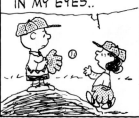
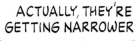

ARE THE DAYS GETTING LONGER OR SHORTER?

ACTUALLY, THEY'RE GETTING NARROWER

SOME MORNINGS, WHEN YOU GET UP, THE DAY IS SO NARROW YOU CAN HARDLY SQUEEZE IN..

I NEVER KNOW WHAT YOU'RE TALKING ABOUT..

TODAY SEEMS TO BE PRETTY WIDE..

6-8

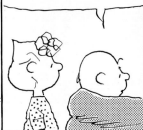

BONK!

WHY DON'T YOU JUST GET RID OF THE CELL PHONE?

6-14

6-17

LET ME ASK YOU SOMETHING...

DO YOU KNOW WHY WE'RE OUT HERE?

The 90s

At different times I have included in the strip names of people I admire. Names such as General Eisenhower, Billie Jean King, Joe Garagiola, Bill Mauldin, Ernie Pyle, and so forth. Sometimes I even like to pay a special tribute to another cartoonist like Patrick McDonnell. I imagine there were readers who may not have understood this strip, but Patrick was well aware of the tribute I was paying him.

I have an unbounded admiration for the work of Andrew Wyeth. When I stand in front of one of his paintings at an exhibition, I find I can only exclaim, "How does he do it?" Looking at my own work some days I feel exactly like little Rerun when he crumples his work, throws it over his shoulder and says, "I will never be Andrew Wyeth."

In this Sunday page where we see Snoopy at Valley Forge, I have included in the center panel a simplified version of a tree that Andrew Wyeth painted in his work entitled *Lafayette's Headquarters*. This is my very small tribute to Andrew Wyeth.

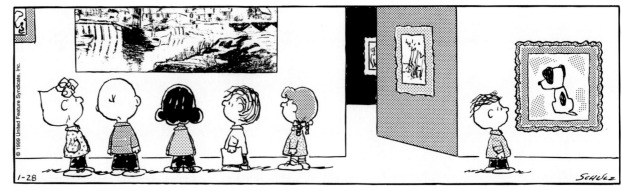

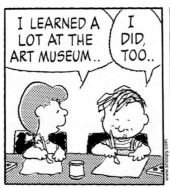
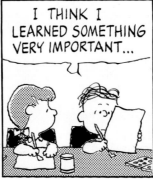

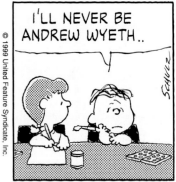
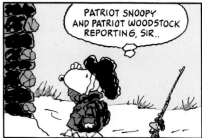

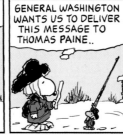
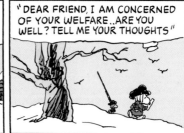
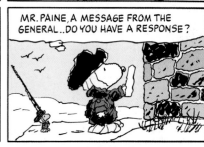

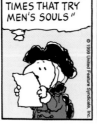

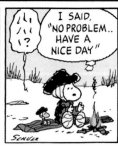

248

Charlie Brown at Work

Every day, Sparky sits down at the same drawing board he has had for many years. After roughing out the story in pencil, he draws the caption balloons. Then with his favorite nib dipping into the small bottle of india ink, he draws in the words. This is done first because what is said is very important, and it's easier to adjust the figures, their expressions, or the background, than to alter the lettering.

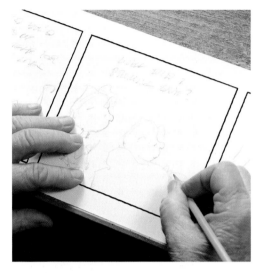

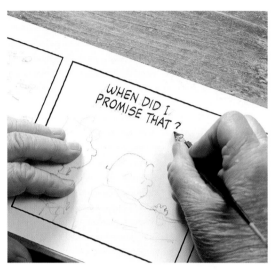

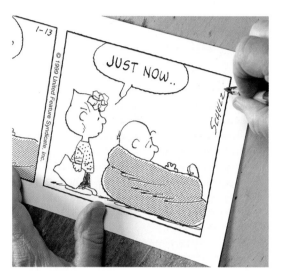

Sparky takes great pride in his lettering. Many other cartoonists have someone else pen in the words, but Sparky has always done his own. Look how well spaced the individual letters are. His illustrating skills are now better than ever, with a looser, more dramatic edge than the smooth, slick line of 50 years ago.

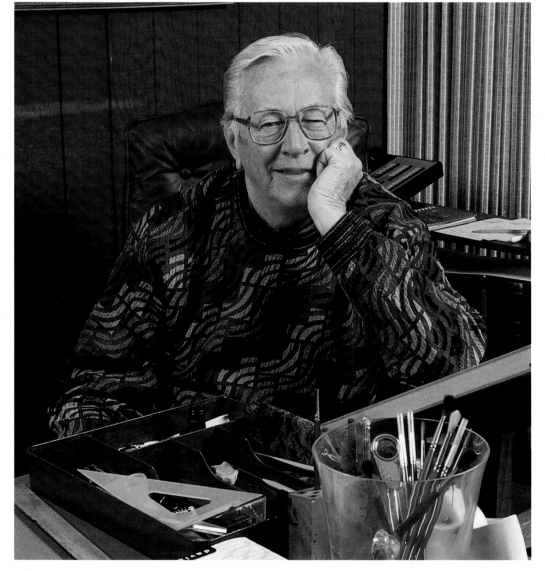

Sparky has no intention of ever stopping work on the strip, but he hinted that he might when he wore through the thickness of his drawing board.

The Studio

Conclusion

IT IS EXTREMELY IMPORTANT for a cartoonist to be a person of observation. He not only has to observe the strange things that people do and listen to the strange things that they say, but he also has to be reasonably observant as to the appearance of objects in the world around him. Some cartoonists keep a file of things they might have to draw. Other cartoonists do a good deal of actual sketching. This kind of observing has led me to something I can only describe as mental drawing, and at times that has become a real burden, for I seem to be unable to stop it. While I am carrying on a conversation with someone, I find that I am drawing with my eyes. I find myself observing how his shirt collar comes around from behind his neck and perhaps casts a slight shadow on one side. I observe how the wrinkles in his sleeve form and how his arm may be resting on the edge of the chair. I observe how the features on his face move back and forth in perspective as he rotates his head. It actually is a form of sketching and I believe that it is the next best thing to drawing itself. I sometimes feel it is obsessive, but at least it accomplishes something for me.

It is also important to me, when I am discussing the comic strips, to make certain that everyone knows that I do not regard what I am doing as Great Art. I am certainly not ashamed of the work I do, nor do I apologize for being involved in a field that is generally regarded as occupying a very low rung on the entertainment ladder. I am all too aware of the fact that when a reviewer for a sophisticated journal wishes to downgrade the latest Broadway play, one of the worst things he or she can say about it is that it has a comic-strip plot. This is also true for movie reviewers, but I tend to believe that movies, as a whole, really do not rank that much higher than comic strips as an art form.

The comic strip can be an extremely creative endeavor. At its highest level, we find a wonderful combination of writing and drawing, generally done by one person sitting at a drawing board in a room all by himself, much the same as a composer sitting at a piano, or a writer crouched over a typewriter. But there are several factors that work against comic strips, preventing them from becoming a true art form in the mind of the public. First, there is the quality of reproduction.

The Gallery

Comic strips are reproduced with the express purpose of helping publishers sell their publications. The paper on which they appear is not of the best quality, so the reproductions lose much of the beauty of the originals. The strip is not always exhibited in the best place, and there are always annoying things like copyright stickers, which can break up the pleasing design of a panel, or the intrusion of titles into first panels in order to save space. The true artist, working on his canvas, does not have to put up with such desecrations.

The comic strip serves its purpose in an admirable way, for there is no medium that can compete with it for readership or for longevity. There are numerous comic strips that have been enjoyed by as many as 60 million readers a day, for a period of 50 years. Having a large audience does not, of course, prove that something is necessarily good, and I subscribe to the theory that only a creation that speaks to succeeding generations can truly be labeled art. But it really does not matter what you are called, or where your work is placed, as long as it brings some kind of joy to some person someplace. I work as hard now as I ever did. I do the strip because I want to. Some who say they create for unselfish reasons, for humanity, are not being honest. They do it for themselves, because they have to. They are driven to it.

A short while ago, the phone rang in our house, about 7:15 in the morning. My wife, Jeannie answered it. It was a young girl calling from the Midwest. She said, "My friends and I are having an argument. Is Mr. Schulz still alive?"

Jeannie said, "I just saw him in the bedroom about ten seconds ago."

So the girl said, "Oh well, I guess I lose the bet then."

Considering what some of Charlie Brown's friends say, I must admit that things like this are not totally lost on me. Even useful. To create something out of nothing is a wonderful experience. To take a blank piece of paper and continue drawing with the same pen and materials as when I started the strip in 1950 is a real privilege. To draw characters that people love and worry about is extremely satisfying. I am happy that I have been allowed to do it for 50 years.

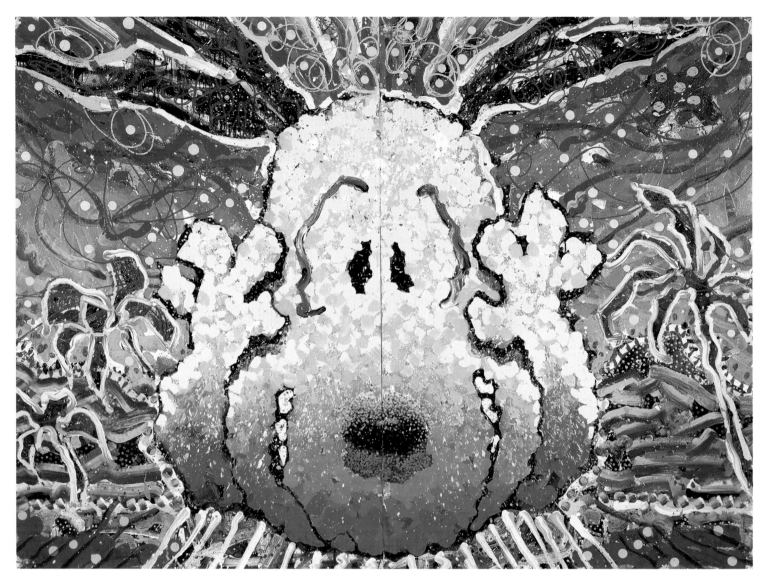

Editor's Note:

But as usual, Snoopy has the last word. This is a very large painting of our hero by Tom Everhart, entitled *Nobody Barks in L.A.* Tom is the only painter authorized by Sparky's agents, United Media, and himself to artistically render *Peanuts* line art, and the only painter authorized to use them as painting subjects. Tom Everhart became involved with *Peanuts* in 1980 when he was asked to render some drawings of the characters for a commercial project. A successful painter with no background in cartooning, Everhart prepared for the task by projecting *Peanuts* strips onto a 25-foot wall in his studio for closer examination. He was stunned to discover that blown up larger than life, Sparky's pen strokes translated into painterly brush strokes that closely connected to his own form of expression. His immediate fascination with Sparky's "line"—and his remarkable ability to reproduce it impressed Sparky, and launched their subsequent friendship and collaboration.

Everhart's paintings have been exhibited at museums all over the world, from Milan to Minneapolis to Japan, and in the Louvre in Paris.

A *Peanuts* Chronology

1950
Peanuts daily strip debuts with Charlie Brown, Snoopy, Shermy, and Patty in seven newspapers on October 2.

1951
Schroeder is introduced.

1952
Peanuts Sunday page debuts on January 6.
Lucy and Linus make their first appearances.
First book collection, *Peanuts*, published by Rinehart.

1955
Charles M. Schulz receives National Cartoonists Society Reuben Award.

1958
Yale University names Schulz Cartoonist of the Year.

1959
Sally enters strip.

1960
School Bell Award from National Education Society.
Hallmark introduces series of *Peanuts* greeting cards.

1961
Frieda introduced into strip.

1962
Happiness Is a Warm Puppy published by Determined Publications.
Best Humor Strip of the Year Award from National Cartoonists Society.

1963
Honorary degree from Anderson College, Anderson, Indiana.

1964
The Gospel According to Peanuts, by Robert Short, published by John Knox Press.
Second Reuben awarded Charles Schulz by National Cartoonists Society.

1965
Peanuts featured on cover of *Time* magazine (April 9).
Television Special *A Charlie Brown Christmas* wins Emmy and Peabody Awards.
Snoopy appears in first Red Baron sequence (October 10).

1966
Snoopy's doghouse burns—he receives many letters of condolence.
Peppermint Patty enters strip.
Schulz receives Honorary Doctor of Humane Letters from St. Mary's College, California.
Television Special *It's the Great Pumpkin, Charlie Brown*.

1967
Certificate of Merit awarded by Art Director's Club of New York.
Snoopy and Charlie Brown featured on the cover of *Life* magazine (March 17).
You're a Good Man, Charlie Brown opened off Broadway on March 7, and ran for four years.

1968
Snoopy joins Manned Flight Awareness Program.
Franklin enters strip.

The gang in the 60s.

1969
Snoopy and Charlie Brown accompany astronauts into space aboard Apollo X.
Lucy and Snoopy featured on the cover of *Saturday Review* (April 12).
The Redwood Empire Ice Arena in Santa Rosa is opened.

1970
Woodstock introduced into strip.
Snoopy joins the Ice Follies.

1971
June 17: *Peanuts* Day in San Diego—Charles M. Schulz given key to the city.
Snoopy publishes *It Was a Dark and Stormy Night* (Holt, Rinehart and Winston).
Marcie enters strip.
Snoopy, Charlie Brown, Linus, Lucy, and Woodstock on cover of *Newsweek*.
Snooopy joins *Holiday on Ice*.

A *Peanuts* Chronology

1972
Rereun introduced into strip.
Ice Follies television show—*Snoopy's International Ice Follies*.

1973
Charles Schulz given Big Brother of the Year Award in San Francisco.
U.S. government uses Snoopy as Energy Conservation Symbol.
Television special *A Charlie Brown Thanksgiving* earns an Emmy Award
 for Charles M. Schulz as writer of the show.

1974
Schulz is Grand Marshal of the Tournament of Roses Parade, Pasadena.

1975
Spike introduced into strip.
Television Special *You're a Good Sport, Charlie Brown* wins Emmy Award.

1976
Television Special *Happy Anniversary, Charlie Brown* wins Emmy Award.

1978
International Pavilion of Humor, Montreal, names Schulz Cartoonist of the Year.

1980
Television Special *Life Is a Circus, Charlie Brown* wins Emmy Award.

1983
Television Special *What Have We Learned, Charlie Brown?* wins a Peabody Award for
 "distinguished and meritorious public service in broadcasting."
Camp Snoopy opens at Knott's Berry Farm, Buena Park, California.

1984
Peanuts strip sold to 2,000th newspaper and recorded by Guinness Book of World Records.

1985
Oakland Museum opens *Peanuts* exhibit, *The Graphic Art of Charles Schulz*.

1986
Lydia enters strip.

1989
Publication of Charles M. Schulz's authorized biography, *Good Grief*,
 by Rheta Grimsley Johnson.

1990
Charles M. Schulz receives *Ordre des Arts et des Lettres* from the French Ministry of Culture.
In Paris, the Louvre presents the *Snoopy in Fashion*: exhibit.
The National Museum of History in Washington, D.C., opens
 This is Your Childhood, Charlie Brown—Children in American Culture. 1945-1970.

1992
The Montreal Museum of Fine Art exhibits *Snoopy, the Masterpiece*.
The Italian Minister of Culture awards the Order of Merit to Charles M. Schulz.

1995
Around the Moon and Home Again: A Tribute to the Art of Charles M. Schulz at the
 Space Center in Houston celebrates the strip's 45th anniversary.
A&E Biography features *Charles Schulz—A Charlie Brown Life*.

1996
Star is placed on Hollywood's Walk of Fame in honor of Charles M. Schulz.

1997
World premiere at Carnegie Hall of *Peanuts Gallery*, by composer Ellen Taaffe Zwilich.

1998
The Little Red-Haired Girl finally appears, but just as a silhouette, dancing with Snoopy.

1999
You're a Good Man, Charlie Brown opens new production on Broadway.

The editor would like to thank the staff of Charles M. Schulz Creative Associates for their help in preparing this book, in particular, Lorrie Myers, Edna Poehner, and Erin Samuels. Thanks to Freddi Margolin for a generous supply of material from her immense *Peanuts* archive, and thanks also to Sparky's editor at United Media, Amy Lago, and his editor at HarperCollins, Lois Brown.

Sparky's daughter Jill rescued the original illuminated pole that used to hang outside her grandfather's barbershop.